# Chinese Jades from Han to Ch'ing

BY JAMES C. Y. WATT

## The Asia Society

IN ASSOCIATION WITH JOHN WEATHERHILL, INC.

*Chinese Jades from Han to Ch'ing* is the catalogue of an exhibition shown in Asia House Gallery in the fall of 1980 as an activity of The Asia Society to further understanding between the peoples of the United States and Asia.

This project is supported by grants from The Friends of Asia House Gallery, the Andrew W. Mellon Foundation, and the National Endowment for the Arts, Washington, D.C., a Federal agency.

Library of Congress Cataloguing in Publication Data:
Watt, James C Y
   Chinese Jades from Han to Ch'ing.
   "Catalogue of an exhibition shown in Asia House Gallery in the fall of 1980 as an activity of The Asia Society."
   Bibliography: p.
   1. Jade art objects—China—Exhibitions.
I. Asia House Gallery, New York. II. Title.
NK5750.W37      736'.24'095107401471      80-20115
ISBN 0-87848-057-9
ISBN 0-87848-056-0 (pbk.)

Frontispiece: Ducks with Lotus Plants (no. 87).

736.24095107401471
W

1

## Foreword

I N VIEW of The Asia Society's reputation as the organizer of small, carefully selected, thematic exhibitions concerning the historic arts of Asia, the idea of a display of Chinese jades is a natural one. It is, in fact, surprising that this should be the first show on the subject to be presented in Asia House Gallery. However, it should be noted that exhibitions of Chinese jade have been under consideration here for many years. The general idea was first discussed at a meeting of the Gallery Advisory Committee as early as November 1964 when a broad survey of jades from all periods was proposed under the guest curatorship of Richard Fuller.

At that time, Dr. Fuller was not able to take on such a project, and as the years passed, more specific presentations were made periodically. By 1967, serious discussions concerning an exhibition of Chinese jades and other mineral carvings from the medieval and later periods were held with Walter Trousdale, and such an exhibition was actually scheduled to take place in the spring of 1970. Work was already well along when, just a year before the opening date, it was necessary to cancel this exhibition because one important lender had to withdraw a large number of objects.

Although such vicissitudes caused obvious havoc in the Gallery schedule, this long period of gestation has finally produced a more coherent exhibition than any of those which had been under consideration earlier. As our guest curator James Watt states in his acknowledgments, this is still a new field and he is engaged in what he modestly refers to as an "expansion of immature ideas." It was not until very recently that jades of the periods represented here were seriously collected and considered to be more than the "nonsense" to which they were sometimes jokingly referred. Despite a handful of earlier studies and some recent exhibitions and catalogues, in many instances basic questions of dating, evolution of forms, and use and meaning have remained unanswered. This book and the exhibition it accompanies provide new information and suggest solutions that should form a solid base for future scholarship.

One of the most significant facets of this study is the incorporation of the results of recent archaeological work in China into the analysis of certain heirloom types whose dates have been largely conjectural. Of additional significance has been the discovery of inscriptions, some on pieces that had been thought to be without them. As a result, the outlines of a chronology now begin to appear, new styles of sculpture emerge, and schools of carving can be identified. Of particular interest is the attempt to present something of the scope and quality of the work of the legendary Ming carver Lu Tzu-kang, whose work is almost unknown in the West.

We have been fortunate to have had the opportunity of collaborating with James Watt, Curator at the Art Gallery of the Chinese University of Hong Kong. His intimate knowledge of the material has enabled him to organize two previous exhibitions that were held in Hong Kong in 1972 and 1977. He has also encouraged many private Hong Kong collectors to look into the qualities of these "new jades" and has worked closely with them. The majority of pieces we show here are from such collections and are published for the first time.

As always, there are many individuals and organizations to thank for bringing about the completion of this complex task. Mr. Watt has mentioned those who assisted him in this country and in Hong Kong, and I add my thanks to his. We are particularly grateful to the many Hong Kong lenders who have shared these precious objects with us, and allowed them to be kept at the University for many months for study and photography. Katharine Parker edited the entire manuscript in record time. My staff has continued to perform with characteristic efficiency: Sarah Bradley in overseeing the production of the catalogue on a very tight publication schedule; Terry Tegarden in arranging for the packing, shipping, circulation, and proper handling of the material; Mahrukh Tarapor in creating the education programs arranged around the exhibition in New York; Kay Bergl in coordinating the publicity; and Carol Lew Wang, Peggy O'Neill and Meg Gilroy in keeping up with the large amount of correspondence and paperwork. All of them have my deep thanks. The effective mounting of a large number of small objects in a clear and simple installation has been the work of Cleo Nichols and his crew. The interest of Frederick Cummings, Henry Trubner, and Howard Link has allowed us to send the exhibition to The Detroit Institute of Arts, the Seattle Art Museum and the Honolulu Academy of Arts after its appearance in New York.

Always necessary financial assistance has come from many quarters. We continue to benefit from the support of the Andrew W. Mellon Foundation through a grant that has assisted in the publication of this catalogue. A planning grant from the Friends of Asia House Gallery allowed Mr. Watt to travel to collections in America to select loans, and the same group has also given a generous basic support grant to the exhibition itself. An Aid to Special Exhibitions grant has been received from the National Endowment for the Arts, and additional contributions have been made by the Auchincloss Foundation and Dr. and Mrs. John C. Weber.

Finally, we are indebted to Judith Ogden Bullitt who served as our "agent in the field" in Hong Kong and oversaw many details of this vast, long distance undertaking. We are

also grateful to her husband John Bullitt, who allowed us to use the pouch of his firm, Shearman and Sterling, in communicating with Hong Kong, and to Joyce Vincent of their New York office who cheerfully supervised the flow of correspondence.

This is the seventieth and last exhibition to be held in the Asia Society building at 112 East 64th Street. More than twenty years have passed since the first one opened in January 1960, in the small space that has served as Asia House Gallery during these two decades. In its selection of materials and scholastic approach to its subject matter, "Chinese Jades from Han to Ch'ing" is typical of the exhibitions that have been held here and have had such an influence on the appreciation of the arts of Asia throughout America. This exhibition not only maintains the fine reputation of the Gallery, but sets it in the proper direction for the future challenges and achievements which will face it in the Society's new headquarters.

Allen Wardwell
*Director*
*Asia House Gallery*

## Preface

THE PERIOD of the fifties and sixties was the heyday of the antique market in Hong Kong, although it may not have seemed so at the time, for those were also days of innocence in the history of collecting in Hong Kong. As far as the story of jade is concerned, by the beginning of the 1960s most of the genuine archaic pieces had been garnered by the knowledgeable few, although brown and black pieces, known as "Han jades," were still in plentiful supply. By about 1963, attention began to turn to the almost unmentionable subject of "new jades," that is to say anything fashioned after the Han period. A group of collectors began quietly to assemble "pieces of non-sense," as one of the collectors is wont to say, and there was certainly a great deal of "non-sense" around. The growth of sizable collections engendered an academic interest in the subject that led to an exhibition of jade carvings in 1972 at the Art Gallery of the Chinese University of Hong Kong. During the organization of this exhibition it was discovered that "new jades" were also to be found in "old collections," except that they were generally given a place of secondary importance. However, finely carved white jades of whatever period had always been a permitted area of collecting and the name of Lu Tzu-kang, almost unknown in the West until recently, had never lost its magic in China in the four centuries since his death. Another larger and more comprehensive exhibition, which grew out of a smaller show at the Min Chiu Society, was held in 1977–1978, again at the Chinese University Art Gallery. This second exhibition is the forerunner of the present show at Asia House Gallery and other American museums.

The exhibitions in Hong Kong were accompanied by very simple catalogues because the exhibitions were more in the nature of explorations into a largely unknown realm rather than expositions of established knowledge or the results of accomplished research. The present catalogue attempts to expand on the few "immature ideas" (as my colleagues in China would say) conceived during the days when hundreds of fine examples of later jade carving were assembled in the Chinese University Art Gallery for an extended period, providing excellent conditions for comparative study.

I am very glad to have the opportunity to acknowledge here the forbearance and support of all the lenders to the Hong Kong exhibitions, most of whom have also lent to the present show in the United States. In particular, I should like to mention Mr. Chiu Chu-tung, one of the last surviving members of the Jade Society in Canton, who taught me much in the early stages of my studies in jade; Mr. J. S. Lee, who has been the Chinese University Art Gallery's chief supporter over the years; Mr. Brian McElney and Mr. Victor Shaw, who have both been as generous with their knowledge of the subject as with their loans for the exhibitions; and Mr. and Mrs. S. L. Fung, who have made their collection available for study at all times. Mrs. Fung, in her former capacity as the Librarian of the Fung Ping Shan Library of the University of Hong Kong, also gave ready assistance in providing reference material. The Hong Kong Museum of Art is always ready to lend, and Mr. Laurence Tam, Curator, has been most cooperative.

When, as a result of a suggestion by Mr. Allen Wardwell that the exhibition should be augmented by pieces from American collections, I went on a rapid tour all over the United States to make selections, I was given a warm welcome and assistance everywhere. Basically I followed my own trail made in 1974 when I traveled through the United States as a JDR 3rd Fund Fellow and much of the material was known to me. I should particularly like to record the hospitality and assistance of Mr. Henry Trubner and Mr. William Rathbun at the Seattle Art Museum, Mr. Yvon d'Argencé and Mrs. Terese Bartholomew at the Asian Art Museum of San Francisco, Mr. Laurence Sickman and Mr. Marc Wilson at the Nelson Gallery-Atkins Museum in Kansas City, Mr. Robert Jacobsen at The Minneapolis Institute of Arts, Mr. Jack Sewell at The Art Institute of Chicago, Dr. Bennet Bronson at the Field Museum of Natural History in Chicago, Professor John Rosenfield and Mr. Robert Mowry at the Fogg Art Museum, Harvard University, and Miss Jean Gordon Lee at the Philadelphia Museum of Art. The private collectors in New York were equally generous with their time and hospitality. In addition, Mr. Robert Ellsworth gave me considerable help in practical matters.

This trip was also most edifying because all the scholars I have mentioned above gave me much advice and information. Mr. d'Argencé shared some of his notes on the San Francisco pieces with me, and Mr. Robert Mowry was most generous in supplying me with research material. At his suggestion, physical tests were made on some of the Fogg Art Museum's pieces at the museum's Center for Conservation and Technical Studies, with the results discussed in the Introduction, which confirm the information on the dyeing of jades told me long ago by dealers in Hong Kong.

I did not travel to Cleveland on my selection tour, but when I later saw Dr. Sherman Lee and Mr. Wai-kam Ho in Hong Kong they told me of the inscribed white jade *ko* in The Cleveland Museum of Art and readily agreed to lend both this piece and the Yüan cup to the exhibition. Mrs. Jean Cassill was subsequently most efficient in sending photographs and details. It may be appropriate to record here that my interest in the *mo-hou-lo* (the boy image in Sung and Yüan art) originated in a conversation with Wai-kam Ho years ago.

In my search for reference material on the "animal style" pieces, I was given generous guidance by Mrs. Emma Bunker, but any fault in the use of the material that she so kindly supplied is entirely my own. I am also indebted to Mr. André Newburg for translations of Russian articles.

And so with a great deal of help and goodwill from many quarters I found myself facing an embarrassment of riches that proved almost too much for me to cope with. There was the dilemma of having to choose between an exhibition that would provide a "comprehensive" survey of the entire subject and one that would isolate a number of special themes for close study. Nearly all the pieces included in the exhibition were selected primarily for their intrinsic artistic qualities. However, when the number of datable jade pieces is so small, it is difficult to resist the temptation to put in a piece or two whose merit consists mainly of "datability." In the end, compromises have been made that will necessarily reduce the impact and coherence of the exhibition and the underlying arguments. However, at the present "infantile" stage of our study of this subject, a certain untidiness in presentation may be forgiven.

Several other aspects of this catalogue must be mentioned and the invaluable assistance of my colleagues acknowledged. The Wade-Giles system of romanization of Chinese names is generally adhered to in the text, both for my own convenience and for those who have not yet adapted to the *pinyin* system. Besides, for an exhibition of jades in which archaism is one of the chief characteristics, a certain degree of archaism in language may even be appropriate. The purists will find the *pinyin* equivalents in the list of Chinese terms that has been ably assembled by my colleague Mr. Peter Lam who, together with Miss Tse Yin-ping, also compiled the bibliography. In my research work I was assisted by all my colleagues, especially Mr. Yang Chien-fang and Miss Lai Suk-yee. Ms. Anne van Merlin (Mrs. Charles de Lantsheare) years ago assisted me with an English version of the descriptive catalogue for the 1978 Hong Kong exhibition, which was never published, but her draft entries have been incorporated into the present version. Finally, Miss Kwok Po-chu turned pages of scribble into a legible typescript.

This exhibition would not have materialized without the energetic and most able effort of Judith Ogden Bullitt who liaised between Asia House Gallery and the Hong Kong collectors, arranged and supervised the photography of the loans from Hong Kong, wrote the first drafts of the descriptive catalogue entries on the Hong Kong pieces, and kept me to the various deadlines for my own contributions. Without her constant support and encouragement, I would not have been able to see the project to its conclusion.

It remains to thank The Asia Society for affording the opportunity to assemble and study a large and important group of jades. I also wish to thank Mr. Allen Wardwell and Ms. Sarah Bradley personally for their patience and encouragement and for their advice and assistance at every stage of the organization of the exhibition. Finally, a special vote of thanks is due to Ms. Katharine O. Parker for her meticulous editing, which has made the text more readable and more accurate.

J. C. Y. Watt

## Lenders to the Exhibition

Art Gallery, The Chinese University of
  Hong Kong
The Art Institute of Chicago
Asian Art Museum of San Francisco,
  The Avery Brundage Collection
Bei Shan Tang Collection
Dr. and Mrs. Cheng Te-k'un
Ch'eng Chai Collection
Chih-jou Chai Collection
Sammy Chow Collection
Mr. and Mrs. Philip Chu
Quincy Chuang, Esq.
The Cleveland Museum of Art
Mr. and Mrs. Alan E. Donald
Robert H. Ellsworth Collection
Field Museum of Natural History, Chicago
Fogg Art Museum, Harvard University,
  Cambridge, Mass.
Gerald Godfrey, Esq.
Guan-fu Collection

Hong Kong Museum of Art, Urban
  Council, Hong Kong
Charlotte Horstmann
Joseph E. Hotung
K'ai-hsüan Studio Collection
B. S. McElney Collection
Paul Mills-Owens
Philadelphia Museum of Art
The St. Louis Art Museum
Seattle Art Museum
Victor Shaw
Laurence Sickman
Dr. Paul Singer
Ssu-ch'uan-ko Collection
The T. B. Walker Foundation
T'ing-sung Shu-wu Collection
Mr. and Mrs. B. H. Tisdall
Wilfred Tyson
Ching-yin Watt
Dr. Shing-yiu Yip

# Introduction

THE HISTORY of jade in many ways reflects the evolution of Chinese culture, encompassing its entire history and geographical extent and the many cultural traditions associated with the various regions that have finally been brought together in the unity of present-day China. This exhibition illustrates several facets of this long history and begins not with the ritual jades of the Shang and Chou periods, which have been the subject of extensive study by scholars both inside and outside China (the ornamental jades of these periods are in a way also ritual), but with the Han period, when the ritual jades became fossilized and the secular use of jades became more prevalent. Ritual jades of the Han period are not included in this exhibition.

For convenience of organization, the exhibition has been divided into sections that may or may not individually constitute a "theme." The sections on animals and on objects for the scholar's desk are the most coherent and self-contained, each in its own way. The former spans all of two millennia and many areas of the country, and yet a basic continuity and some central trends of evolution of style will be apparent as we examine the sculptures of the different periods. The latter has mainly to do with the tastes and predilections of a small group of scholar gentry in the eastern provinces of China in the seventeenth and eighteenth centuries A.D., and the homogeneity is clear. The other sections are less amenable to definition except on superficial levels of form, use, and subject matter. It would be difficult to demonstrate any affinity or link between the figure of a "westerner" of the T'ang period, that of a boy with lotus leaf of the Yüan period, and that of a lady reclining on a banana leaf of the late Ming period. The section on birds and fishes is also more heterogeneous than it may at first seem. The section on plaques and personal ornaments most nearly illustrates the work of the Su-chou school of jade in the Ming and Ch'ing periods, but it would give an incomplete picture.

It is therefore necessary to make an attempt to discuss some of the cultural and art historical problems, especially those that are unavoidably obscured by the very

organization of the exhibition. The division into periods and the methods of dating, which concern many students of later Chinese jades, will also be discussed.

*Cultural Manifestations*

The first part of this exhibition concerns the Chinese animal style, which is as yet imperfectly understood and not much studied. Among other things, it aims to illustrate the slow process of adaptation of one type of artistic expression, the vigorous and animated, to another, the sedentary and contemplative. The early animal sculptures that portray the power and grace of the creatures of nature, to be observed at a distance and wondered at, gradually become the relaxed companions of people, sharing their own comfortable domesticity. The animals in mortal combat become the playful cats in the house (nos. 19–24).

Although the general trend of development in Chinese animal art is clear, it is not always possible to place individual carvings in the correct sequence of the evolutionary process. For example, an animal in yellow jade (no. 58) in this exhibition dated to the Sung period is almost identical to another in the collection of the late King Gustav VI Adolf of Sweden that is dated to the Wei period.[1] There are good reasons for the discrepancy, but the datings cannot both be right, and this is an obvious case for "further study." As far as possible, the reasons for assigning specific dates to individual pieces are given in the catalogue entries. There is, however, an empirical rule in the dating of jades that applies especially to sculptures of animals: a completely flat base often indicates an early date. A number of known Han pieces, including several in this exhibition (nos. 9, 15, 19), have this feature, as do some T'ang animals (nos. 25, 26). The flat base may indicate that the piece was meant to be used as a weight. In any case it is rare after the Yüan period. Similarly, some animal and figure carvings of the T'ang, Liao, and Chin periods may have been used as decorations for tops or legs of vessels, for these have a large (by comparison with their size) central vertical perforation that is rectangular or oval in cross-section (see nos. 31, 63, 65). These perforations are to be distinguished from the small circular drilled holes that are found on pieces used as toggles or pendant ornaments. A white jade horse found in a Chin site displays this feature, as mentioned in catalogue entry no. 63.

Jade also symbolizes another dualism in Chinese culture, the Confucian and the Taoist. The central position of jade in the ritual system instituted as part of early Chinese statecraft is well known. The Confucianists later imbued jade with all the virtues appropriate to the ideal man in an ideal state. The simple forms of ritual jades remained almost unchanged up to the absolute end of the "feudal" period in Chinese history, except that the later versions of the *kuei*-scepter in the Ming and Ch'ing periods are often decorated with constellations symbolic of Taoist deities. The association of jade with Taoism came later, perhaps at the time of the rise of Taoism as a quasi-religious movement toward the end of the Han period, and was at first expressed more in literature than in the plastic arts.

Taoist art, which is mainly derivative, has little distinctive iconography apart from what was evolved in the T'ang and Sung periods in the illustrations to the *Tu-jen Ching*, the Deliverance Scripture used at the Taoist service for the dead. This tradition of figure painting reached its apotheosis in wall paintings on Taoist temples of the Southern Sung, Chin, and Yüan periods. The tradition is said to have originated from no less a personage than Yen Li-pen, a member of an artist family who played an important part in the artistic life of the imperial court at the beginning of the T'ang period.[2]

Those who seek to interpret early jade ornaments and implements as Taoist cult objects usually have to exercise considerable ingenuity. Thus the short *kuei*-shaped knife with a broad edge and decorated with dragons and archaistic motifs can, with a little imagination (and perhaps esoteric knowledge?) be regarded as a scraper or spatula for Taoist elixir. The image of an infant in a ring may be regarded as the symbol of the essence of the *yang* principle.[3] Such identifications are difficult to substantiate and should be approached with great caution. However, there do exist a great many jades from the Yüan to the Ch'ing periods that exhibit unmistakable association with Taoism, and these reflect the evolution of Taoism during these periods from an organized religion with some official support to a diffused system of popular beliefs that became almost an integral part of secular life in China. The Cleveland cup (no. 131), which answers in every iconographic detail to the standard representations of deities such as are found on Yüan Taoist temples, must be counted as a distinctly Taoist object. But the many jade sculptures of Taoist figures of the Ming and Ch'ing periods, such as Liu Hai (no. 106) and Shou-lao (no. 102), can only be regarded as folk art. Similarly, the landscapes decorating many jade brush holders and large plaques of the late Ming and early Ch'ing periods, which derive from the Taoist fairy landscapes of the Yüan period, cannot be accorded any religious significance in the ordinary sense.

*Periodization and Dating*

The dating of later Chinese jade objects is notoriously difficult, mainly because of the lack of reliable points of reference such as published archaeological finds and detailed historical records. Some early illustrated catalogues on jade do exist, but the editions we know today are all either late or apocryphal.[4] Early writers on the subject hardly ever made any attempt to relate styles or subject matter to historical periods—with the great exception of Kao Lien, the late Ming connoisseur who showed remarkable analytical insight and who was able to propound a general hypothesis on the development of Chinese jade carving in terms of subject matter and carving technique.[5] It was Kao who suggested that the use of different color areas of the jade pebble to enhance the effect of a sculpture group carved out of a single stone (such as a boy in white jade riding on a black buffalo) was a Sung invention. This theory is still current today among Chinese students of jade and is probably correct. However, the art historical term "Sung," except in paintings, carries with it inherent problems as a result of the traditional Chinese reluctance to recognize any contribution made in the Yüan period. Kao Lien's list of

subject matters of jade carving of the various historical periods should be closely examined one day in the light of fuller knowledge.

In this exhibition, attribution of pieces to the Han period has been done with reference either to archaeological evidence or to style. Two of the pieces that have been given a Han date by comparison with excavated material (nos. 11 and 156) are particularly important because they are representative of two standard classes of jade carving in the Western Han that were much copied in later periods. In the past the *chüeh*-pendant (no. 156) would have been given a pre-Han date and the chimera (no. 11) a post-Han date.

At the present stage of our studies, the entire period of the two Hans and up to the fall of the Western Chin at the beginning of the fourth century may be regarded as a single stylistic period. A cursory perusal of the available archaeological material from the Han period seems to indicate no great or sudden changes in style and subject matter of jade carving during this time. A more detailed study may reverse this opinion but it has yet to be done.

The violent upheaval of Chinese society and the arrival of large numbers of nomadic peoples in the Yellow River basin after the collapse of the Han Empire must be reflected in the material remains, if they are to be found. However, hardly any jade has been discovered in Northern Dynasties sites so far. The reason for this lack of finds of jade must be that the people of the Northern Dynasties did not have a practice of burying the dead with jades, because it seems unlikely that they did not use the material at all. If other art forms are anything to go by, many elements of the artistic expression of the Northern Dynasties went into the cosmopolitan art styles of Ch'ang-an of the T'ang period. There is no reason to suppose that jade carving was an exception.

The finds of jades in Southern Dynasties sites reveal a conservative adherence to Han forms and practices such as the prevalent use of funerary jade pigs, which in the more southern areas are often replaced by stone pigs, probably because of the scarcity of the material. Some Han families in the north must have practiced the same custom otherwise Yen Chih-t'ui, who lived in the Northern Ch'i period, would not have admonished his family against it (see entry no. 16). However, it must be said that Yen himself was an "immigrant" from the south.

The lack of archaeological evidence, apart from the ubiquitous pig, makes the dating of jade to the Six Dynasties period a speculative activity. In some cases comparisons can be made with stone sculptures of the period, but usually one assigns to this period anything, especially animals, that may appear to belong to an intermediate stage between the indefinite Han style and the somewhat better understood T'ang style. In this exhibition, attributions to the Six Dynasties period have been based on both comparisons with sculptural styles and the cultural associations of the pieces.

Most ornamental jades of the T'ang period, such as the belt plaque (no. 157) and the back of a comb (no. 159) can be dated by reference to archaeological finds. This is not the case with carvings of animals and human figures, and again one normally resorts to comparisons with stone and pottery sculptures of the period. The metalware of the

period, the gold and silver and bronze, with their strong Central Asian links, provide another excellent set of references. For example, the little deer with growing horns (no. 31) can be assigned with some certainty to the eighth century A.D. because this motif, of Sogdian origin,[6] is found on T'ang gold and silver pieces (and ceramic copies of them) and not on works of any other period. A similar jade found in an early Ch'ing tomb has also been dated by the excavators to the T'ang period.[7] The T'ang dating of no. 31 is reinforced by its central oval perforation and its flat base, characteristics that have been singled out in the discussion on animal carvings in the previous section.

In contrast to the T'ang style, a certain softening of the outlines, a lack of angularity, and an apparent bonelessness are characteristic of the plastic arts of the Sung period. Of course, the change did not coincide exactly with the official establishment of the new dynasty. The beginning of the transition occurred perhaps as early as the middle of the ninth century and reached its conclusion in the late eleventh century, toward the end of the Northern Sung period.

It may not be too far-fetched to draw an example from calligraphy. The brush stroke changed from the classical boned structure of the early T'ang calligraphers to the relaxed elegance of Huang T'ing-chien and Mi Fu in the Northern Sung period. The structure of modeled objects underwent a similar change. A three-color T'ang camel is strong and robust in form and spirit, but a camel from the royal tombs of Nan-t'ang in Nanking collapses completely into a comfortable heap.[8] It is by comparison with these tenth-century pottery camels that the two jade ones in this exhibition have been given early Sung dates. Other features of the Sung style are discussed in the various entries on Sung pieces such as no. 38.

For a long time the dating or identification of jades from the tenth to the thirteenth centuries has been the most difficult problem in the study of post-Han jades, again mainly due to the lack of archaeological data. However, the recently published reports of finds of jade from Liao and Chin sites have at least provided some clues to the northern style of jade working during this period. This in turn has narrowed the field of search for jades made in the Sung domain proper. The available evidence, both from literary sources and from the actual specimens that have been assigned Sung dates by a process of elimination rather than on the basis of positive evidence, seems to indicate that Northern Sung jade carvers carried on working with T'ang motifs but in their own style. At the same time, there was a steady increase of carvings of naturalistic subjects, such as birds among lotus plants, and what might be called genre carvings, such as children at play. These subjects, also known from paintings of the same period, represent the beginning of a truly indigenous style in post-Han Chinese jade carving. Because of the continued popularity of these subjects, jade carvings of these categories are rather difficult to date. A very good general guide to the relative dating of such pieces, apart from the style, is the amount of workmanship involved, especially in the modeling of details, which tend to become simpler in the later periods.

Flowers and floral rosettes were certainly part of the repertory of northern jade sculptors in the Liao and Chin periods. The floral rosettes became one of the most

common forms of ornamental jade in the Yüan and Ming periods (see nos. 164–174). But the most interesting type of jade carving, stemming from the Liao-Chin tradition, is the winged deities on clouds (nos. 98, 99). They have been identified as *apsaras* and given a T'ang date, but it seems that they have more to do with the age-old Chinese image of immortals with wings than with any Buddhist deity. If they have a link with an earlier period it would be with pieces like the hat ornaments (nos. 73, 74).

Archaism in jade carving was probably very much more developed in Yüan and Ming times, although it must have had a late Sung beginning. One refers here to the conscious imitations of genuine archaic material as opposed to the creative reconstructions of the earlier periods such as illustrated in the *San-li T'u,* an early Sung work that exacted strong criticism from the scientifically minded Shen Kua (A.D. 1031–1095).

The Sung imperial workshops probably made ceremonial pieces out of pure white jade that look like the Cleveland *kuei* (no. 121), even if this particular piece may not be of the exact date given in the inscription. It must have been pieces like this that the Chin people took back to their capital after the sacking of the Northern Sung capital Pien-ching. In any case, these pieces should be more properly regarded as continuations of a long tradition rather than as archaistic works of art.

Both the Sung and the Chin traditions of subject matter and technique survived, even developed, during the Yüan period. Carvings of boys, playing (no. 95), riding on buffalos (no. 47), or flying on clouds (no. 99), continued to be produced. Openwork carving, often in two layers, was the rule rather than the exception with belt plaques. Archaism was rampant and often combined with new and unexpected motifs. The scene was a rich one, if sometimes confusing.

Three pieces will serve to define the Yüan style—it should be said at once that they are more complicated in form than anything else that had happened before in Chinese jade carving. The first is the Cleveland cup (no. 131), the date of which is firmly established, although Ch'ien-lung marked copies are known.[9] From the point of view of the study of the general style of jade carving of the Yüan period, the important aspect of this cup is not the figures on the outer wall of the cup but the two handles, which take the form of two female deities riding on clouds. The concept and depiction of cloud forms, *yün-ch'i,* in association with spirits and immortals have long roots in Chinese thought and artistic expression, but the universal use of the cloud forms as a base for any kind of sculpture was a result of the widespread influence of Taoist art in the Yüan period. Thus elephants, lions, and a number of "auspicious animals" all went around on "cloud vehicles" (see no. 51), and the manner persisted right through the Ming period (see no. 52), but the treatment of the cloud forms became more stiff and formalized in the later pieces.

The use of clouds is also evident on the second piece, a shield-shaped plaque now in the Victoria and Albert Museum, London (see fig. 1). The main subject of the carving is the slaying of a dragon by a winged boy riding on clouds and holding in one hand a ring and in the other a dagger with which he attacks the dragon. This must be a depiction of

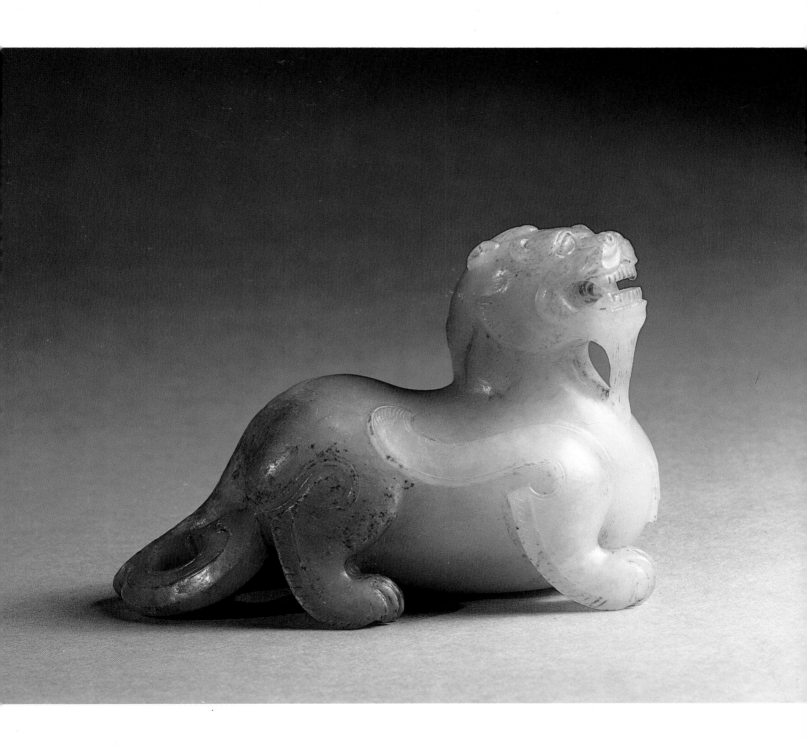

65.  Recumbent Horse

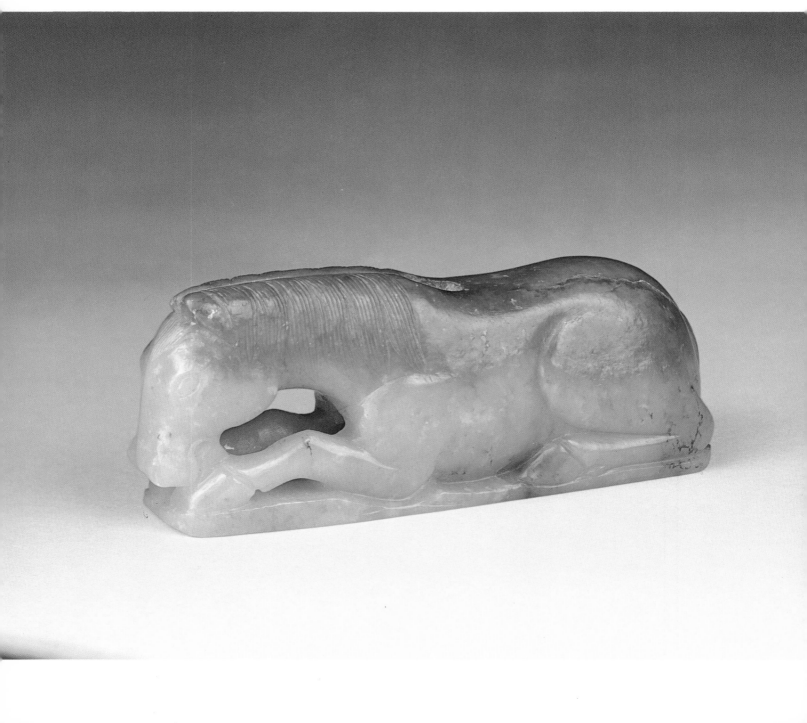

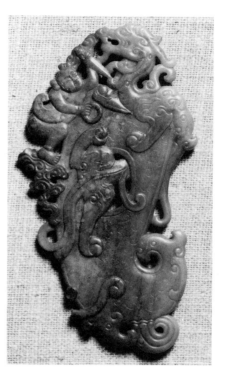

fig. 1.  Jade plaque. Yüan–early Ming
dynasty. Victoria & Albert
Museum, London.

the story of the slaying of the third son of the Dragon King of the Eastern Seas by the
"third prince" No-cha (or Nata), the third son of Li Ching, a historic figure in the early
T'ang period who later became deified in Taoist mythology as one of the manifestations
of the Heavenly King of the North, and who took on the name *Pi-sha-men* (Vaiśravana),
borrowed from Buddhism.[10] The exploits of No-cha, whose characteristic weapon is the
ring, were incorporated in the popular novel *Feng Shen Yen I*, which took its present form
in the sixteenth century A. D. but which has its roots in the Yüan period; indeed No-cha's
earliest appearance in Chinese popular literature was in the Yüan dramas. [11] In the 1975
Oriental Ceramic Society jade exhibition, the Victoria and Albert Museum piece was
dated Sung or Chin on stylistic grounds. However, as the legend of No-cha became
popular in Yüan times and persisted into the Ming, it may be more appropriate to date
this piece to the Yüan or even early Ming period. Having settled the approximate date of
the piece, the other motifs, especially the archaistic pattern, become most useful
references for the dating of pieces with similar archaistic designs. Thus, another
shield-shaped plaque in the Museum für Ostasiatische Kunst, Berlin, with an inscribed
date of T'ien-sheng (1023–1032), may well belong to the same period.[12]

   The third piece to be discussed is the most famous and best documented piece of
Yüan jade to have survived to the present day. This is the large black jade wine bowl in
the Round Fort in Peking (fig. 2), whose interesting history has been well recounted by
Hansford.[13] It suffices to say here that this jade carving is the only one that stands an

21

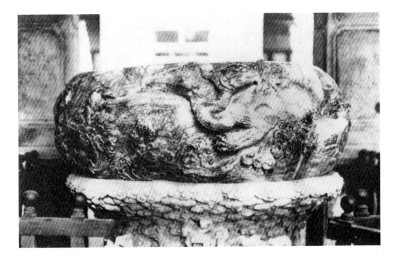

fig. 2.　Black jade wine bowl. Yüan dynasty. Round Fort, Peking.

excellent chance of being the actual piece recorded by both Chinese and foreign writers of the Yüan period, and for a good reason. This bowl was regarded in the fourteenth century as one of the wonders of the Mongol court at Peking on account of its size, approximately 4 feet and 6 inches across at the rim. Whether it turns out to be nephrite or not, it was regarded as jade and must have been worked as such. Photographs of this piece show that it is decorated on the sides with waves and dragons. Most probably the bottom of the bowl is carved in a similar manner. The use of waves and breakers as an independent decorative motif can again be traced to the late Sung–Chin period, as for example on "northern celadons" and bronze mirrors of the same age. The use of waves as decoration on Yüan blue-and-white porcelain is well known. Sometimes "dragons" (in this case sinicized nagas and makaras) and other creatures of the water are included to provide the motivating force for the waves. The use of waves (and dragons) as carved decorations on the outer walls and bases of jade vessels persisted throughout the Ming and into the Ch'ing period. After that it was probably not considered worthwhile for jade workers to spend so much time decorating parts of vessels that are not usually seen. The treatment of the waves went through distinct phases during the five centuries in question, as can be demonstrated by some of the pieces in this exhibition (nos. 61, 87, 111, 112). Generally speaking, the later the period the simpler the lines and the more formal the composition.

Another feature of Yüan carving that became a standard style throughout the Ming period is the openwork used for belt ornaments and decorative plaques (see no. 175 and also entry no. 157). The frame is either plain with circular cross-section or takes the form of "connected pearls." An important piece of early Ming carving (fig. 3 a and b), which is the only known piece of Ming jade bearing reliable reign and workshop marks, provides the evidence of the continuity of this style through the fifteenth century to the later part

of the Ming period, from which time many pieces have survived (for example, nos. 178–180 in this exhibition). This piece is an openwork decorative plaque with a crescent-shaped frame enclosing a mythical animal such as those found floundering or riding high in tempestuous seas on the outside walls of decorated porcelain (underglaze blue and/or overglaze iron red) of the Hsüan-te to Ch'eng-hua eras. On the back of the frame is carved the marks of "Ta Ming Hsüan-te-nien Chih" (made in the Hsüan-te reign of the great Ming) and "Yü-yung-chien Tsao" (made by the Yü-yung-chien). The Yü-yung-chien is of course the palace workshop of the Ming, which produced everything from furniture to everyday utensils in jade, cloisonné, and lacquer.[14] Unlike the Hsiu-nei-ssu mark of the Sung period, the Yü-yung-chien mark is not controversial, and few, if any, works of art bearing this mark are open to serious question. The only remaining problem relating to this mark is the actual location of the jade workshop, for the center of jade carving during the Ming period, especially the white jades, was firmly established in the Chiang-nan area, including Nanking and Su-chou. The amount of white jade carving recovered by archaeological work in this area has provided ample confirmation of this historically known fact.

On the whole, jade carving in the Su-chou area in the first half of the Ming period follows very much in the line of the Yüan style with more refinement and coherence in the decoration. In this way it parallels the development of the blue-and-white porcelain of the same period. During the sixteenth century a new style of carving developed in Su-chou that found its greatest exponent in Lu Tzu-kang. In spite of the great fame of the man and the many records of his work in late Ming writing, not much is known about

fig. 3a.  Openwork jade plaque with mythical animal. Ming dynasty.

fig. 3b.  Reverse of plaque showing Hsüan-te reign and palace workshop marks.

23

Lu's life and up to now it has not been possible to ascertain the exact dates of his birth and death. It seems most likely that he was a contemporary of both the poet-painter Hsü Wei (1521–1593) and Wang Shih-chen (1526–1590), who was one of the leading literary figures of his time. Hsü Wei's poem on Lu has been quoted in entry no. 195, and Wang's reference to Lu is in a passage in his *Ku-pu-ku Lu,* in which he discusses the collecting fashion of his time and lists the names of contemporary artists of Su-chou whose works fetch especially high prices.[15] This would indicate that Lu was active and famous in the lifetime of Wang Shih-chen, and the date corresponding to A. D. 1561 on the box (no. 114) in this exhibition fits well into this scheme of things. Various twentieth-century writers[16] on Lu Tzu-kang have referred to Ming editions of district gazetteers, the *Su-chou-fu Chih* and the *T'ai-ch'ang-chou Chih,* but the actual locations of these references have proved extremely elusive.

The various recorded carvings by or attributed to Lu Tzu-kang constitute a comprehensive repertory of work by the Su-chou carvers. The most well-known category of Tzu-kang carvings is the hairpin, of which there are good examples in this exhibition (nos. 193–195). Another type of ornament, the plaque pendant, which in later periods became so closely associated with Lu Tzu-kang that these pieces are often referred to as Tzu-kang plaques, was probably not a popular form of ornament in Lu Tzu-kang's own time. It is doubtful whether Lu himself ever carved any, even if the finest examples of this kind of carving in the early Ch'ing period always bear his signature. In this exhibition an attempt has been made to put a number of these plaque pendants in chronological order (nos. 205–219).

Perhaps the most important group of carvings that Lu Tzu-kang and the Su-chou carvers did were the articles for the scholar's desk and the archaistic vessels. This is confirmed by both the records and the actual pieces that have survived to this day. The desk objects are typified by nos. 107–109, 112–114, and 117–119 in this exhibition, particularly the box (no. 114) and the water pot (no. 109). Articles such as these supposed to have been made by Lu Tzu-kang are recorded by Kao Lien in his *Yen-hsien Ch'ing-shang Chien.* Similar *pi-hsieh*–shaped water droppers have been unearthed from Ming sites. The archaistic vessels are typified by the cylindrical cup, *chih* (no. 140 in this exhibition). The dating of this piece and its association with Lu Tzu-kang, at least with Su-chou, are discussed in the catalogue entry. Ch'en Chi-ju (1558–1639) in his *Ni-ku Lu* also records a covered *chih* (a different character from that for the cylindrical cup, but the nomenclature for ancient bronzes was not exact in Ming times) made by Lu Tzu-kang. The cover of the piece recorded by Ch'en Chi-ju is connected to the handle by a chain of thirteen links. This is of course not a new technique, for linked rings are known from as early as the Warring States period, but the later fashion of carving chains out of one block of jade must date from the sixteenth century A.D. Again, other archaistic vessels like the *kuei* are also common products of Su-chou at this time. A typical piece from a late Ming tomb is in the Wu-hsi Museum, and others are known in various collections, such as no. 385 in the 1975 Oriental Ceramic Society exhibition.

Before leaving the subject of Ming carving, mention must be made of the discovery in

the tomb of Emperor Shen-tsung, whose reign was known as Wan-li, of jade pieces that are markedly different in style and workmanship from those carved in the Chiang-nan area. These are vessels, ewers, and basins of a dark green jade with thick walls and shapes that are not found in jade objects in the south. It must be assumed that these jades were made in Peking workshops, if not in the palace itself. It is perfectly easy to envisage the existence of two distinctly different schools of jade working in the late Ming period, for the Chiang-nan area had outstripped every other part of China, including the capital, in economic prosperity and artistic development. Moreover, Peking was more open to cultural influences from northwest China and Central Asia as a result of the overland "tributary trade," whereas the culture of Chiang-nan was almost purely autonomous.

Jade carvings of the Ming–Ch'ing transitional period (ca. A.D. 1620–1670) are recognized by the standard representations of popular subjects of the period such as the illustrations to Su Shih's *Ode to the Red Cliff,* Li Po with his crackled glaze wine jar, Chang Ch'ien on his raft, and Mi Fu and his rocks. However, because most of these motifs carried on to quite recent times, the use of motif identification as a means of dating must be tempered with formal stylistic analysis. Some of these themes, such as the Red Cliff and the Gathering in the Western Garden (*Hsi-yüan Ya-chi),* had a beginning in earlier times—both examples quoted began in the Sung period—but they did not find widespread expression in the popular arts until the seventeenth century. This is an area of enquiry where the results of specialist researches on Chinese painting can be applied with profit to the study of the decorative arts.

The chief characteristic of jade carving in the Ch'ing period, as compared with those of other periods, is its increased size. This is both a matter of taste and the result of the availability of relatively large pebbles from the rivers and, even more important, the large boulders quarried from the mountains, a topic that will be enlarged upon in the next section. The most typical of Ch'ing carvings are therefore large vessels with naturalistic or archaistic patterns, mostly carved in Peking, and large screens and brush holders with landscape decoration (see also entry nos. 145, 147, and 148 for further comments on the Ch'ing style). Another type of carving that had its beginning in the late Ming period is the jade mountain with figures, trees, pavilions, birds and animals—in fact, a translation of the orthodox landscape painting into a jade sculpture. Unfortunately it has not been possible to include a jade mountain in the present exhibition. However, the style and technique of such carvings can be gauged from a number of pieces in this exhibition (nos. 100, 104, 107, 108, 118). Also, smaller pieces that represent the survival of the Ming style continued to be produced in Su-chou, employing motifs mentioned in the previous paragraph. This tradition finally ended in the 1930s.[17]

By far the most intriguing group of jade carvings in the Ch'ing period is the so-called Hindustan jades, which are stylistically related to the jade carvings of Moghul India. It will be some time before the question of Chinese versus Indian workmanship is resolved, for we know relatively little about the workmen who produced these carvings in India and China. The only observation that can be made at this stage is that the cultural differences may be more apparent than real. To put it in another way, there may

be more cultural affinity between the jade carvers of India and north China than one would normally assume. Considering that the population of the jade-producing areas has been Muslim for centuries, it is not surprising that the jades were collected in the seventeenth century by "turbaned Muslims."[18] It is much less generally known that the rest of the jade trade in northern and western China, including the transportation, carving, and dealing in carved jades, has been largely handled by Chinese Muslims up to the present time. For all we know, this situation may have begun in the sixteenth century and contributed to the emergence of what I have tentatively proposed as a distinct northern school of jade carving in the late Ming period. However, without further research into historical sources and investigations over a vast area, it will not be possible to come to any definite conclusions. Some observations on the stylistic and technical difference between Moghul pieces and Chinese pieces, which must be of later date, are made in entry no. 148.

*The Sources and Colors of Jade*

The student of jade need go no further than Joseph Needham and Howard Hansford for a complete geological description of the stone and for an account of the traditional methods of working it.[19] A few historical notes may be added here to further the inquiry and to emphasize those points that may have a bearing on identification and dating. The Chinese have always known that nephrite, the Chinese jade, comes from the K'unlun Mountains in the Western Regions. There is, however, an early tradition that asserts that some jades in ancient times were found in central and northeastern China. This assertion has been hotly disputed for the past three hundred years, beginning with the scientific writer Sung Ying-hsing in the early part of the seventeenth century. The question is complicated by the fact that in early times, especially in the pre-Han period, the definition of jade, *yü*, was not geologically strict. Certainly, by the time of Sung Ying-hsing, true jade referred to nothing other than nephrite. According to Sung, nephrite in his time came only from the K'unlun mountain range near Khotan, and that had always been the case.[20]

The earliest actual geographical descriptions of the rivers of Khotan (formerly Yü-tien) date from the period of the Six Dynasties, for example, in the History of the Northern Wei, *Pei-wei Shu* (*chüan* 102), in the chapter on the Western Regions and the section on Khotan. It says that "thirty *li* to the east of the city of Khotan is the Shou-pa River, which produces jade." Again, quoting from another source, it says: "Twenty *li* to the east of the city is a river which flows north and it is called Shu-chih River....Fifty-five *li* to the west of the city is a river called Ta-li River, it joins the Shu-chih River and both flow north." According to the *T'ung-tien,* the Shou-pa River is the same as the Shu-chih River.[21] Fujita Toyohachi further proposed that Shou-pa is a transliteration of *sphātika,* Sanskrit for rock crystal, whose meaning is extended here to include white jades. Similarly, he identified Ta-li with *vaidūrya,* meaning beryl and extended to cover green jades.[22]

The most detailed early account of the jade rivers of Khotan is contained in the records by Kao Chü-hui of his travels to Khotan as a member of a delegation sent to the king of Khotan by the short-lived Hou-chin dynasty (A.D. 936–946). Kao kept a notebook in which he recorded his observations of all the districts that he visited. These valuable notes have been preserved in various states of completeness in the New History of the Five Dynasties, *Hsin Wu-tai Shih*, in the Appendix on Foreigners, and in other notebooks of Sung writers such as Chang Shih-nan's *Yü Huan Chi Wen*. In the *Hsin Wu-tai Shih* version, Kao records that "the river divides into three at Yü-tien, the one to the east is called white jade river, the one to the west is called green jade river and the one further west is called black jade river. All three rivers produce jade but their colors differ. Every year, when the water level falls in the autumn, the king collects the jades from the rivers and then the people are allowed to do the same."[23] The existence of the black jade river was vigorously contested by Sung Ying-hsing in *T'ien Kung K'ai Wu*, but other writers on the subject in the Ming and Ch'ing periods all confirm the verity of Kao's account.[24] Indeed the names of the two rivers flowing on either side of modern Khotan, the Yurungkash and Karakash, mean white jade river and black jade river, respectively.

Sung Ying-hsing's denial of the existence of the black jade river may well have to do with the lack of black jade in his time. This is supported by the present author's own experience that virtually all jade pieces from the late Ming period down to the present day are either white or green, with a very small percentage of yellowish green. Conversely, many of the black jade pieces known to us seem to date between the Six Dynasties and the Yüan periods, that is, from about the fifth to the fourteenth centuries A.D.

By the late Ming period, toward the end of the sixteenth century, the supply of jade from the rivers in Khotan was beginning to dwindle after centuries of collecting, and quarrying from the mountains was practiced to meet the demand. Although some quarrying might have been done in earlier times, it was certainly not carried out on a large scale until the late sixteenth century. Among the earliest records of this activity is a note in Kao Lien's *Yen-hsien Ch'ing-shang Chien* in the section on jades in which he records that "large slabs of jade have been produced recently from the Western Regions" and that they were white and "dry" in appearance and often marked by fractures. Altogether they were not as valuable as the "water material" (boulder jade from the river beds). Benedict Göes, who visited Khotan and Yarkand in 1603, also reported that quarried jade was regarded as inferior.[25] With the quarrying of jade, Yarkand now became an important source of supply because it was Mount Mirtagh, "two hundred and thirty *li* from Yarkand," which was the main quarry and which produced large blocks of up to 10,000 *chin* (approximately 6,000 kg.).[26]

The appearance of large blocks of quarried jade accounts for the comparatively big size of some carvings from the seventeenth century A.D. onward. Indeed, very few jades of any size can be dated before 1600. Boulders and blocks of "mountain material" up to about two feet in length (or diameter) are often carved into vases or screens. Another common subject for large carvings is the mountain landscape with figures and animals.

fig. 4.  Jade mountain. Ch'ing dynasty.
The Minneapolis Institute of Arts:
Walker Foundation Loan.

Of these jade mountains the largest ones are still in the Palace Museum in Peking (the tallest measuring 2.24 meters high); one of the most finely worked examples belongs to The T. B. Walker Foundation and is at present housed in The Minneapolis Institute of Arts (fig. 4).

One of the most common features of the largish jade mountains and rockeries of the late Ming to the early Ch'ing periods, especially if they are carved from greenish jades, is the staining of certain areas to simulate the brown "skin" or "rind" that is characteristically found on jade pebbles collected from river beds (see, for example, no. 2). In most cases the staining must have been done at the time of the carving to disguise the mountain origin of the stone and thus to enhance its value. A test was conducted by E. Farrell and R. Newman at the Center for Conservation and Technical Studies of the Fogg Art Museum on the "Lohan in a Grotto" carving (no. 104) in the Museum's own collection, which displays signs of this type of enhanced coloring. The test showed that the caramel-colored patches, coinciding with certain pits on the surface, are caused by staining with an iron-containing agent. The analysts pointed out that the iron staining, which was detected by a scanning electron microscope SEM-EDAX, could not have been incurred during a period of immersion in a river, because the brown skin formed on the surface of riverbed jade pebbles has been shown to be the result of a structural change and not a chemical one.[27]

Another piece in the Fogg Art Museum, a carving in black jade of a water buffalo with a boy on the back, very similar to no. 47 and of the same date, was subjected to similar tests that produced the conclusion that "while the piece is genuine nephrite with real black inclusions, the fractures and some of the surface are synthetically stained."[28] The

black stains, which are ineradicable, are caused by carbon, indicating the possible use of an organic dye. There are probably very few jade pieces that are completely black, and black jade pieces are often found to be stained including those that are only partially black. A black dog in this exhibition, no. 37, is probably stained at least in part; and the large black plaque, no. 125, is almost certainly stained.

The usual method of staining jades, as described by Hansford,[29] is well known and is often recounted by dealers in old jades. Jades to be stained are suspended in a dye that is kept at boiling temperature. However, very little is known about the dyes used and whether the same method is used for the production of different colors.

Of the real colors of jade there are five by traditional Chinese reckoning: red, yellow, white, black, and green. The color gray, which appears often in Western catalogues, is not admissible in the Chinese system; in the present catalogue a compromise is aimed at. From an early period the best colors are described as "red as coxcomb, yellow as steamed chestnuts, white as congealed fat, black as lacquer."[30] It was descriptions like this that inspired the production of dyed jades to achieve the "best colors," especially as in reality there are few black jades, and red ones are even scarcer, if they exist at all. Staining in red, as in the case of the Double Horse (no. 23), is also attempted, although the color tends to dull and fade with the passing of time. In the past, jades with obvious artificial coloring in red and black were regarded as having been stained as a result of use in burials. The black staining was explained as mercury staining (mercury was known to be used in ancient burials) and the red as blood staining. These explanations were perpetuated by dealers but a surprising number of collectors believed them, as is evident from old catalogues of the late Ch'ing period.

The natural colors of jade are caused by the presence of small quantities of metallic ions such as iron, manganese, and chromium. Iron is the most common "impurity," causing colors ranging from a cool pale green to a warm brownish yellow. In the case of "black" jades the color is usually, perhaps invariably, caused by the heavy concentration of inclusions of other minerals, such as chromite in the case of Siberian jade.[31] White jade with a uniform sparse distribution of black inclusions is commonly given the name of mo yü, ink jade.

On the whole pure white is the preferred color of jade throughout Chinese history, especially in the Sung period. However, during the Ming period, especially in the early part of it, there was a vogue for yellow jades. This could be a reflection of the relatively plentiful supply of yellow jades in the fourteenth and fifteenth centuries. Most yellow jades approximate the color of steamed chestnuts (nos. 69 and 81), but the general classification includes greenish yellow (no. 104) and even what some observers would regard as apple green.

Finally, a word must be said on jadeite, of which there are three examples in this exhibition (nos. 116, 153). Jadeite is a distinctly different mineral from Chinese jade, or nephrite, and has been used in China since the seventeenth century, although Western scholars generally give an eighteenth-century date to the first importation of jadeite into China from Burma, its country of origin. A possible early reference to the introduction of

jadeite into China is to be found in Wen Chen-heng's (1585–1645) *Ch'ang-wu Chih, chüan* 7: "The fashionable stone which is clear like crystal and green (kingfisher) in color, is what was known in the past as *pi*. It is not jade." However humble its beginning, jadeite has become one of the most treasured stones for the Chinese people not so much for its "virtue," as with the nephrite of old, but for its gemlike quality and its great value, which is perhaps a sign of the times.

NOTES

1. Gyllensvärd, *Chinesische Kunst Sammlung König Gustav VI Adolf.*

2. Jao Tsung-i, "A Study on the Painting Rubbings of the Stone Plinths of the Hsüan-miao Monastery in Wu-hsien, Kiangsu."

3. Hsieh Ying-po, *Chung-kuo Yü-ch'i Shih-tai Wen-hua Shih Kang,* p. 36.

4. For a discussion on these catalogues, see Laufer, *A Study in Chinese Archaeology and Religion,* pp. 8–15.

5. Kao Lien, *Yen-hsien Ch'ing-shang Chien,* section on "Old Jades." But although Kao Lien was one of the most original writers of his time, the question of attributing ultimate authorship is extremely difficult in the case of Ming writers because the practice of plagiarism was widespread.

6. Gyllensvärd, personal communication.

7. Su T'ien-chün, "Pei-ching Hsi-chiao Hsiao-hsi-t'ien Ch'ing-tai Mu-tsang Fa-chüeh Chien-pao," illustration of deer on p. 42.

8. Nanking Museum, *Southern T'ang Mausoleums,* pl. 98.

9. *Arts of Asia,* November–December 1974, p. 48.

10. Liu Ts'un-yan, "Vaiśravana and Some Buddhist Influence on Chinese Novels."

11. Liu Ts'un-yan, *The Authorship of the Feng Shen Yen I,* Chapter 11, "The Story of Vaiśravana and Nata."

12. Museum für Ostasiatische Kunst, *Kunst Ostasiens,* no. 90.

13. Hansford, *Chinese Jade Carving,* pp. 74–78, pl. XXVIII a; *Chinese Carved Jades,* p. 89, pl. 78. See also Chou Nan-ch'uan and Wang Ming-shih, "Pei-ching T'uan-ch'eng nei Tu-shan Ta-yü-hai K'ao," *Wen Wu* 1980.4. The authors, quoting the *Yüan Shih,* date the completion of the wine bowl to the second year of Chih-yüan in the reign of Kublai, corresponding to A. D. 1265.

14. For lacquer pieces with this mark, see Gyllensvärd, "Lo-tien and Laque Burgautée," pl. 8, and for the Hsüan-te cloisonné piece in The British Museum, see Sir Harry Garner, *Chinese and Japanese Cloisonné Enamels.*

15. Wang Shih-chen, *Ku-pu-ku Lu.*

16. Probably all quoting from Li Fang, *Chung-kuo I-shu-chia Cheng-lüeh.*

17. Ch'en Lien-chen, "Su-chou Cho-yü Kung-i."

18. Sung Ying-hsing, *T'ien Kung K'ai Wu,* p. 452.

19. Needham, *Science and Civilisation in China,* vol. 3, pp. 663–669; Hansford, *Chinese Carved Jades,* chapters 2 and 3.

20. Sung Ying-hsing, *T'ien Kung K'ai Wu.*

21. Tu Yu, *T'ung-tien, chüan* 192, section on Yü-tien.

22. Fujita Toyohachi (trans. Yang Lien), "The Rivers Shu-chih and Ta-li in Yü-tien."

23. *Hsin Wu-tai Shih, chüan* 74, p. 918.

24. See note on p. 449 of Chung Kuang-yen's annotated edition of *T'ien Kung K'ai Wu.*

25. See Hansford, *Chinese Carved Jades,* p. 41.

26. The most detailed and most often quoted record is that of Ch'un Yüan (Ch'i-shih-i) in the eighteenth century. The best English translation of the relevant passage is found in Hansford, *Chinese Carved Jades,* pp. 42–43.

27. Hall, Banks, and Sterns, "Uses of X-Ray Fluorescent Analysis in Archaeology," p. 86.

28. E. Farrell, Fogg Art Museum Center for Conservation and Technical Studies Analytical Report, April, 1979.

29. Hansford, *Chinese Carved Jades,* p. 39 and pl. H opposite p. 108.

30. The earliest authority to whom this description has been attributed is Wang I, a scholar of the Eastern Han period (fl. early decades of the second century A. D.), quoted in the seventh-century encyclopaedia *I-wen Lei-chü.*

31. Hansford, *Chinese Carved Jades,* p. 35. See also Hall, Banks, and Sterns, "Uses of X-Ray Fluorescent Analysis in Archaeology."

# Chronology

CHINESE DYNASTIES AND REIGNS

| | | | | |
|---|---|---|---|---|
| WESTERN HAN | 206 B.C.–A.D. 8 | | MING | 1368–1644 |
| HSIN (Wang Mang) | 8–23 | | Hung-wu | 1368–1398 |
| EASTERN HAN | 25–220 | | Chien-wen | 1399–1402 |
| SIX DYNASTIES | 220–589 | | Yung-lo | 1403–1424 |
|   Three Kingdoms | 220–265 | | Hung-hsi | 1425 |
|   Western Chin | 265–316 | | Hsüan-te | 1426–1435 |
|   Eastern Chin | 317–420 | | Cheng-t'ung | 1436–1449 |
|   Southern Dynasties | | | Ching-t'ai | 1450–1456 |
|     Liu Sung | 420–479 | | T'ien-shun | 1457–1464 |
|     Southern Ch'i | 479–502 | | Ch'eng-hua | 1465–1487 |
|     Liang | 502–557 | | Hung-chih | 1488–1505 |
|     Ch'en | 557–589 | | Cheng-te | 1506–1521 |
|   Northern Dynasties | | | Chia-ching | 1522–1566 |
|     Northern Wei | 386–534 | | Lung-ch'ing | 1567–1572 |
|     Eastern Wei | 534–550 | | Wan-li | 1573–1619 |
|     Western Wei | 535–556 | | T'ai-ch'ang | 1620 |
|     Northern Ch'i | 550–577 | | T'ien-ch'i | 1621–1627 |
|     Northern Chou | 557–581 | | Ch'ung-chen | 1628–1644 |
| SUI | 581–618 | | CH'ING | 1644–1911 |
| T'ANG | 618–907 | | Shun-chih | 1644–1661 |
| FIVE DYNASTIES | 907–960 | | K'ang-hsi | 1662–1722 |
| LIAO | 907–1125 | | Yung-cheng | 1723–1735 |
| SUNG | 960–1279 | | Ch'ien-lung | 1736–1795 |
|   Northern Sung | 960–1127 | | Chia-ch'ing | 1796–1820 |
|   Southern Sung | 1127–1279 | | Tao-kuang | 1821–1850 |
| CHIN | 1115–1234 | | Hsien-feng | 1851–1861 |
| YÜAN | 1271–1368 | | T'ung-chih | 1862–1874 |
| | | | Kuang-hsü | 1875–1908 |
| | | | Hsüan-t'ung | 1909–1911 |

# The Stone

## 1.  Tribute Bearer

*Grayish green jade with brown veins and*
*    markings*
*T'ang or later*
*Height: 84mm; Length: 36mm;*
*    Width: 23mm*
*Dr. and Mrs. Cheng Te-k'un*
*Published: Rawson and Ayers,* Chinese
Jade, *no. 219.*

A standing foreign figure, dressed in a two-piece robe and a cloak, both gloved hands holding a jade boulder, wears an earring and on his head a simple circlet whose ends are formed by inverted and standard C scrolls.

For centuries jade came to central China in the form of boulders and pebbles as "tribute" from the Western Regions *(Hsi-yü).* This conventionalized tribute-bearer, holding a jade boulder in his arms, is a perfect representation of the importation of jade into the capital district of China, where the stone would be worked. The style of the carving and the treatment of the foreigner's dress suggest a T'ang dating for this piece, although it could possibly be from a later period.

## 2. Pebble

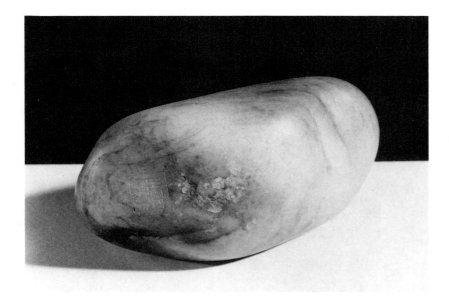

*White jade with brown markings*
*Ch'ing (18th century A.D.)*
*Length: 119mm; Width: 75mm*
*Philadelphia Museum of Art; gift of*
*    Major General and Mrs. William*
*    Crozier*
*Mark: T'ai-shang huang-ti chih pao*
*    (Treasure of T'ai-shang huang-ti)*

In the eighteenth century love for jade pebbles was such that many of them were left in their natural state, or polished until the white jade showed through the outermost layer, or skin. The present example bears a very well-designed and well-carved mark of Ch'ien-lung as *T'ai-shang huang-ti*, a title he assumed after his formal retirement as emperor.

## 3. Button in the Form of a Mushroom Cap

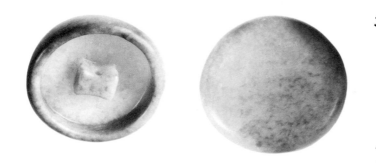

*Yellow jade with brown mottling*
*Date uncertain, probably Yüan or later*
*Height: 10mm; Diameter (outer):*
*    37mm; Diameter (inner): 29mm*
*Gerald Godfrey, Esq.*

The underside of this button has a carved bar in the center with a tunnel perforation for attachment.

When a boulder or pebble is worked, a part of the outer layer, or skin, is often left untouched to retain a part of the natural surface. The reddish brown surface of the pebble adds richness of color and a feeling of mellowness that are much appreciated by jade lovers, especially in the Ming and Ch'ing periods. The colored skin is often cleverly used to highlight certain areas of the finished sculpture. This button, of indeterminate date, is a simple but good example of the effective use of the skin of the pebble.

## 4. Brush Washer

*Brownish green jade with darker brown*
*markings*
*Ch'ing (18th–19th centuries A.D.)*
*Height: 41mm; Length: 230mm;*
*Width: 120mm*
*The T. B. Walker Foundation*

A shallow bowl for use on a scholar's desk, this brush washer is carved out of a boulder with a flat base but retaining the natural surface of the boulder for the sides. A four-character mark on the base reads: *Ch'ien-lung yü-shang*, appreciated by Ch'ien-lung.

This is another example of the use of part of the natural surface of the jade boulder in a finished object. In more recent times, large pieces of "mountain material" are sometimes worked to resemble "river pebble material" (see Introduction). The Ch'ien-lung mark on this piece may be apocryphal.

## 5. Recumbent Lion

*White jade with iron-rust markings*
*17th–18th centuries A.D.*
*Height: 41mm; Length: 77mm;*
*Width: 73 mm*
*B.S. McElney Collection*

His body coiling round, the sleeping lion rests his flat heavy head, with its prominent eyes and nostrils, on his flank. The details of mane, tail, eyebrows, and beard are incised with striations.

This piece, which is carved out of a pebble with minimum cutting away of the material, is an excellent illustration of the jade worker's respect for the material and his skill in adapting the inanimate form of the stone to that of a live animal.

A comparatively late date has been ascribed to this piece. However, this particular version of the Chinese lion has a long ancestry going back at least to Chin and Yüan times (thirteenth–fourteenth centuries) with relatively little change; see illustrations of stone lions on the balustrades of the Lu-kou Bridge outside Peking in an article in *Wen Wu* 1975.10, especially fig. 12, which illustrates the early type of lion decorating this famous bridge.

Animals

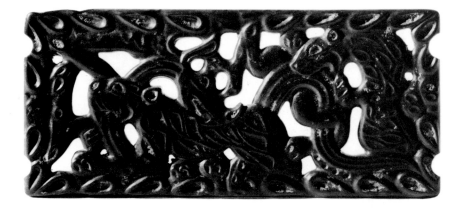

## 6. Plaque with Animals in Combat

*Dark green opaque jade*
*Late Warring States–Western Han*
*Length: 164mm; Width 72mm*
*Robert H. Ellsworth Collection*

This openwork plaque, with earth and cinnabar encrustations in its grooves and hollowings, depicts two tigers attacking a dragonlike creature whose turned head bites the tiger on the left.

Two identical pieces in bronze, each measuring 12 by 6.1 centimeters, were found in an Ivolghino grave (RSS Bourietie) during excavations in 1963 and 1966. A.V. Davidova has discussed these finds and other similar bronze objects and has come to the conclusion that they are belt buckles. The present jade piece, which is flat on the reverse, must have been an inset for a bronze buckle. According to Davidova, the stylistic particularities of these objects make it possible to identify the Hun stratum among many Siberian artistic bronzes in the animal style and to date them from the third to first centuries B.C. The areas in which such pieces are found correspond completely with the territories which the Huns controlled toward the end of the third century B.C. (see Davidova, "On the Question of the Hun Artistic Bronzes," *Sovietskaia Archaeologia,* 1971.1, pp. 93–105).

Bronzes in similar style have been found in Mongolia where they are also associated with the culture of the Huns—Hsiung-nu to the Han Chinese. They have been assigned dates equivalent to late Warring States (see Bunker et al., *Animal Style,* nos. 114, 115).

Other similar pieces are to be found in the former collection of C.T. Loo (see M.I. Rostovtzeff, "Le Centre de l'Asie, la Russie, la Chine et le style animal," *Seminarium Kondakovianum,* Prague, 1929). Another fragment is in the Hermitage Museum (see Davidova article cited above).

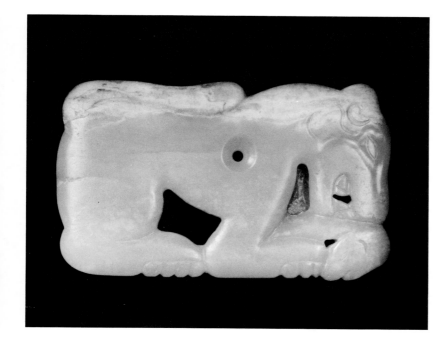

## 7. Belt Buckle in the Form of a Tiger (?)

*Green jade with cream and brown*
*    mottling*
*Late Warring States–early Han*
*Length: 85mm; Width: 50mm;*
*    Thickness: 11mm*
*Paul Mills-Owens*

A stylized crouching tiger (?) in profile, his head lowered, displays an open jaw with three large canine teeth and is about to devour a small animal held between the clawed paws. The broad tail lies flat along the tiger's rump, completing the rectangle. A tunneled perforation is centered over the foreleg. The ears, nose, mouth, legs, paws, and claws are all grooved with one or two stylized lines. The back of the jade is devoid of decoration and has two raised bars for threading a belt.

This piece bears stylistic resemblances to bronze plaques found in Inner Mongolia dating from the late Warring States to the early Han period (see Nei-meng-ku Tzu-chih-ch'ü Wen-wu-kung-tso-tui, *Nei-meng-ku Ch'u-t'u Wen-wu Hsüan-chi,* no. 48; Bunker et al., *Animal Style,* no. 113).

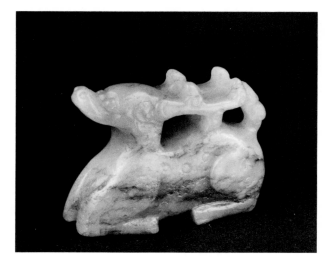

## 8. Stag

*Greenish white jade with brown veins*
*Warring States–Han*
*Height: 39mm; Length: 54mm;*
*Width: 18mm*
*Guan-fu Collection*

A recumbent stag, his legs tucked under the body and his head raised slightly, rests his antlers on his back and curls his trifoliate tail with its lateral striations. The articulations are well detailed, and the stag is decorated all over with circles.

The posture, the treatment of the antlers, and the decoration of circular dots on the body indicate a style that is associated with the northern cultural borders of China in the Warring States and early Han periods. The surface of the jade is much weathered and worn.

## 9. Tiger

*Dark gray jade with brown veins and*
*markings*
*Han*
*Height: 38mm; Length: 44mm;*
*Width 39mm*
*B.S. McElney Collection*

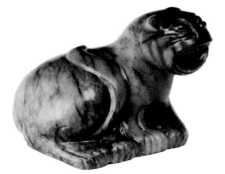

A tiger, sitting with all four legs to one side and the paws in a row, curls his tail upward on his flank from between his rear legs. His head and shoulders are turned sideways and his mouth is wide open in a roar. There is one perforation between the forepaws; the base is flat.

An almost identical piece is in the Sonnenschein Collection (Salmony, *Sonnenschein Collection*, p. 273, pl. CVL.1). Stylistically these jade pieces can be compared with bronze pieces with gold inlay or gilding found in recently excavated tombs of the Western Han period. The most well known of these bronzes are the set of four from the tomb of Tou Wan, two of which were included in the great archaeological exhibition that toured Europe in 1973 and later North America (Watson, *Genius of China*, nos. 150–151). Another pair are in the Tokyo National Museum *Silk Road Exhibition* catalogue (no. 11). In the latter example the paws are also arrayed in a row.

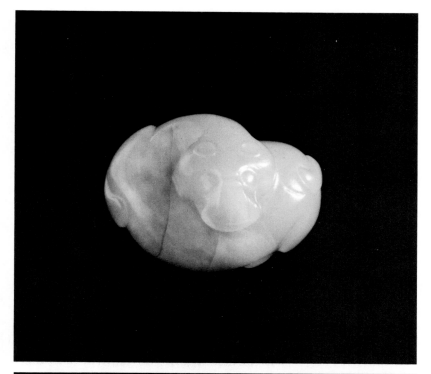

## 10. Coiled Feline

*White jade*
*Han*
*Length: 50mm*
*Robert H. Ellsworth Collection*

This coiled feline animal has circular eyes, doughnut-shaped ears, and a broad snout with raised longitudinal ridges. There is light brown staining along natural cleavages of the jade. The legs are indicated on a flat base by broad slanting cuts; all four are more or less parallel.

The coiled form and flat base are characteristic of the Han period. For a gilt bronze tiger of identical form, one of a set of four pieces found in the corners of one of the inner chambers (not associated with the coffin) of a mid-Western Han tomb, see *Wen Wu* 1973.4, p. 34. The quality of the white jade is similar to Han jades in the Tokyo National Museum's *Silk Road Exhibition* catalogue (nos. 14–17).

base

## 11. Pi-hsieh Chimera

*White jade*
*Han*
*Height: 58mm; Length: 92mm*
*Anonymous loan*

This *pi-hsieh* chimera is similar in style to one in the Tokyo National Museum's *Silk Road Exhibition* (no. 17) and to the stone monumental sculptures associated with the royal tombs of the Southern Dynasties (A.D. 420–589) in the vicinity of Nanking. As in most early animal sculptures the mouth is wide open. The ears are rounded in front and pointed in the back, and the eyebrows and the single central horn are of the "twisted rope" type. The eyes point toward the sides, the cheeks are prominent with fur markings along the edge, and there are two tufts of fur on the protruding chest. Flowing ribbonlike wings extend from the forelegs, and there are fur markings on the legs and long claws on the paws. Along the spine and on the top of the tail are V-shaped markings. The white jade has black specks (chromite?) included, and the pitted surface is stained reddish brown in parts.

T'eng Ku, in an essay on the stone statuary of Southern Dynasties royal tombs near Nanking (in Chu Hsi-tsu et al., *Liu-ch'ao Ling-mu Tiao-ch'a Pao-kao*), put forth the view that winged animals, including the *pi-hsieh*, were importations from Persia and ultimately from Assyria. Chu Hsi-tsu, writing in the same volume on the nomenclature of these animals, favored an indigenous origin for the winged beasts. Chu worked out the system that the horned species was collectively called *t'ao-pa* and the hornless species *fu-pa*, both presumably foreign names.

Chu further subdivided the *t'ao-pa* into the one-horned category, the *t'ien-lu*, and the two-horned category, the *pi-hsieh*, both names occurring for the first time in the Han period.

Chu quoted the entry in the "Records of the Western Regions" in the *Hou-han Shu* of *shih-tzu* (lions) and *fu-pa* occurring in the kingdom of Wu-i-shan-li, which he identified as "in present-day Persia." However, this may be his misreading of a passage that recorded the importation of *shih-tzu* and *t'ao-pa* in the year A.D. 87 from An-hsi (Parthia), which was adjacent to Wu-i-shan-li. Chu also quoted the records of the importation of *shih-tzu* and *fu-pa* from Yüeh-chih and An-hsi in the years 87 and 88 respectively. Nevertheless he insisted that the *t'ao-pa* imported from Persia in Han times was a "live animal" and therefore was unlikely to have wings. The image of winged animals, he averred, existed in Chinese literature before the opening of the routes into the Western Regions. But then Chu had probably not seen pictures of Assyrian and Persian winged animals.

Whether the imported *pi-hsieh* in Han times was live or a likeness in stone or metal, it is entirely possible that the early winged beasts in Chinese monumental sculpture had a Persian origin but became acculturalized at the latest by the fifth century A.D. There is also the distinct possibility, as suggested by T'eng Ku, that the image of the winged animal came into China from more than one source and at more than one time in history.

Of other early jade *pi-hsieh* chimeras, the best known is in the Palace Museum, Taipei, published by Hansford in *Chinese Carved Jades*, pl. 64.

See color illustration p.19.

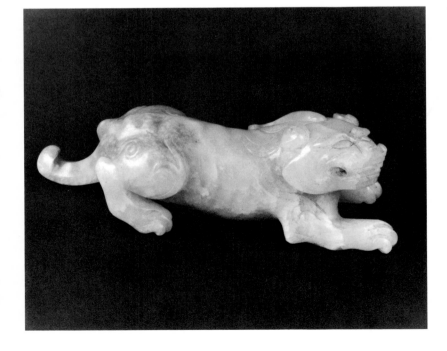

## 12. Pi-hsieh Chimera

*Light green jade with iron-rust markings*
*Six Dynasties*
*Height: 38mm; Length: 117mm;*
*    Width: 36mm*
*Dr. and Mrs. Cheng Te-k'un*
*Published: Rawson and Ayers,* Chinese
*    Jade, no. 180; Hansford,* Chinese
*    Carved Jades, pl. 66.*

A feline-like unicorn is in arrested position, one front limb slightly in front of the other, its ferocious-looking head to one side. It has a knobbed spine and bony flanks. There is a perforation through the mouth.

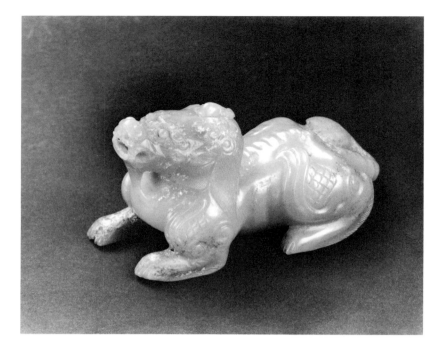

## 13. Pi-hsieh Chimera

*Light green jade with iron-rust markings*
*Six Dynasties*
*Height: 42mm; Length: 83mm;*
*Width: 33mm*
*Dr. and Mrs. Cheng Te-k'un*
*Published: Rawson and Ayers,* Chinese
Jade, *no. 179.*

Crouching on four legs, its single-horned head looking slightly upwards, this *pi-hsieh* chimera has an open mouth, prominent eyes, a knobbed spine, bony flanks, and a coiled tail.

## 14. Mythical Animal in Kneeling Position

*Pale grayish green jade with white*
*markings*
*Late Han–Six Dynasties (ca. 3rd–6th*
*centuries* A.D.*)*
*Height: 45mm; Width: 34mm*
*Field Museum of Natural History,*
*Chicago*
*Published: Salmony,* Chinese Jade, *pl.*
*XLI-1; Rawson and Ayers,* Chinese
Jade, *no. 193.*

Kneeling on its hind legs with its forepaws clasped on its chest, this animal has modeled wings, fine lines arranged radially in a circle on either side, and three curved lines and bands of short vertical strokes on its belly; a perforation runs from cheek to cheek.

The posture of this piece is reminiscent of animals that form part of the support for third-century Yüeh-ware pottery lamps and the pillar supports in the form of kneeling demon figures in Buddhist cave-temples of the Northern Dynasties (see, for example, Mizuno and Nagahiro, *The Buddhist Cave-Temples of Hsiang-t'ang-ssu,* pls. LVII and LVIII c-d). As observed by Rawson and Ayers, this creature,

whatever its correct name, is similar to a pottery figure in an Eastern Han tomb (KKHP 1964.1, p. 111, pl. IV).

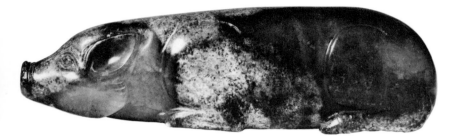

## 15.  Pig

*Mottled brown jade*
*Han (2nd century B.C.–2nd century A.D.)*
*Height: 25mm; Length: 95mm*
*Laurence Sickman*

This pig is in a reclining posture, its head and limbs depicted in detail. The base is mainly flat but the four legs and hoofs are all modeled.

Jade carvings of reclining pigs were used in burials throughout the Han and Six Dynasties periods. The earliest in date are a pair of crudely fashioned jade pigs found in the hands of a body in a burial in Hsü-chou, Kiangsu Province, which has been dated to the end of the third century B.C.—late Warring States to early Western Han (*K'ao-ku* 1974.2, p. 121). Numerous jade pigs, or stone substitutes, mostly in pairs, have been found in Han tombs over the entire extent of the empire. The great majority of them are sharply cut from a rectangular block, creating an abstract image with sometimes brilliant technical effect (see, for example, Loehr, *Ancient Chinese Jades*, nos. 554–560). The present piece is unique in its sculptural qualities and fine workmanship. Because it is more realistic than other Han pigs, one's first impulse is to date it to the end of the Han period, when jade pigs do generally become more realistic—and shorter. However, it becomes evident on closer examination that this piece shares several characteristic features with some realistic jade carvings of animals recently found in Western Han period archaeological sites in China (Tokyo National Museum, *Silk Road Exhibition,* nos. 14–17). These features are the treatment of the ear, which takes the form of a concave depression with a raised rim; the emphatic cheeks, which are marked with incised lines; and the detailed treatment of limbs and hoofs. Several animal carvings dated to the Han period in this exhibition exhibit the same characteristics, no. 11 in particular.

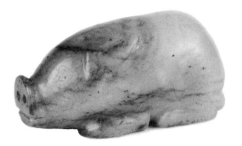

## 16. Pig

*Pale gray jade with iron-rust markings*
*Six Dynasties*
*Height: 28mm; Length: 55mm;*
     *Width: 28mm*
*Bei Shan Tang Collection*

This squat, somewhat naturalistic pig has a straight incision for the mouth, two large ears, and a fairly long tail curling to one side. The snout is square and flat, with two drilled holes indicating the nostrils. The base is incised.

The "shortened version" of the stone or jade pig, more realistic than the Han equivalent, appeared perhaps for the first time in the third century A.D. As in the Han period, these pigs are found in pairs in burials in the positions of the hands. The funerary use of these pigs in the Six Dynasties period is confirmed by literary sources. In the *Yen-shih Chia-hsün*, Yen Chih-t'ui (A.D. 531–after 590) forbade his family to use jade pigs and other burial accessories by way of stressing frugality as a virtue.

Pottery pigs similar to the present jade piece are found in many Six Dynasties tombs, for example in the Chin period (A.D. 265–420) tombs in Nan-ch'ang, Kiangsi (see *K'ao-ku* 1974.6, p. 373 and pl. 8.3).

See also the pig in d'Argencé, *Brundage Jades*, pl. XXV.

## 17. Pig

*White jade with black inclusions*
*Six Dynasties*
*Height: 21mm; Length: 49mm;*
     *Width: 22mm*
*Field Museum of Natural History,*
     *Chicago*

This recumbent pig rests its snout on its forefeet, its hind feet tucked underneath and its long tail curling forward. It has large leaflike ears and a square snout with grooved mouth and grooved eyes. There is a large oval perforation through the back.

This pig, more realistic than the pig in the previous catalogue entry, shows the swayback that is characteristic of Chinese pigs from at least Han times until very recently. The dating of the pig is probably rather late in the Six Dynasties period.

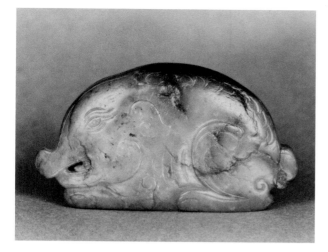

## 18. Archaistic Recumbent Pig

*Green jade with brown markings*
*Sung–Yüan*
*Height: 38mm; Length: 68mm;*
  *Width: 16mm*
*Guan-fu Collection*

A slab of jade has been cut and decorated in low relief with a pig's profile in reclining position. There is an oblong perforation for the mouth; the tail is knobbed; and the jaws, eyes, ears, hips, and bony flanks are incised.

The style of this piece is very close to the supposed archaic jades illustrated in Sung and Yüan catalogues such as the *K'ao-ku T'u* and the *Ku-yü T'u*. The style was probably invented in Sung times during the first period of intense antiquarian studies. Many archaistic jades of comparatively recent manufacture take their design from such catalogues. The workmanship and state of wear of the surface of the present example warrant an attribution to a date close to that of the invention of the style.

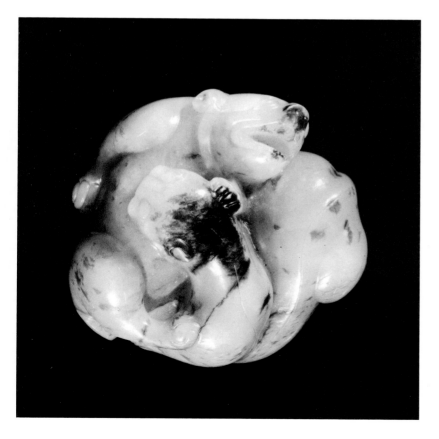

## 19. Tiger and Bear in Combat

*Pale green jade with reddish brown*
  *staining where degraded*
*Han*
*Length: 69mm*
*Robert H. Ellsworth Collection*

The bear's mouth is open, showing its teeth, and a "collar" passes over its ears. Its eyes are not dissimilar to those of no. 14. The claws of both bear and tiger are depicted in detail. The tiger's back has a fine incised line along it; the bear's back has curved lines across it. Volute and ribbonlike markings occur on the hind legs of the tiger and on all four legs of the bear. The base is flat.

A remarkably similar piece in gilt bronze is in the collection of Dr. Paul Singer (see Bunker et al., *Animal Style*, no. 80, and Schloss, *Art of the Han*, no. 48). Emma Bunker observed that "a combat between a bear and a tiger, seen here, is a theme ultimately borrowed from the Animal Style repertory" (*Animal Style*, p. 103).

## 20. Eagle and Bear in Combat

*Mottled green jade with brown markings*
*Han*
*Height: 60mm; Length: 65mm;*
*    Width: 50mm*
*Guan-fu Collection*

The animals are coiled around each other in a heavy mass, so that the beak and the muzzle are locked. The bear tries to get free by pushing one hind leg against the bird's head.

The eagle and bear are found together from at least the Warring States period in Chinese art. It cannot yet be established whether the pun of "eagle-bear" and "hero" (both pronounced *ying-hsiung*) was intended from the beginning. Certainly, puns of this nature abounded in the art and literature of the late Han and Six Dynasties periods. Although the motif of animal combat came from the Western Regions, the popularity of the eagle-bear combination might have been the product of Chinese sensibility.

## 21. Eagle Attacking a Dog

*White jade with iron-rust markings*
*Late T'ang–Sung*
*Height: 43mm; Length: 60mm;*
*    Width: 23mm*
*Dr. and Mrs. Cheng Te-k'un*
*Published: Rawson and Ayers,* Chinese
    Jade, *no. 238.*

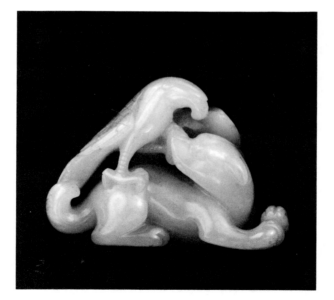

The dog in sprawled position with its head turned backward, forelegs outstretched, and tail coiled, is fighting an eagle that has one claw on the dog's hip and the other on its muzzle. The bird's outstretched wings and back make use of iron-rust markings.

This piece is undoubtedly a later version of the piece in the previous catalogue entry (no. 20) with a dog substituting for the bear. The whiteness and translucency of the jade may suggest to some connoisseurs a much later date than the present attribution. However, the general iconography and treatment of certain features, such as the eye and claws of the eagle and the paws of the dog, suggest a T'ang date or one close to it. The crossed paws of the dog are likely indicative of a Sung date.

## 22. Double Ram

*Pale gray jade with brown markings*
*Sung*
*Height: 23mm; Length: 35mm;*
*Width: 31mm*
*Guan-fu Collection*

The animals are coiled around each other, one biting the other's hind leg and the second grabbing the first between forelegs. There is a perforation between each head and rump. The base is incised to indicate the legs.

By the Sung period the animal combat motif had been "tamed" and the animals take on a domestic look.

See also Sullivan, *Barlow Collection,* no. 157b and Rawson and Ayers, *Chinese Jade,* no. 247.

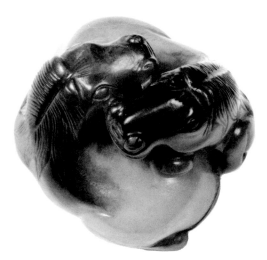

## 23. Double Horse

*White jade with red staining*
*Sung or later*
*Height: 39mm; Length: 50mm;*
*Width: 45mm*
*Victor Shaw*

A recumbent pair of horses, heads touching, lie opposite each other, front legs and hoofs resting on each other's flank. Their hind legs and hoofs lie curled beneath them; their finely striated tails are also curved to the side and underneath. The features of the faces, the double forelocks, and the manes are all well defined. The coloring is almost certainly a result of artificial staining.

This piece is similar to no. 22 with horses substituted for rams. The motif of two horses biting each other was to be found in other art forms of the Sung period. Mi Fu in his *Hua Shih,* for example, records a painting on this subject. The present piece is possibly a later version of the Sung model with the horses resting on each other but no longer biting.

See also Kuwayama, *Chinese Jade,* no. 62.

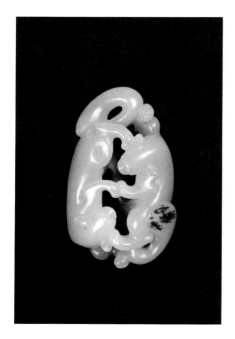

## 24. Double Cat Pendant (Shuang Huan)

*White jade with brown markings*
*Ch'ing (18th century A.D.)*
*Length: 48mm; Width: 30mm;*
*Thickness: 14mm*
*Guan-fu Collection*

A pair of feline animals gracefully touch rather than claw each other with their paws. Both have broad bushy tails curving back on their flanks. The perforation is cleverly absorbed in the curve of the left cat's tail.

This piece represents the final stage of the evolution of the animal style in China. After over two millennia the artistic animals from Central Asia are finally domesticated and made to behave with the decorum appropriate to an eighteenth-century Chinese drawing room, although retaining postures ultimately derived from rougher earlier days.

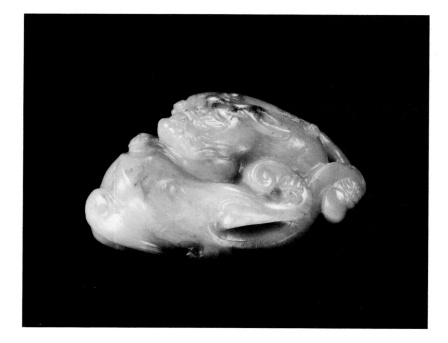

## 25. Recumbent Animal

*Mottled white jade*
*T'ang or earlier*
*Height: 33mm; Length: 75mm;*
*Width: 37mm*
*Victor Shaw*

A single-horned animal (*t'ien-lu?*) rests its thickset head on its flank. The muzzle is blunt, the eyes deep-set and surmounted by heavy grooved eyebrows, and the cheeks tufted. A front and rear paw grab at the bushy tail, which is bifurcated and curled forward. The spine and tail are decorated with incised curved lines from which short lines issue perpendicularly, indicating fur, and the paws have well-delineated claws. The base is flat.

This piece is stylistically characteristic of the T'ang period. The treatment of the ears, for example, is similar to that found on representations of dragons in this period. The detailed treatment of the body and claws, and the fine lines indicating fur, suggest perhaps an even earlier date.

detail

## 26. Winged Lion

*Yellowish jade with mottled brown
 markings, some decomposition
T'ang or earlier
Height: 25mm; Length: 79mm;
 Width: 61mm
Mr. and Mrs. B. H. Tisdall*

A coiled feline, with one hind leg drawn up, scratches its left ear with the paw; the other hind paw, strongly articulated, clutches the tail, which curls forward beneath the feline's jaw. The large ears are grooved and sweep backward, while a beautiful mane divides from a ridge between the ears into a series of striated curls resting on the back. The long face with broad forehead ends in a narrow square jaw that holds a long flowing branch of a plant. The wings can both be seen, almost as vestiges, one at the rear, the other coming from the curvature of the body as the knobby spine curls around. The base is flat.

The coiled feline, with a paw scratching an ear, is one of the most common motifs in the sculpture and decorative arts of the eighth century. Although no equivalent jade piece has so far been found archaeologically, a comparison with early T'ang stone and ceramic sculptures, especially with reference to the general posture of the feline and the treatment of the eyes and ears (see detail), gives the piece an unmistakable early T'ang date.

See color illustration p.53.

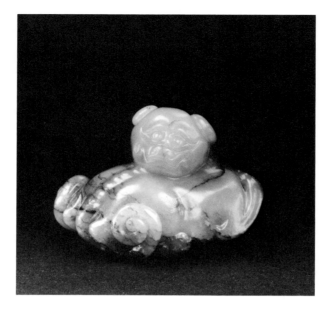

## 27. Coiled Mythical Animal

*Greenish jade with brown and black markings*
*T'ang*
*Height: 36mm; Length: 55mm;*
*Width: 46mm*
*Victor Shaw*

A doglike animal, its head coiled over the left shoulder and surmounted by a long horn, has folded legs, knobbed spine, a bifurcated spiraling tail, globulous eyes, and pointed ears. Two upper canines protrude from the closed mouth. There is one perforation, probably recent, under the right forepaw.

The posture of this animal is almost a caricature of the coiled position commonly found among animals of the Han period (see no. 10). The treatment of the spine, ears, and tail is also a survival of an earlier style. Other features, such as the eyes and nose, suggest a later date. This excessively coiled position is found rarely, if at all, in animals after the T'ang period.

## 28. Ibex

*Yellow jade with brown markings*
*T'ang or earlier*
*Height: 27mm; Length: 61mm;*
*Width: 47 mm*
*Mr. and Mrs. Philip Chu*

Sleek, with two legs tucked under the body and a third folded in front, the ibex turns its head to bite one rear leg. It has a smooth back with beveled spine, a short stumpy tail, and well-detailed hoofs and spirally cut horns.

A stylistically similar carving of a "ram" in the 1963 jade exhibition in Stockholm (Gure "Selected Examples," pl. 30, 4) was given an early Sung date, whereas a bronze piece illustrated by Gure was given an earlier date of T'ang. Another similar bronze piece in an exhibition held in 1974 at Osaka (Osaka Municipal Museum, *Art of the Han*, no. 2-186) was dated Han. The question of precise dating could, of course, be settled ultimately only by archaeological data. However, the piece is stylistically closer to a T'ang rather than a Han date. Gure's date of early Sung for his jade piece could have been suggested by the stiffer or more stylized posture of the ram or ibex.

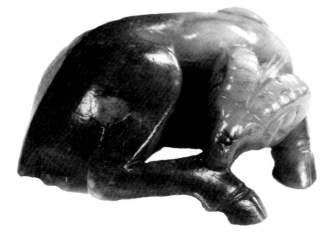

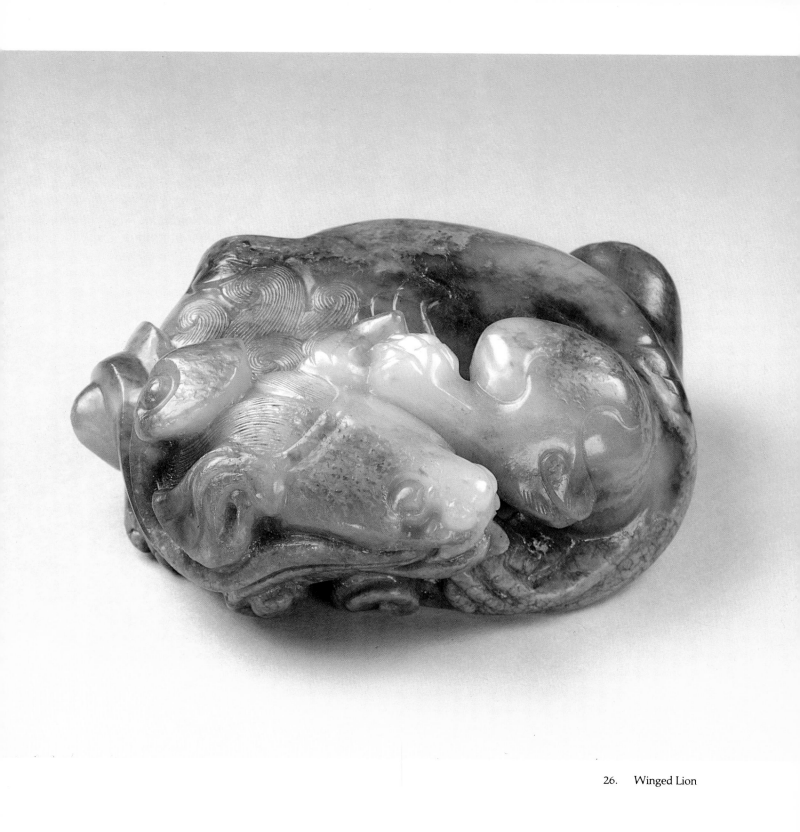

26.    Winged Lion

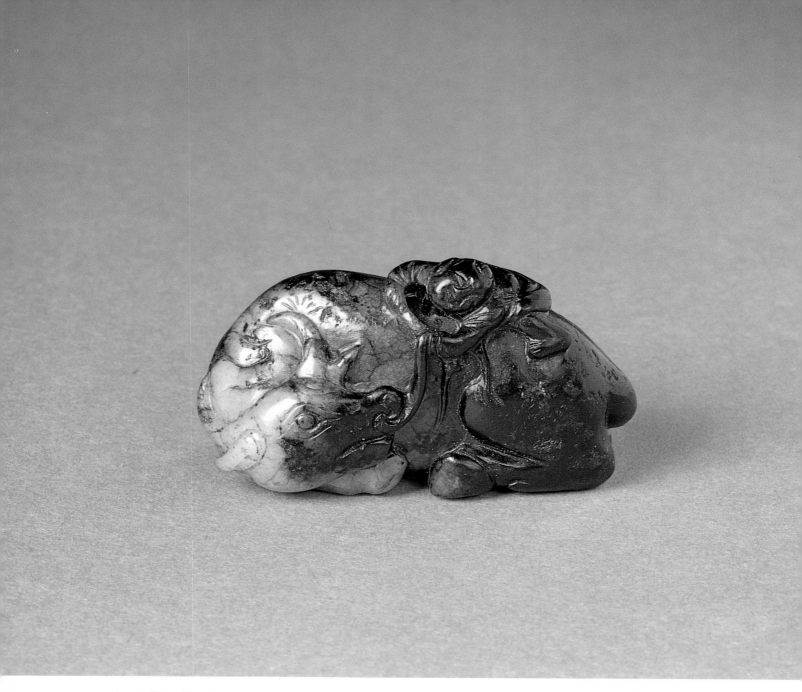

46.   Buffalo with a Boy

## 29. Bovine-Headed Rhyton

*Burnt white jade*
*T'ang*
*Height: 28mm; Length: 49mm;*
*Width: 23mm*
*Ching-yin Watt*

This cylindrical cup is decorated with the head, tail, and hind legs of a bovine whose head and neck extend forward while both horns are linked to the cup. The pierced nostrils serve as a suspension hole. The spot where the tail begins is marked by two concentric semicircular lines. An inscription on the underside reads *Kung-hsü*.

A ram-headed rhyton found in a hoard in Sian, together with many T'ang silver pieces, has given rise to some discussion as to its probable date. Many scholars believe that it could be considerably earlier than the eighth century,

the date of the hoard. However, this piece can be ascribed to the eighth century with greater certainty on account of the treatment of its tail, which can be compared to tails found on pottery rhytons of the eighth century; the marking of the area where the tail joins the body by two semicircular lines is characteristic.

Although the use of the drinking horn goes back to at least the beginning of the Han period (see, for example, the depiction of Hsiang Yü holding a drinking horn in the wall painting in a Western Han tomb in Loyang, KKHP 1964. 2, color pl. II), the animal-headed rhyton probably began in China as a result of Sassanian influence in about the seventh century.

See also the bull's-head rhyton in d'Argencé, *Brundage Jades*, pl. XXXIV, which bears an almost uncomfortable resemblance to the line drawing in volume 29 of the *Ku-yü T'u-p'u*.

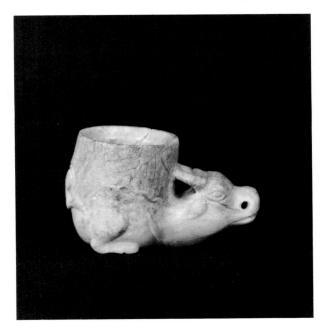

rubbing of inscription

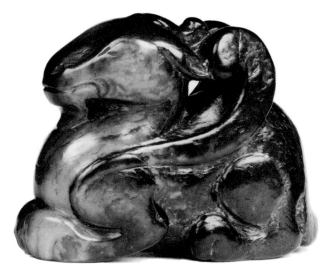

## 30. Mythical Animal

*Dark brown jade*
*T'ang*
*Height: 45mm; Length: 62mm;*
*Width: 22mm*
*Victor Shaw*

This crouching animal has its front and rear legs folded, a deer's bearded head tucked back behind the puffed-out chest, a single horn between the pointed ears, and two coiled wings emerging from the shoulder blades, flowing back up to the ears.

This animal is perhaps what used to be called the celestial deer, on account of its winglike ribbons. The posture can be compared to many deer found in the decoration of T'ang silver pieces.

## 31. Deer

*Grayish white jade with iron-rust*
*markings*
*T'ang*
*Height: 29mm; Length: 38mm;*
*Width: 15 mm*
*Guan-fu Collection*

A recumbent deer, with very stylized anatomy, faces forward. Its pointed ears and growing antlers use the iron-rust marking. There is a top-to-bottom perforation that is slightly larger at the bottom.

The deer with growing antlers is a characteristically T'ang motif, as discussed by Gyllensvärd in *T'ang Gold and Silver*, fig. 71 (see also Introduction). Examples of this deer abound in the decoration of T'ang silver (e.g., the silver gilt dish in pl. 5 of *K'ao-ku* 1977.5) and ceramics (e.g., a Yüeh-ware dish in the Ashmolean Museum).[1] A similar jade deer found in an early Ch'ing tomb (*Wen Wu* 1963.1, p. 42) is also dated in the report to the T'ang period. Another jade deer with growing horns (48206) is in the collection of The Art Institute of Chicago.

1. Tregear, *Catalogue of Chinese Greenware*, pl. 195.

## 32. Deer

*Mottled gray jade with brown and black*
  *markings*
*T'ang*
*Height: 29mm; Length: 41mm;*
  *Width: 15mm*
*Mr. and Mrs. B.H. Tisdall*

This recumbent deer has all four legs tucked under its body forming two parallel "rails." The head with two coiling horns and a flat crest looks forward. Nostrils, eyes, mouth, hooves and tail are all incised.

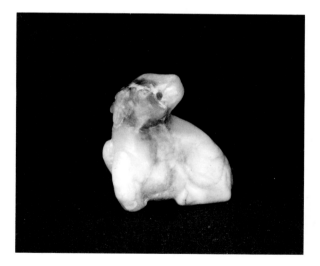

## 33. Deer

*Gray jade with iron-rust markings and*
  *some calcification*
*T'ang*
*Height: 34mm; Length: 33mm;*
  *Width: 17mm*
*Guan-fu Collection*

A seated deer, with forelegs folded in front, turns its antlered head backward. There is one perforation at the mouth.

This piece exemplifies another typical representation of the deer in the T'ang period. The turned head position is derived from the Animal Style art of the Western Regions, while the resting posture with forelegs folded in front was certainly popular by T'ang times. Gyllensvärd in *T'ang Gold and Silver,* pl. 11-d, illustrates a "box in the form of a resting ram" in the collection of the Nelson Gallery–Atkins Museum, Kansas City, which is given a seventh century date. The ram's forelegs are raised somewhat, like those of this jade deer.

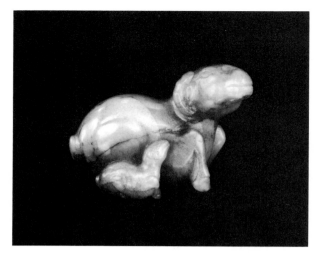

## 34. Ewe with Lamb

*Green jade with iron-rust markings*
*T'ang*
*Height: 34mm; Length: 49mm;*
*Width: 38mm*
*Victor Shaw*

The parent is reclining with forelegs folded on her breast, head looking to the side; her lamb is seated at her flank and is looking up at her. The ewe has spiraled horns that curve back then forward in an arc, with small pointed ears encircled by the horns.

As in no. 33, the posture of the ewe, with forelegs folded in front, is indicative of the T'ang period. The parent-and-child motif is common in the T'ang period in ceramic sculpture. A predecessor of this motif is a pottery ewe with lamb found in a Northern Wei tomb (*Wen Wu* 1975.4, p. 72).

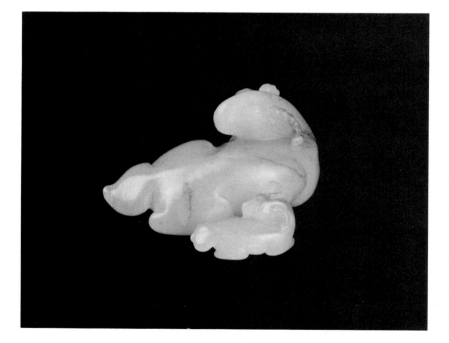

## 35. Ewe with Lamb

*Greenish white jade with iron-rust*
*markings*
*Sung-Yüan*
*Height: 28mm; Length: 65mm;*
*Width: 46mm*
*Victor Shaw*

A recumbent sheep, with incised horns and broad tail, turns her head over her shoulder to give a cursory look toward her lamb, which has curled up against her side in an identical position. There is a perforation between the lamb and its parent.

The broad-tail sheep, which is nowadays quite common in Sinkiang, and was perhaps also in earlier times, was regarded as an unusual animal worthy of note by early travelers to the Western Regions. The Sung collectanea *T'ai-p'ing Kuang-chi* quotes one of the numerous works dating from T'ang and before, all with the name of *I-wu Chih* (Notes on Strange Things), which record the existence of the broad-tail sheep in the Central Asian kingdom of Yüeh-chih. Even in relatively late periods the broad-tail sheep receives special mention in descriptions of foreign lands, such as in the

list of products of Samarkand in the Ming geography, *Ta Ming I-t'ung Chih*. Edward H. Schafer in *The Golden Peaches of Samarkand* quotes the T'ang book *Yu Yang Tsa Tsu* by Tuan Ch'eng-shih as recording the existence of the broad-tail sheep in Samarkand and identifies it with the "fat-tailed dumba of Bukhāra and the Kirghiz steppe, whose young are the source of the famous astrakhan fur." In early Chinese records this fat-tailed dumba was valued for its tail as a gourmet's delight, which it may well remain today to some people. Given the fact that the fat-tailed dumba is not native to the central regions of China, the motif of this particular species of sheep must have come in together with the material itself. It is indeed likely that the earliest representations in jade of the fat-tailed dumba might have been made in the regions where the animals were raised, and the subject matter was later incorporated into the repertory of the Chinese jade carver.

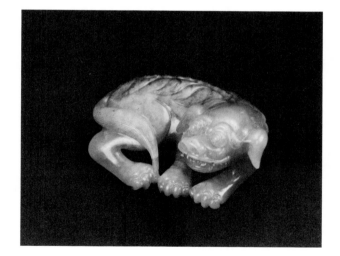

## 36. Mythical Animal

*Mottled gray jade with iron-rust*
  *markings*
*T'ang*
*Height: 19mm; Length: 42mm;*
  *Width: 31mm*
*Victor Shaw*

This animal (lion?) lies with forepaws, shoulders, and head facing sideways. The open jaw, bulbous nostrils, protruding globulous eyes with their heavy striated brows, and large ears all give an impression of limpidness rather than ferocity. This feeling continues with the knobby spine and the heavy striated tail that rests on the hind flank. The elbow and paw of this rear leg are soft and round; only the nails are articulated, but with rounded, soft demarcation indicating meticulous work with a soft abrasive.

This "lion" is stylistically very similar to lions found on the backs of many T'ang mirrors. The treatment of the spine, with tufts of fur issuing on either side, is characteristic.

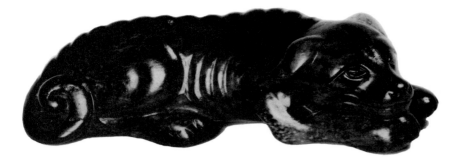

## 37. Dog

*Grayish black jade*
*T'ang*
*Height: 17mm; Length: 71mm;*
  *Width: 23mm*
*Guan-fu Collection*

This dog lies with its head resting on its outstretched forepaws. Its spine is sinuous and knobbed, and its tail is curled in a spiral on one bony flank.

Houndlike dogs first appear in Chinese art in the T'ang period, when many pottery hounds were produced in the recumbent posture of this jade piece. However, this motif was revived in the Yüan period and continued in a mannered and simplified form into the early Ming era. The appearance of the hound in Chinese art is of course related to the popularity of hunting as a pastime in China.

See also Rawson and Ayers, *Chinese Jade*, no. 251, which is a later version.

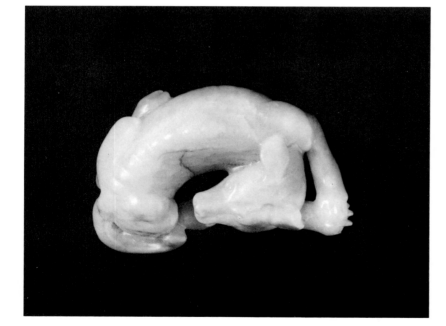

## 38. Recumbent Dog

*White jade with brown markings*
*Sung*
*Length: 57mm*
*Robert H. Ellsworth Collection*

Carved in white jade with degraded areas stained reddish brown, the dog lies curled with knobbed spine and head turned back with front paws crossed. The paws are depicted in detail, and a round tail rests on the right flank.

The crossed-hands position is one of the great markers of Sung sculpture. The archexample of this style is to be found in the large metal (iron?) reclining Buddhist animal, called a *ti-t'ing*, in the Hsiang-kuo Ssu in K'ai-feng. Sung ceramic and stone figures found in recent excavations all conform to this style. Among many examples that can be cited, the pottery figures of men and beasts from the Northern Sung tomb at Yung-feng dating from the reign of Huang-yu (A.D. 1049–1054) are the most typical (see *K'ao-ku* 1964.2, p. 85 and pl. 8).

The head folded back and resting on the body in a graceful, but not always natural, position is

quite often found on Sung and Yüan sculptures. This is perhaps a stylization of the backward-looking pose of animal carvings of the T'ang period. The detailed and accurate treatment of the paws is yet another indication of a comparatively early date for this piece. In animal carvings of the Ming and Ch'ing periods, paws and hoofs are usually executed in a summary manner and are often inaccurate in the details.

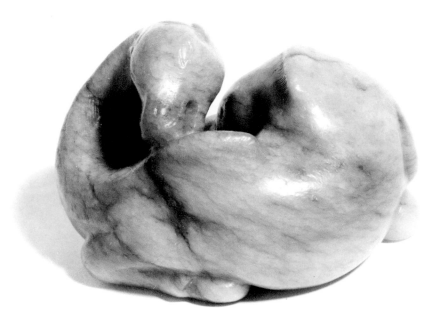

### 39. Camel

*Tan jade with brown veins*
*T'ang*
*Length: 84mm; Width: 54mm*
*Asian Art Museum of San Francisco,*
  *The Avery Brundage Collection*
*Published: d'Argencé,* Brundage Jades,
  *pl. XXXII.*

A recumbent camel, with head turned, nuzzles the first of two humps. Hatched lines indicate the hair on the neck and on the two humps. The features of the head and face are simple incisions that seem worn. The hoofs and legs, tucked under the body, are by contrast well defined.

Representations of the camel with a coiled neck are common among early jade carvings from about the sixth to the ninth centuries. The most famous of these camels is the one in the Victoria and Albert Museum published in many catalogues and books on jade, for example, Palmer, *Jade,* pls. 14, 15; Rawson and Ayers, *Chinese Jade,* no. 201; and Gure, "Selected Examples," pl. 24, 1. An exceptionally large piece is the one in Dr. Paul Singer's collection (Rawson and Ayers, *Chinese Jade,* no. 202). Other examples are in various private collections in Hong Kong.

### 40. Recumbent Camel

*Grayish green jade with brown markings*
*T'ang or earlier*
*Height: 29mm; Length: 67mm;*
  *Width: 19mm*
*B.S. McElney Collection*

A camel, with legs folded under it, rests its chin on the ground. The features of its leaflike ears,

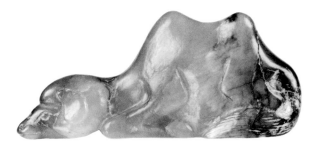

and eyes, mouth, limbs, and hoofs are grooved with simple lines. The two humps take advantage of the change in the color of the stone, the second being mottled brown, as is the long tail, drawn to one side, which is finely striated. The surface of the jade is weathered and worn; the base is flat.

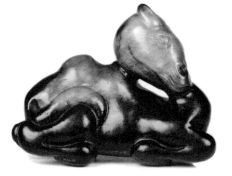

## 41. Recumbent Camel

*Greenish black jade*
*Probably 10th century* A.D.
*Height: 37mm; Length: 47mm;*
*Width: 17mm*
*Victor Shaw*

This camel lies in a contorted position with its head folded back on the neck, which in turn rests on the first hump. The disproportionately large head with well-articulated eyes, nostrils, and mouth, has small pointed ears. The legs are curled under the body, and are well articulated on the underside. The tail curls around the right flank.

Stylistically this camel can be compared with the pottery camels found in the tomb of Li Pien, founder of the short-lived Southern T'ang dynasty, who ruled from A.D. 937 until his death in 943 (see Nanking Museum, *Southern T'ang Mausoleums*, pl. 98). It also marks the beginning of the contorted and "collapsing" posture discussed in the Introduction.

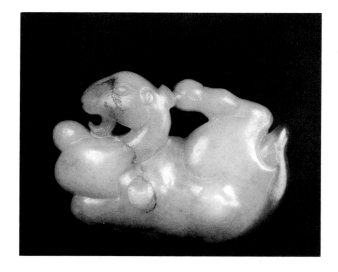

## 42. Recumbent Camel

*Grayish green jade with brown markings*
*10th century* A.D.
*Height: 19mm; Length: 61mm;*
*Width: 42mm*
*Guan-fu Collection*

A camel lies with head and neck curled in an S-shape to one side, the right hind leg is raised in a parallel curve, the hoof touching the pointed ear. The other legs are tucked under the body, one being indicated by a thick incised line; light lines indicate fur on the two humps. Although the configuration is different, the style and ethos of the piece are very much the same as those of no. 41 in this catalogue.

See also Gyllensvärd and Pope, *Chinese Art*, no. 76.

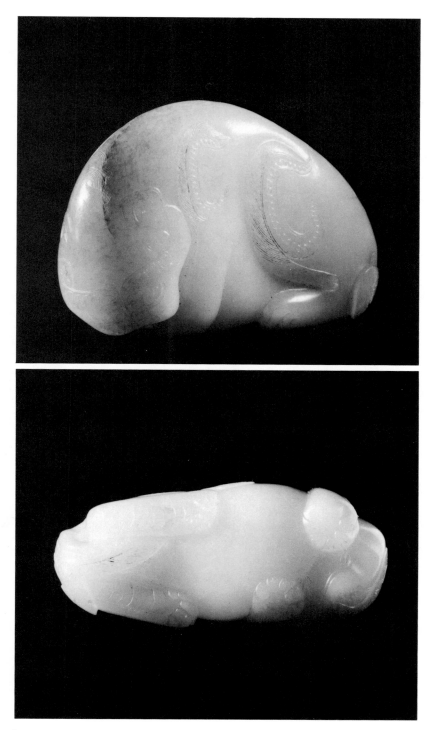

base

## 43. Archaistic Animal

*White jade*
*Sung–early Ming (13th–14th*
*centuries* A.D.)
*Height: 51mm; Length: 76mm*
*Robert H. Ellsworth Collection*

Carved out of a white jade pebble with brown skin, this animal is decorated on its body with wide C-shaped bands marked with circular dots and with striations adjacent to the outside edges. The eyebrows are also wide bands coming together in the center and decorated with spikelike markings pointing in from the upper boundary. The mane falls in tufts on either side. The underside of the legs is depicted in detail with scales and claws.

The motif of a string of circular dots within flamelike or C-shaped bands is quite commonly found on archaistic jade animals. The circles are perhaps a late survival of the grain pattern on archaic pieces of the Warring States and Han periods, except that the archaic grain patterns were shaped like commas, with tails coming out of the circular dots. A jade tiger with a similar motif is illustrated in Li Feng-kung's *Yü Ya*, a catalogue of supposed archaic jades; however, this volume contains mostly rather well-carved archaistic pieces. The carving of scales on the underside of the legs reminds one of the treatment of the legs of dragons in the early Ming period, such as are seen on what survives of stone sculptures of the Hung-wu period in Nanking and on a few pieces of porcelain which can be dated to the beginning of the Ming.

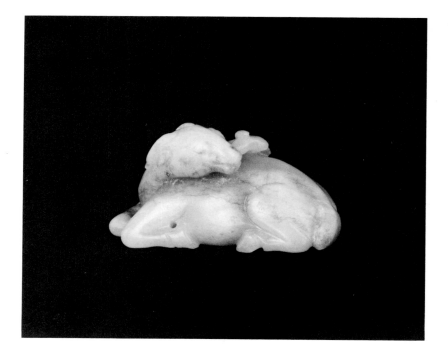

## 44. Deer

*Greenish white jade with iron-rust*
   *markings*
*Sung-Yüan*
*Height: 33mm; Length: 54mm;*
   *Width: 32mm*
*Victor Shaw*

A recumbent deer, forelegs folded in front and to one side and the hind legs tucked under the body, turns its head over the left shoulder and munches a fungus. The antlers follow the back line, the short tail lies to one side, and the hoofs are detailed. There is a perforation between the left foreleg and the back.

The fungus associated with the deer in northern Asia is the fly agaric (see Wasson, *Soma*). In China the fly agaric has been replaced by the *ling-chih,* a fungus-like plant with allegedly miraculous medicinal properties. In present-day China the *Ganoderma lucidum* is accorded the name of *ling-chih,* although this name has probably been applied to different kinds of fungus at different periods in history and in different parts of China.

A Sung-Yüan date is given to this piece on account of its pose with the head turned and resting on the body.

## 45. Ram with T'ai-chi

*Greenish white jade with iron-rust*
   *markings*
*Late Sung–Yüan*
*Height: 34mm; Length: 46mm;*
   *Width: 20mm*
*Victor Shaw*

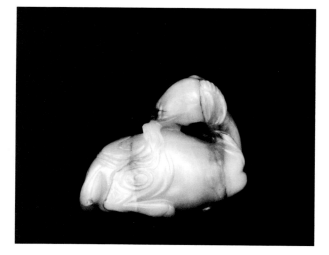

A recumbent ram or mountain goat folds its four legs beneath itself, its head twisting back. The horns, ears, hoofs, and head are all well delineated; the short tail ends in a puff. From the mouth of the animal issues a cloud, *ch'i,* enclosing a symbol of the *T'ai-chi.*

The ram here is symbolic of peace and prosperity. The spiritual cloud, *yün-ch'i* or *ch'i,* that emanates from its mouth carrying the *T'ai-chi* symbol, is a popular motif in Taoist art of the Yüan period.

Although the concept of *T'ai-chi*, the Absolute in Taoist cosmogony, is as old as Taoism itself, the conscious adoption of this well-known symbol (which itself is perhaps even older than the concept) took place only with the growth of Neo-Confucian thought in the eleventh century incorporating much of the Taoist system. The Northern Sung Neo-Confucian scholar Chou Tun-i was the first to publish the *T'ai-chi* diagram.

## 46. Buffalo with a Boy

*Black jade with gray mottling*
*Southern Sung–Yüan (12th–14th*
*centuries* A.D.*)*
*Height: 31mm; Length: 58mm;*
*Width: 24mm*
*Victor Shaw*

The buffalo rests, its four legs tucked underneath it and its head turned toward a small boy who lies sprawling on the buffalo's thigh, holding it by a rope attached to its nose. The little boy's head is turned to look at the buffalo, his bare feet straddling the rump. The buffalo's eyes, nose, mouth, limbs, and hoofs are all incised; its ears, horns, and curled tail are in high relief. A series of geometric whirls are incised on the thighs and back of the buffalo.

The subject of a boy on a buffalo made its first conspicuous appearance in the art of the Southern Sung period, the painting by Li Ti entitled *Cowherds Returning in Wind and Rain* in the Palace Museum, Taipei, being the best known example. The motif is one of the most common found in the popular art of the Yüan period. Among the *ch'ing-pai* porcelain water droppers of the Yüan period, which have been found in large quantities in Southeast Asia in recent years, are many in the form of boys riding on buffalos. It is not easy to date jade carvings of this subject, for the motif seems to have persisted longer in jade carvings than in other art forms. However, the present example, which is very similar to another one in the Fogg Art Museum, deserves a position in the early phase of the tradition on account of the style and technique of carving.

See color illustration p.54.

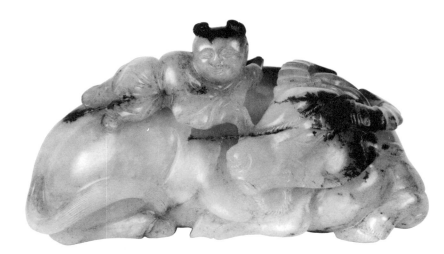

## 47. Boy on a Water Buffalo

*White jade with brown mottling*
*Yüan*
*Height: 47mm; Length: 85mm;*
    *Width: 43mm*
*Victor Shaw*

A small boy sprawls on the back of a resting water buffalo, holding in his right hand a rope that passes through the buffalo's nose and over its horn. The little boy is dressed in tunic and pants, his hair is in two topknots. His left hand holds two ears of rice. The buffalo's face is in profile, resting on its foreleg, its massive serrated horns curving back. Fine hatching on its chin and hoofs suggests hair; its long striated tail curls up over its flank. The buffalo's haunches are marked by deep grooves, as are its hoofs pulled up underneath it.

Boys riding on *ch'ing-pai* porcelain water droppers of the Yüan period often hold ears of rice, *ho,* in their hands, a pun with the word *ho* meaning harmony.

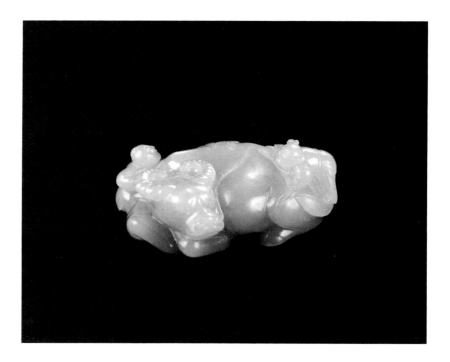

## 48. Buffalo with Two Children

*White jade*
*Ming*
*Length: 59mm; Width: 40mm*
*Gerald Godfrey, Esq.*

A recumbent water buffalo with a rope attached to its nose, is being held by a small boy climbing up its flank, using the buffalo's curled striated tail for a foothold. Another boy leans sprawled across the buffalo's shoulder, a bunch of rice in his outstretched hand. Both boys are dressed in tunics and trousers, one with one topknot, the other with two. The buffalo's face and its curled ridged horns are carved with great attention to naturalism. The legs are folded underneath, with hoofs in high relief.

The fine quality of carving and the jade do not necessarily presuppose a late date for this piece. The treatment of the legs of the buffalo and the feet of the boys suggests a possible Ming date.

## 49. Mythical Animal

*Yellow green jade*
*Late Sung–Ming (13th–15th*
*centuries* A.D.)
*Height: 34mm; Length: 60mm;*
*Width: 35mm*
*Bei Shan Tang Collection*

A crouching feline cub, tail curled on one side ending in a C scroll, has a knobbed spine, heavy scrolled eyebrows and whiskers, round ears and snout, and protruding eyes. The front paws are round balls, but with well-detailed claws.

The soft texture and warm tone of the yellow jade, together with the plastic qualities of the carving, make this piece especially attractive to the lover of jade. Stylistically this piece is extremely hard to date, but yellow jades do tend to occur mostly in the Yüan and Ming periods, especially in the fourteenth and fifteenth centuries. The numerous notebooks of connoisseurs of the Ming period, from the first edition of the *Ko Ku Yao Lun* (David, *Chinese Connoisseurship*) onward, contain numerous references to yellow jade, which, according to some Ming writers, is preferable to pure white jade.

See color illustration p.71.

## 50. Animal on Waves

*Black jade with traces of white, brown,*
*and yellow*
*Sung-Yüan (12th–14th centuries* A.D.*)*
*Height: 44mm; Length: 68mm;*
*Width: 49mm*
*Mr. and Mrs. Philip Chu*

This trapezoidal stone is carved in the form of a crouching monster, head turned toward its flowing bifurcated tail, paws with claws in front. The monster's flat head has two side horns and a third central horn that curves across its back, its heavy mane breaking out on either side in large striated curls. Its large protruding eyes, incised to show the pupils, and *ju-i*-like muzzle give an impression of alertness. Its mouth ends in one long curve and C scroll by its ear. A striated pointed beard flows beneath its jaw. The rear of the pebble is engraved with archaic motifs of a double spiral encasing diaper patterns. The base keeps the pebblelike form, but is incised and carved with a series of waves.

The carving of this piece is at once powerful and delicate, which is quite typical of the Sung period. The *ju-i*-shaped muzzle also helps in placing this piece in the Sung-Yüan period; the treatment of the waves is consistent with certain standard manners of representing waves in Southern Sung paintings such as those attributed to Ma Yüan. The black-white coloring and archaistic pattern of linked S and C curves are both possible attributes of Sung-Yüan jades.

See color illustration p.72.

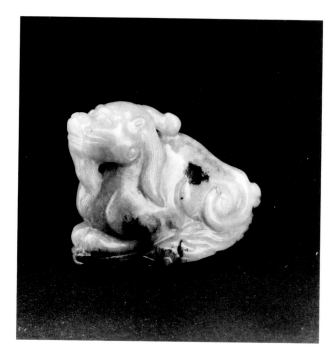

## 51. Mythical Animal on Clouds

*Light green jade with brown markings*
*Probably Yüan–early Ming (14th*
*century A.D.)*
*Height: 42mm; Length: 57mm;*
*Width: 35mm*
*Guan-fu Collection*

A feline-looking unicorn crouches on a stylized cloud, its head forward with a beard and a dual mane framing the curling horn, a prominent spine, and a tail coiling in three different places. There are perforations beneath the horn and the beard.

As observed in the Introduction, immortals and mythical beasts riding on a vehicle of billowing clouds is a theme most prevalent in the art of popular Taoism in the Yüan period such as the sculptures and wall paintings of the Taoist temple Yung-lo Kung. Although the motif of the cloud-vehicle persists throughout the Ming and Ch'ing periods, the formation of the clouds does change with time. The earlier versions are more irregular and "naturalistic," as in the present case, and by the fifteenth century the treatment becomes more regular and stylized (see no. 52).

The slight yellowish tinge to the green jade also agrees with a fourteenth century date.

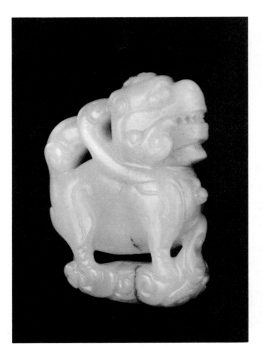

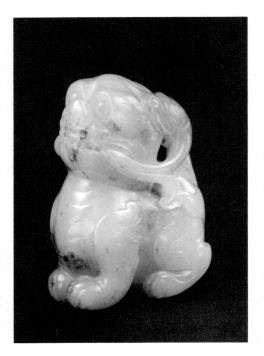

## 52. Mythical Animal

*Greenish white jade with brown veins*
*Ming (15th–16th centuries A.D.)*
*Height: 60mm; Length: 44mm;*
    *Width: 24mm*
*Victor Shaw*

This fabulous beast stands squat but erect on a cloud base. Its square muzzle with serrated teeth clutches a *ling-chih,* its circular eyes protrude out of circular discs and it has horns on top of its head. Wings emerging from its chest end up behind its head, cushioned by a long bushy tail. The articulations of the shoulder and rump are of the "spiral and point" type. Fine comblike striations mark the sides of the lower jaw. A perforation in the center back extends from top to base.

The cloud base or "vehicle" of this animal is typical of the Ming period, being a stylized version of the earlier formations such as that of no. 51.

## 53. Animal with Fungus

*Mottled pale grayish green jade*
*Ming (15th–16th centuries A.D.)*
*Height: 59mm; Length: 40mm;*
    *Width: 26mm*
*Victor Shaw*

A seated doglike animal holds in its mouth a branch of *ling-chih* that is curling around it. The nose is *ju-i*-shaped, and the teeth are indicated by a series of drilled holes. The eyes are also circular with flamelike eyebrows, the chest is marked by double incised lines, and ribbonlike ornaments arise from the front and hind legs.

The style of carving of this piece is somewhat similar to that of no. 52.

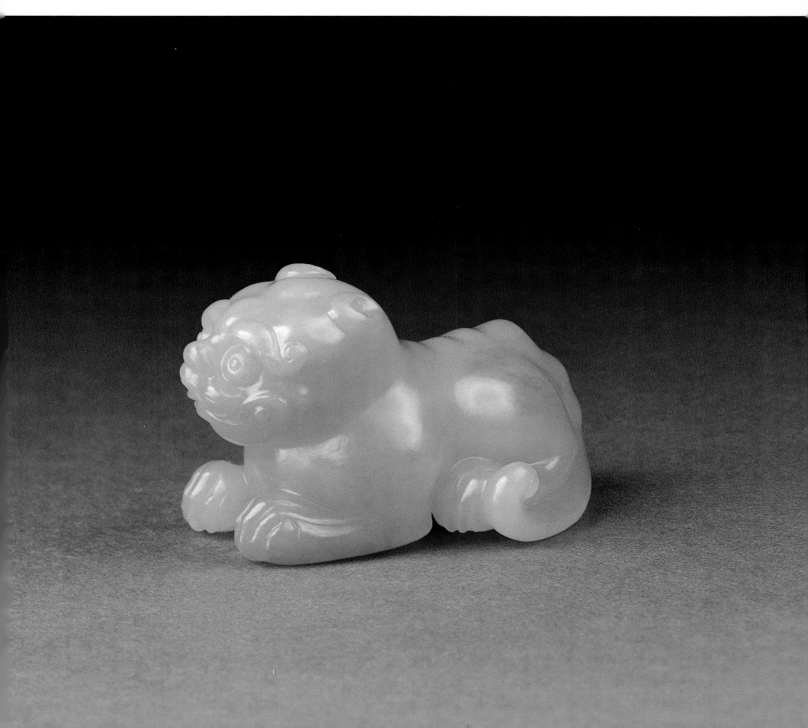

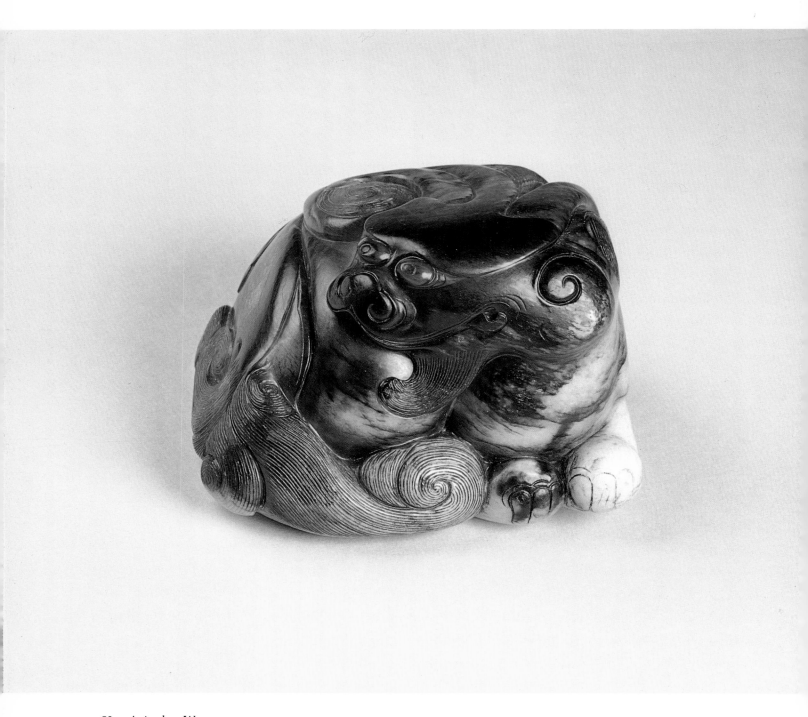

50.  Animal on Waves

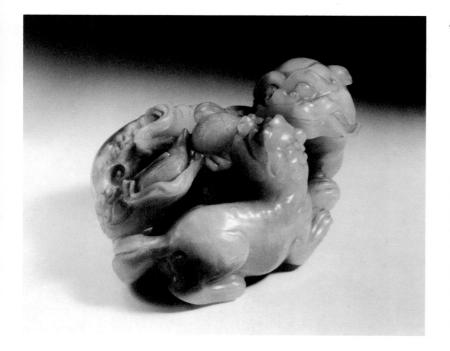

## 54. Two Lions Playing with a Brocade Ball

*Pale green jade with beige and light
    brown markings
Ming (late 15th–16th centuries A.D.)
Length: 91mm
Asian Art Museum of San Francisco,
    The Avery Brundage Collection*

Two single-horned "lions" with flat snouts, triangular noses, hooded eyelids, bulging eyes, knobbed spines, long paws, and bushy tails play with a brocade ball. Flamelike ribbons arise along their thighs and shoulders.

The motif of lions playing with brocade balls may have had an earlier beginning, but it became very popular in the second half of the Ming period and is often seen on blue-and-white porcelain and on the decorative arts of the sixteenth century.

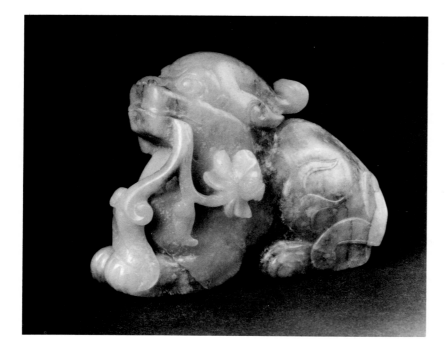

## 55. Mythical Animal with Peony

*Light green jade with iron-rust markings*
*Ming (15th–16th centuries A.D.)*
*Height: 71mm; Length: 99mm;*
*Width: 33mm*
*Guan-fu Collection*

A crouching feline chimera, forepaws together in front, has a bifurcated tail and a prominent spine. The single-horned head looks forward, holding in its mouth a floral spray consisting of a peony and two acanthus leaves. There is one perforation, between the forepaws.

The acanthus leaf is commonly found on floral decorative motifs of the Ming period. It is usually attached to an imaginary scrolling plant with the "foreign lotus" flower, and sometimes, as in the present case, matched with a stylized peony. The underside of the legs is flat, as is usual in the Ming period.

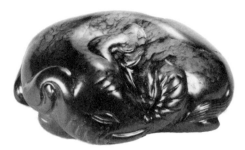

## 56. Recumbent Elephant

*Black and green jade*
*Sung–Yüan (13th–14th centuries* A.D.*)*
*Height: 28mm; Length: 63mm;*
*Width: 45mm*
*Charlotte Horstmann*

A sleeping elephant curls its trunk over its flank. Its large ears are striated; its curled tail and its tusks are incised with deep grooves. There is a perforation between the trunk and the body.

This well-carved piece has obviously been subjected to a great deal of handling. The quality and color of the stone and the pose of the elephant all suggest a possible late Sung to Yüan date.

## 57. Caparisoned Elephant

*White jade with brown mottling*
*Ming–Ch'ing (16th–17th centuries* A.D.*)*
*Height: 47mm; Length: 72mm;*
*Width: 26mm*
*Guan-fu Collection*

A standing elephant, with head and trunk curved toward the viewer, is covered with a fringed saddlecloth that has a large *T'ai-chi* on the center back, a border of herringbone, and an inner decoration of starred honeycomb. The face, trunk, ears, and feet are all deeply grooved, as are the undersides of the large feet.

The elephant is a common figure in Buddhist and Taoist art of the Ming period. The honeycomb and the zigzag border are typical patterns of Ming brocade that also appeared frequently as decorative designs on porcelain and other art objects.

See also Rawson and Ayers, *Chinese Jade*, no. 363.

## 58. Mythical Animal

*Yellow jade with brown markings*
*Sung (11th–13th centuries A.D.)*
*Height: 34mm; Length: 69mm;*
*Width: 45mm*
*Quincy Chuang, Esq.*

Slightly raised on its forepaws, this animal turns its head toward the rear, its tail curved upon its flank and its hind legs and paws drawn up beneath it. The animal's most remarkable feature is its snout, reminiscent of a claw. Its eyes are carved in the round, protruding under heavy folded eyebrows. A large grooved mouth crosses under the pointed snout, with a sloping jaw that adds to the pointedness of the face. The little pointed ears, in high relief, are flattened back, enhancing the sense of watchfulness. The flamelike mane is striated, like the tail, and flows like a horn down the animal's back. The rear legs have hatching for fur, while modeled parallel creases on the belly complete the naturalistic effect of the animal's posture.

The treatment of the snout finds parallels in dragons that decorate Tz'u-chou type pottery vases of the Sung period. An almost identical piece in the collection of the late King Gustav VI Adolf of Sweden has been dated to the Wei period (see Gyllensvärd, *Chinesische Kunst Sammlung König Gustav VI Adolf*).

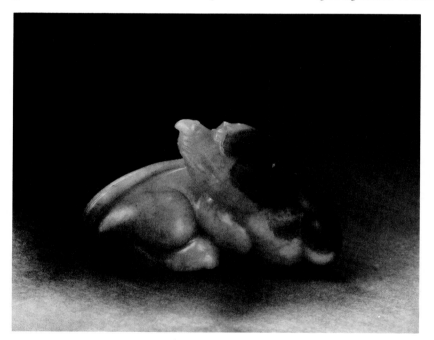

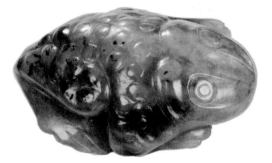

## 59. Three-legged Toad (Ch'an-ch'u)

*Green jade with black markings*
*Yüan–Ming*
*Height: 22mm; Length: 63mm;*
    *Width: 40mm*
*Guan-fu Collection*

A mythical toad with three legs is depicted in lifelike form seated on its two front legs with a third rear leg curled under its body; its back is carved with a series of., smoothly rounded warts, finely polished. Its flat face has large circular eyes.

The earliest record of a *ch'an-ch'u* (a toad often represented as having three legs in later periods) in jade is in the *Hsi-ching Tsa-chi,* a work of the Six Dynasties period. In *chüan* 6 of this book is recorded the tomb-plundering activities of Prince Kuang-ch'uan. From the tomb of Ling-kung, Duke of Chin (seventh century B.C.) was found a jade *ch'an-ch'u* the size of a fist and hollowed out. The prince used this vessel as a water dropper on his desk. In later periods, such a jade object was associated with the artist-connoisseur Mi Fu (Mi Fei), who had two "treasures" in his study named Pao Chin Chai, a naturally landscaped inkstone and a jade *ch'an-ch'u* water dropper.[1] In late Ming times, jade *ch'an-ch'u* droppers were made after the Pao Chin Chai style,[2] and the earlier legendary association with Prince Kuang-ch'uan was probably forgotten.

It is possible to attribute the large number of jade toads surviving to this day to the demand among scholars in the latter half of the Ming period for objects associated with the much admired Mi Fu. However, a more plausible explanation considers the strong connection of the *ch'an-ch'u,* or simply *ch'an,* with popular Taoism. Among the leaders of the so-called Southern School of Taoism, which began in the tenth century, no less than four among a lineage of ten patriarchs have the character *ch'an* in their names.[3] The most well known of them is of course the founder of the school, Liu Hsüan-ying, who was known as Hai-ch'an Tzu (see also entry no. 106). Another famous figure in this line was Pai Yü-ch'an of the Sung period, whose name means white jade *ch'an.*

The common occurrence of jade toads in the Sung and post-Sung periods is one of the many instances pointing to the close association of jade with Taoism.

1. Mi Fu's own description of these objects and a drawing of the landscaped inkstone are reproduced by T'ao Tsung-i in his *Ch'o Keng Lu.* Writers of the Ming period often referred to these "treasures"; see, for example, Kao Lien, *Yen-hsien Ch'ing-shang Chien* in the section on "Various Treasured Objects of the Past."

2. Kao Lien, *Yen-hsien Ch'ing-shang Chien,* and T'u Lung, *K'ao-p'an Yü-shih,* in both the sections on water-droppers.

3. See table of lineage of the Southern School of Taoism from the Five Dynasties to the Yüan period in Ch'en Kuo-fu, *Tao-tsang Yüan-liu K'ao* (The History of the *Tao-tsang*), p. 441.

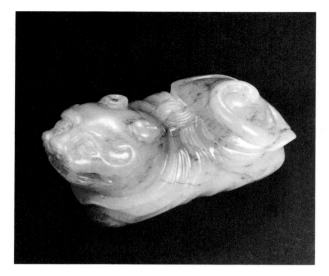

## 60. Animal in Wrapper

*Yellow jade with brown markings*
*Ming*
*Height: 38mm; Length: 64mm;*
  *Width: 30mm*
*Gerald Godfrey, Esq.*

This animal is tied in a cloth wrapper, knotted at the center of the back with long tails trailing at the side. Its head, with open jaw and fangs, broad curled eyebrows, and laid-back, pointed ears, emerges from the front of the wrapper, its long curled tail from the rear. Ridges, as if indicating the hidden legs, run along the base.

Birds, beasts, and inanimate objects such as teapots in a "gift wrap" is a Ming artistic mannerism. The style of the carving, with bold strong lines, suggests a date in the first half rather than the second half of the dynasty.

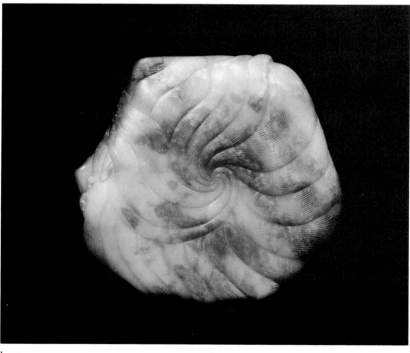

base

## 61. Dragon-headed Tortoise (T'o-lung)

*White jade with brown markings*
*Ming (16th century A.D.)*
*Height: 67mm; Length: 158mm;*
  *Width: 138mm*
*Hong Kong Museum of Art, Urban*
  *Council, Hong Kong*

This vessel is in the form of a mythical animal with the shell and head of a tortoise and the claws of a dragon. The shell is carved with a pattern of hexagons, with a border of thunder pattern (square spirals), and with a circular opening on top. The head has a single horn, comma-shaped ears, ju-i-shaped nose, flame-shaped eyebrows, and a slightly opened mouth showing upper and lower canines. The neck and legs are covered with scales. The underside is carved as a single whirlpool with breakers on the sides that in places rise over the shell itself.

The iconography of the dragon head is consistent with a Ming date, especially in the treatment of the nose and eyes. Similar vessels in

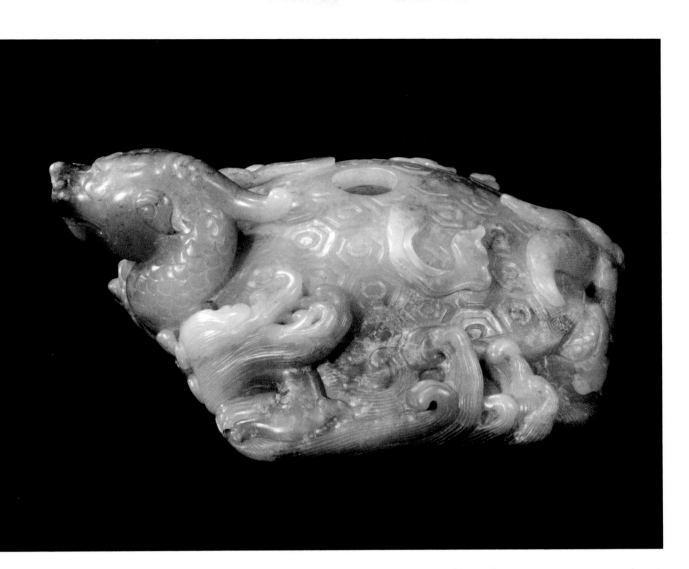

blue-and-white porcelain are known, such as the one in the Villanueva Collection in Manila. In both the jade and porcelain versions the shell is decorated with a pattern of hexagons, traditionally associated with tortoise shells, that is a common decorative motif of the Ming period. This particular pattern of the whirlpool is typical of the middle to late Ming period, covering mainly the sixteenth century.

Except for the head, the iconography of this jade piece is the same as that of a *t'o* illustrated in the *Ts'ung-shu Chi-ch'eng*. However, there is no doubt that the name *t'o* was applied in Han and earlier times to the crocodile. The *t'o*

probably took on its present aspect when it appeared in Yüan popular literature as one of the sons of the dragon (or naga) king of the sea. The dragon head is given to the *t'o* to make its association with the dragon king of the sea more convincing, and the tortoise shell is a faint reflection of the former looks of the *t'o* and perhaps also an attempt to turn it into an even more auspicious animal.

See also a similar piece in the 1963 jade exhibition in Stockholm, illustrated in pl. 28, 4 in Gure, "Selected Examples," and dated to the early Sung period.

## 62. Dragon-Headed Tortoise with a Book

*Mottled gray jade with iron-rust markings*
*Yüan-Ming (14th–15th centuries A.D.)*
*Height: 30mm; Length: 50mm;*
*    Width: 37mm*
*Victor Shaw*

A tortoise turns its long-bearded dragon's head backward, issuing from its mouth a cloud base with a book resting on top of it. One forepaw is grabbing a pearl; the tail coils on top of the shell, which is decorated with a pattern of hexagons.

The iconography of a dragon or tortoise carrying a book on its back can be traced at least to the T'ang period, and such a subject is found in an illustrated manuscript from Tun-huang.[1] The idea, of course, goes back further to classical scholars of the Han period. The tradition was that Fu Hsi, the legendary emperor (sometimes part-creator of the universe), obtained the diagrams of the *I Ching* from the back of a divine dragon or tortoise, which then disappeared in the water again. This is the general idea of the legend of the so-called *ho-t'u* and *lo-shu.*[2] By T'ang times this tradition took visible expression and there were paintings on the subject of a tortoise carrying a book (of diagrams) emerging from the river. Ting Tse, who came first in the civil service examinations in Loyang in 775, wrote in his examination a poem on just such a subject.[3] In the present case, the tortoise is a *t'o-lung* (see entry no. 61). The treatment of the dragon head and the use of the cloud base supporting the book point to a late Yüan or Ming date.

1. Personal communication from Professor Jao Tsung-i.

2. See Ku Chieh-kang and Yang Hsian-kuei, "The History of the 'Three Emperors' in Ancient China," for a full discussion of the *ho-t'u* and *lo-shu.*

3. Chi Yu-kung, *T'ang-shih Chi-shih,* vol. 34, p. 528.

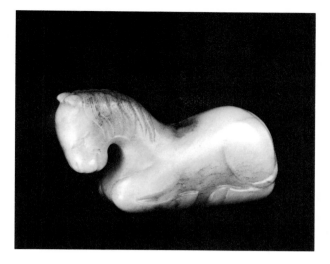

## 63. Recumbent Horse

*White jade with brownish markings*
*Six Dynasties*
*Height: 35mm; Length: 66mm;*
*Width: 22mm*
*Victor Shaw*

A recumbent horse kneels, its face looking downward and its ears pointing forward. The eyes, muzzle, mouth, mane, curving tail, and hoofs are lightly indicated. A rectangular perforation pierces the middle of the flat base.

The base formed by the legs, the relatively long mane, the treatment of the hoofs with the front pair pointing up and the rear pair down, and above all the characteristic treatment of the head and neck all suggest a Six Dynasties date. Recumbent horses serving as knobs of bronze seals of this period (Lo Fu-i and Wang Jen-ts'ung, *Yin-chang Kai-shu*, p. 83) also assume the same pose with the same semicircular curve along the underside of the neck. The same treatment of neck and head is typical of pottery horses of the Northern Wei period. See, for example, those from the tomb of Ssu-ma Chin-lung, *Wen Wu* 1972.3.

## 64. Recumbent Horse

*Grayish black jade with brown markings*
*T'ang*
*Height: 47mm; Length: 53mm;*
*Width: 27mm*
*Guan-fu Collection*

This horse lies with two legs touching its chin; the legs are spread apart, the tail curls between. The ears, eyes, muzzle, and mouth are in relief, the mane well incised. The surface is degraded and worn.

The coiled position with one of the front hoofs at the mouth is similar to stone or pottery lions of the T'ang period with one of the hind paws at the mouth or scratching one ear (see no. 26). This pose applied to a horse is more unusual and gives the piece a slightly comical air. The treatment of the diminutive other front leg is similar to a T'ang deer in this exhibition (no. 33).

## 65. Recumbent Horse

*Grayish white jade with brown markings*
*T'ang or slight later*
*Height: 34mm; Length: 85mm;*
*    Width: 24mm*
*Victor Shaw*

A recumbent horse leans its head on its out-stretched front legs; its hoofs, tail, mane, eyes, and nose are well indicated. The whole animal rests on a flat base. The mane and back, where the surface is degraded through burial, is stained reddish brown. Two rectangular perforations are cut through its base; one is from the forelegs, the other from its tail leading two-thirds up its length.

The pose of this horse is similar to a black jade horse illustrated in Chu Te-jun's *Ku-yü T'u* and attributed to the T'ang period. The treatment of the head is similar to that of no. 64. Stone carvings of recumbent horses on slab bases are found in twelfth-century tombs of the Hsi-hsia kingdom in Ninghsia (see excavation reports on Hsi-hsia royal tombs in *Wen Wu* 1978.8, and illustrations on p. 73 and p. 82). However, these seem to be a late survival of an earlier style. A jade horse found in Chung-hsing, Heilung-kiang Province, and dated to the Chin period (*Wen Wu* 1977.4, pl. VII.2) has a rectangular perforation through the center, as does no. 63 and the present piece. This seems to indicate that jade horses were used as decorations of legs or tops of vessels in northern China over an extensive period.

See color illustration p.20.

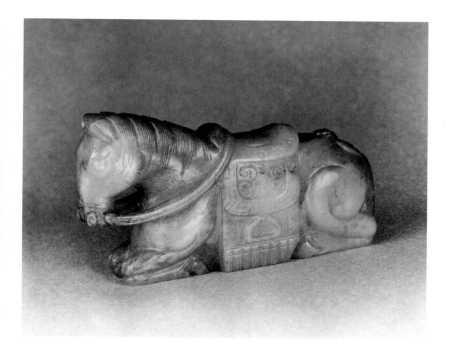

## 66. Recumbent Horse

*Mottled greenish gray jade with brown markings*
*Yüan–Ming*
*Height: 47mm; Length: 90mm; Width: 24mm*
*Victor Shaw*

A stocky Mongolian pony, with thick neck, lies with its four legs drawn up beneath it. Its head is arched and it wears a bridle whose reins are attached to an elaborate saddle with fringed blanket beneath. The mane is striated, the ears drawn forward, the eyes large and globular, the nostrils small. The tail and hoofs are well incised. The base is flat.

Stylistically this horse can be compared with a pottery horse and rider of the Yüan period found in Inner Mongolia (Nei-meng-ku Tzu-chih-ch'ü Wen-wu-kung-tso-tui, *Nei-meng-ku Ch'u-t'u Wen-wu Hsüan-chi*, p. 141, fig. 182). The pattern of mountains arising out of the sea on the side of the saddle, a rebus for "longevity mountains (in a) sea of blessing," indicates a possible Ming date. It is most unusual to find a piece of a comparatively late period with a flat base.

## 67. Man Grooming a Horse

*Light green jade with brown markings*
*Ming (14th–16th centuries A.D.)*
*Height: 95mm; Length: 150mm*
*Asian Art Museum of San Francisco,*
*   The Avery Brundage Collection*
*Published: d'Argencé, Brundage Jades,*
*   pl. XLIV; Rawson and Ayers,*
*   Chinese Jade, no. 366; Gump,*
*   Jade, Stone of Heaven, p. 158.*

A squat Mongolian horse, with its massive head in a halter, has a thick short neck, a heavy, elongated belly, and short stocky legs. The forelock, mane, and tail are all finely striated; the tail rests on an outcropping of the rocky, deeply grooved base. An equally rotund groom, in a belted tunic and boots, reaches with one hand toward the horse's halter. The horse's head is turned back toward the man, and the two regard each other with great amusement.

In d'Argencé's catalogue of the Brundage Collection, a range of dates wider than ours is given. The strength of the carving is perhaps more consistent with the earlier part of the range of dates suggested. The point that d'Argencé makes about the rock base on which the group stands is significant for dating. Such "landscaped" stands do tend to place jade carvings in the Ming period.

Like other types of bases, such as whirlpools and clouds (discussed in the Introduction), the rock base had an earlier beginning. Pottery tomb guardian figures of the T'ang period, whether human or animal, usually stand on a rocky base. Elaborate rocky bases are common in sculptures of the Liao to Yüan periods and became simplified and formalized in the Ming period. The dating of this piece to the Ming period is more secure by virtue of its close stylistic similarity to another piece illustrated in the same plate as this piece in the Brundage catalogue. The latter piece is almost certainly a work of the sixteenth century, which is the period of the most prevalent use of the horse, bee, and monkey group making up the rebus for "may you immediately be elevated to the rank of marquis." Such a rebus is often seen on blue-and-white porcelain of the Chia-ching period.

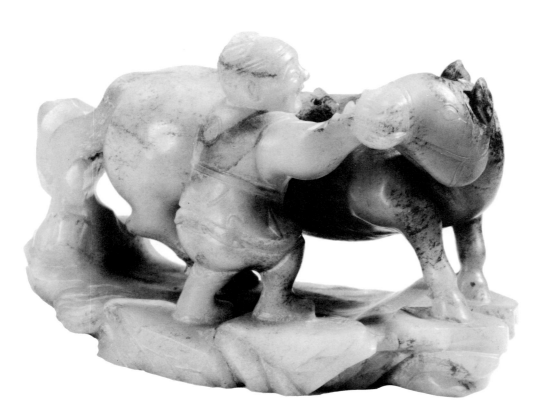

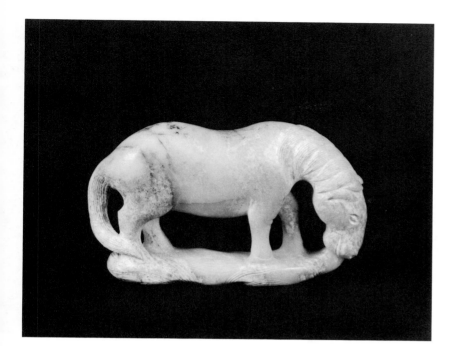

## 68. Horse Drinking

*White jade with calcification*
*Ming*
*Height: 45mm; Length: 75mm;*
*    Width: 16mm*
*Chih-jou Chai Collection*

A naturalistically carved horse bends its head forward to drink water from a stream in which it stands. Parallel incisions depict mane and tail.

The calcified surface gives this piece a deceptively early appearance. The subject of a drinking horse is common in the art of the Ming period, and the style and technique of carving, especially in the liberal use of the tubular drill, suggest a late Ming date. The treatment of the horse is not dissimilar to that in entry no. 67.

See also Rawson and Ayers, *Chinese Jade,* no. 364.

## 69. Monkey with a Peach

*Yellow jade with brown markings*
*Yüan–Ming (14th–15th centuries A.D.)*
*Height: 55mm; Length: 30mm;*
*Width: 26mm*
*B.S. McElney Collection*

A kneeling monkey holds a peach with both front paws, its expressive face looking forward and resting against the peach. The fingers are well detailed.

The gibbon made an early appearance in Chinese literature and painting, but the monkey did not become a prominent motif in both literature and art until about the thirteenth century. Lin P'ei-chih, in an interesting article in *Wen-hsüeh* (1934.2.6), put forth the view that one of the popular stories *(hua-pen)* of the Sung–Yüan periods, the "Story of How Ch'en the Inspector General Lost His Wife in the Mei-ling Mountains," was derived in part from the *Ramayana*. The present author has been much struck by the seemingly sudden appearance of the monkey-and-peach motif as a common decorative element in Chinese pottery exported to Southeast Asia in the thirteenth and fourteenth centuries. Even more notable is the similarity of the iconography of the monkeys with peaches in Chinese pottery to that of Hanuman on the bas-relief carvings on Javanese Hindu-Buddhist monuments. It may not be too far-fetched to postulate that during the great period of Chinese trade with Southeast Asia in the thirteenth and fourteenth centuries, some cultural exchange also took place both in popular literature and the decorative arts, resulting in Buddhist-Taoist novels such as the *Journey to the West* (the English translation by Arthur Waley is entitled *Monkey*) and representations in the plastic arts of the monkey such as this piece.

One of the pranks played by the monkey in *Journey to the West* is stealing the peaches of longevity from the orchard of which he was put in charge by the Jade Emperor.

See color illustration p.105.

## 70. Monkey on a Horse

*Grayish white jade with extended black
   markings*
*Ming (probably 16th century* A.D.*)*
*Height: 44mm; Length: 63mm;
      Width: 24mm*
*T'ing-sung Shu-wu Collection*

A reclining horse, its four legs tucked under
the body, its head resting on its left foreleg, and
its finely incised tail curling to the side, is
mounted by a monkey looking toward its left,
one hand on the horse's well-incised mane, one
leg folded under it and the other hanging on
the horse's flank. There is a perforation under
the monkey's right arm.

Ku Ying-t'ai in his *Po-wu Yao-lan,* published in
the early Ch'ing period, lists under the heading
of jade carvings a carving of a gibbon and a
horse that he dates to the T'ang or Sung period.
If nothing else, this entry demonstrates the
existence in the late Ming period of jade
carvings of the horse–gibbon or horse–monkey
subject, some of which were regarded as being
of considerable age.

In Buddhist literature of the early T'ang period,
the horse and gibbon were often used as
symbolic images for the willfulness and
wayward nature of human desires. The most
famous monk of this period, Hsüan-tsang, was
fond of this imagery. In the novel *Journey to the
West,* which was developed in the Yüan and
completed in the Ming period, the monkey,
and to a lesser extent the horse, played such
symbolic roles. Whether this Buddhist imag-
ery ever found independent concrete expres-
sion in the plastic arts in T'ang or Sung times is
not known, and Ku Ying-t'ai's record is the
only pointer in this direction. In the late Ming
period, the horse is often associated with the
monkey in a popular rebus in the decorative
arts. Sometimes a bee is added to make the
meaning unmistakable (see entry no. 67).

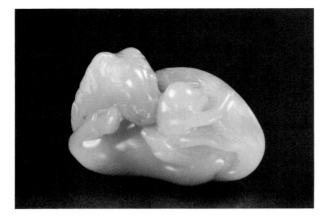

## 71. Monkey on a Horse

*White jade*
*Ch'ing (perhaps early 18th century A.D.)*
*Height: 35mm; Length: 51mm;*
    *Width: 26mm*
*Chih-jou Chai Collection*

The horse is lying on its back, its four legs drawn up and its head and tail turned in. The monkey is seated on the horse's flank and grabbing the tail. The details are finely incised.

This is a later and more dynamic interpretation of the classical theme of no. 70.

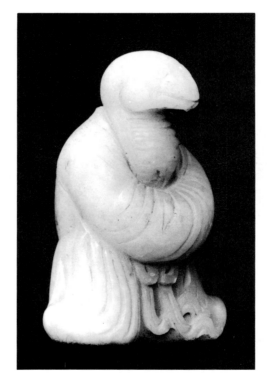

## 72. Snake-Headed Figure

*White jade*
*Sung–Yüan (13th–14th centuries A.D.)*
*Height: 57mm*
*Field Museum of Natural History,*
    *Chicago*

A small figure with a snake neck and head emerging from a human-type body stands with its hands hidden beneath heavy folding robes. The flowing ends of a girdle are also indicated in front.

Pottery figures featuring the twelve animals symbolic of the twelve "earthly branches," or horary characters, occur commonly in burials of the T'ang period.[1] Although such pottery figures became rare in burials after the Northern Sung period, horary animal figures continued to be made in jade in subsequent periods. The treatment of the robe of this figure, with the knot of the girdle tied in front in a loose bow with long flowing ends, is indicative of the late Sung and Yüan periods. This is the most common manner of treating the girdle in figure paintings of the Yüan period such as the wall paintings of the Taoist temple Yung-lo Kung. The general stance of the figure and the treatment of the head remain reasonably close to the T'ang pottery prototypes.

1. See, for example, a report on an early T'ang tomb in Ch'ang-sha in KKTH 1958.3, the figures reproduced on pl. V. For textual references to the use of the horary animals in the burials of the T'ang period, see Wang Ch'ü-fei's article in KKTH 1956.5, pp. 50–54.

# Birds & Fishes

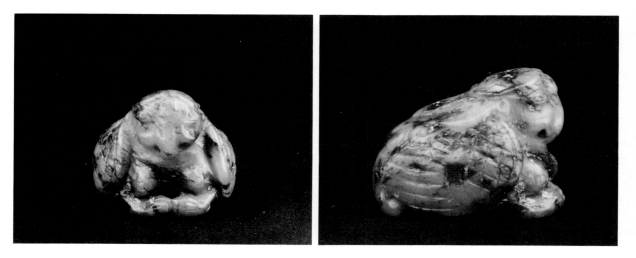

## 73. Bird-Shaped Hat Ornament (Chi)

*Mottled grayish green jade with brown markings*
*Six Dynasties*
*Height: 33mm; Length: 41mm; Width: 38mm*
*Guan-fu Collection*

A round bird figure spreads its wings and tail. The head is generally modeled on that of an owl but with certain human features. The hands or claws are joined in front below the human, or animal, breasts. The figure wears a headdress shaped like a slotted ring with the ends curled inward, from the rear part of which emerge three tufts of hair. It also wears a round object on its forehead. The central part of the tail is decorated with a geometric design. There are five oblique perforations on the underside for attachment, and one beneath the beak.

This is one of a number of similar jade carvings first discussed by Desmond Gure in "Some Unusual Early Jades and Their Dating." Gure identified them as hat ornaments and dated them all to the T'ang period. To the present author, there is no doubt that this carving is a representation of a shaman and probably was worn as a hat ornament by shamans or a certain class of Taoist priests in ritual dress. The feather coat and "mirror" on the forehead are important parts of the paraphernalia of shamans of the Tungusic groups of northern Manchuria.[1] The mirror cult was most preva-

lent in the time of the Six Dynasties, perhaps as a result of the mass movement of nomadic tribes from northern Asia into central China. The mirror, according to writings of the immediate post-Han period, is attributed with the powers of revealing the internal organs of human beings (as in the case of the mirror in the Ch'in palace recorded in the *Hsi-ching Tsa-chi*) or the true shape of other living creatures who, through many years of cultivation, were capable of taking on the appearance of human beings (see Ko Hung, *Pao P'u Tzu,* "*Teng-she Pien*," chapter on "Climbing and Fording"). Yü Hsin, a poet of the late Six Dynasties, made numerous references to such beliefs in his writing, for example in the prose poems *Ching Fu* (On the Mirror) and *Hsiao-yüan Fu* (The Little Residence). The lore of the mirror reached its apotheosis in the "Story of the Ancient Mirror" supposed to have been written by Wang Tu in the early seventh century. The description of the "ancient mirror" in the story answers to that of a mirror of the early seventh century, but the version of the story known to us today can only be traced back to the Sung period.

The prominent bare breasts of the figure also relate this carving to the so-called caryatid figures in stone sculptures of the Northern Ch'i period.

Similar pieces of later periods can be found; no. 74 is such a piece of the T'ang period. The tradition must have survived in the northernmost parts of China through the Liao and Chin kingdoms to the Yüan period. The two exam-

ples discussed by Gure seem to belong to the later tradition of Liao, Chin, and Yüan. In these later pieces, the treatment of the birds takes on the stylistic characteristics of contemporary jade carvings of birds, and the mirror is missing.

1. Eliade, *Shamanism,* pp. 153–154. See also Waterbury, *Bird Deities in China,* p. 86, where the headdress of the Tungusic shaman is described as having "a hooked ornament with a brass mirror in front." She also notes that "the headdress of the northern Tungus shaman has a brass framework on which one, three, or more birds are fastened."

## 74. Bird-Shaped Hat Ornament (Chi)

*Light green jade with black markings*
*T'ang*
*Height: 33mm; Length: 55mm;*
*Width: 53mm*
*Guan-fu Collection*

This circular ornament has a flat base that is perforated in five places for attachment. The upper part is in the form of a bird with spread wings and tail. The head is that of a human monster, and the braceleted hands in front hold a disc between them. The headdress is in the form of a slotted ring with the ends curling inward and with tufts of hair emerging from it at the back. The area inside the circular headgear is decorated with the *T'ai-chi* symbol.

This piece is similar in shape and function to no. 73. The head, of demonic aspect, is comparable to those of tomb guardians (in pottery and sometimes in stone) of the Sui and T'ang periods. Again, there is little doubt that the disc held in the hands of the figure is a mirror.

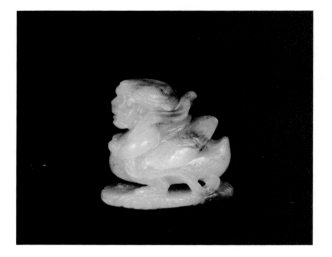

## 75. Bird Man

*White jade with iron-rust markings*
*Probably Yüan*
*Height: 32mm; Length: 34mm;*
*Width: 26mm*
*Guan-fu Collection*

A half-man half-bird figure with flowing scarf stands on a cloud platform that is pierced. The figure wears a circular band on its head, with the ends curling inward, and circular earrings. The feathers of the wings are depicted with fine incised lines, and the duck-shaped body is decorated with archaistic patterns. The eyes are circular drilled holes that might have held insets. The nose and upper part of the mouth are damaged.

This piece is only slightly related to nos. 73 and 74,[1] being rather later in time and seeming to owe something to Buddhist iconography. One is indeed tempted to call this piece a Taoist Kalavinka. The flowing scarf and cloud platform are common features of Yüan Taoist art, and the archaistic patterns on the body are also consistent with this period.

1. However, the carving of the eyes displays similarity to the headdress ornament formerly in the collection of Desmond Gure and published by him in "Some Unusual Early Jades" and also by Hansford in *Chinese Carved Jades.* In the opinion of the present author, the former Gure piece is of a later Sung–Yüan date.

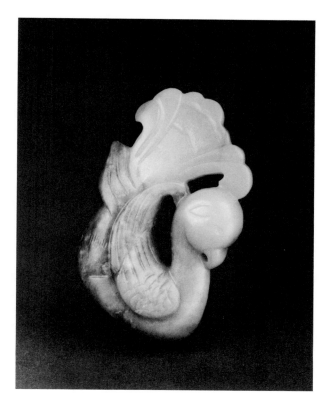

## 76. Phoenix

*Grayish green jade with brown markings*
*T'ang*
*Height: 59mm; Length: 50mm;*
*Width: 22mm*
*Guan-fu Collection*

The phoenix is at rest, one tail feather on the crest. Details of wings, tail, and articulations of the legs are incised. There is one perforation between the beak and the neck and a drilled hole on the underside.

The representation of this bird with the exaggerated tail plumage is typical of the T'ang, as can be seen on the back of T'ang mirrors and other decorated objects of the same period. The fact that there exists an almost identical piece in another collection suggests that this was an object common in the T'ang period, but its function is still to be determined.

See also a similar piece in the Asian Art Museum of San Francisco, published in d'Argencé, *Brundage Jades*, pl. XXXI.

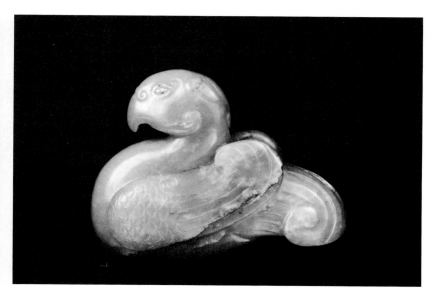

## 77. Bird

*Light grayish green jade*
*T'ang*
*Height: 53mm; Length: 69mm;*
*Width: 27mm*
*Guan-fu Collection*

This griffinlike bird has folded curving wings, a spiraling two-sided tail, legs in low relief on the underside, a curved beak, a sinuous crest, two ears, and two whiskers above the beak.

The general pose of the bird, with the chest well out, and the clear separation of the wings and bifurcated tail plumage point to an early T'ang date for this piece. The jade is somewhat discolored, which confirms its considerable antiquity.

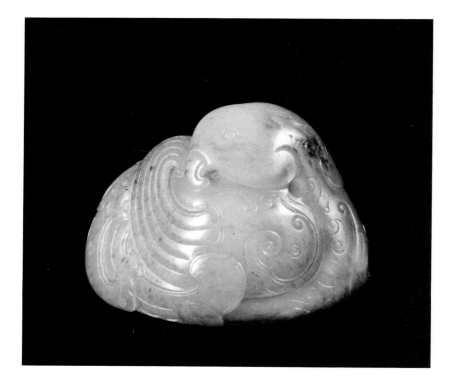

## 78. Archaistic Bird

*Light green jade with brown skin*
*Sung*
*Length: 63mm*
*Robert H. Ellsworth Collection*

Carved from a pebble, the bird with its head turned backward has a hooked beak, stylized wings, and tail feathers that fold under it. The tail issues from the mouth of a square-jawed animal, and the areas not covered by indications of plumage are decorated with spirals and concentric circles arranged in an archaistic manner. The two-clawed feet are depicted in detail underneath.

One of the characteristics of jades attributable to the Sung period is the combination of a strong overall design and finely incised decorative patterns. The use of archaistic patterns on naturalistic animals perhaps began as early as the T'ang period and continued to the end of the Ming (see no. 86) with minor modifications in the style.

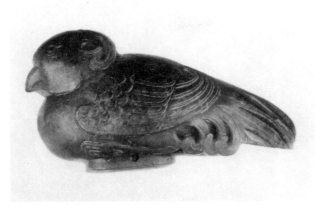

### 79. Staff Finial

*Gray jade with brown markings*
*Sung or later*
*Height: 38mm; Length: 75mm;*
  *Width: 30mm*
*Field Museum of Natural History,*
  *Chicago*

A finial in the form of a phoenix has incised wings and roughly carved tail feathers flanked by curled feathers. The phoenix's claws appear in relief on either side of an oval rimmed opening for shafting.

According to records of the Han period, men who achieved seventy years of age were granted a "king's staff," *wang chang,* and certain social privileges. These staffs or walking sticks were decorated with finials in the shape of a dove, *chiu.* In most of the later texts of these records, the word *wang,* for king or prince, was corrupted by scribes to *yü,* for jade, the two characters being very similar in structure.[1] It was no doubt a result of this misreading of the old text that led to the making of bird-shaped jade staff finials in the archaizing period of Sung to Ming. There is, of course, no reason why such staffs should not have been fitted with a jade finial in the Han period, and the dove-shaped finial formerly in the collection of Wu Ta-ch'eng and now in the Asian Art Museum of San Francisco[2] is a possible candidate for a Han date or belongs to a period not too much later. Most of the others such as the other jade finial illustrated in Wu Ta-ch'eng's catalogue, the *Ku-yü T'u-k'ao,* and this piece are not earlier than Sung.

1. See Ch'en Meng-chia's discussion on this subject in *Wu-wei Han-chien.* Ch'en also pointed out that the length of the staff should be 9 (Han) feet, i.e., about 2 meters, rather than the often quoted 1 (Han) foot, i.e., about 23 centimeters.

2. See d'Argencé, *Brundage Jades,* pl. XXIV, lower part of plate, and explanatory notes.

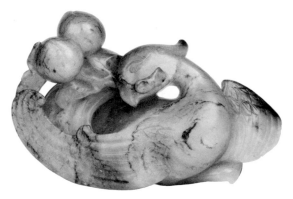

## 80. Bird with Peaches

*Mottled grayish green jade with brown*
*    veins*
*Sung*
*Height: 47mm; Length: 72mm;*
*    Width: 21mm*
*Guan-fu Collection*

The phoenix, lying with its head turned backward, holds a peach branch in its beak. One wing is half unfolded, the other resting at the phoenix's side. The plumage and tail are deeply incised.

The phoenix holding a peach branch is a common decorative motif in the Sung and Yüan periods. It is seen, for example, as appliqué decoration on Lung-ch'üan celadon dishes of Yüan date. The motif survived into later periods but the treatment changes.

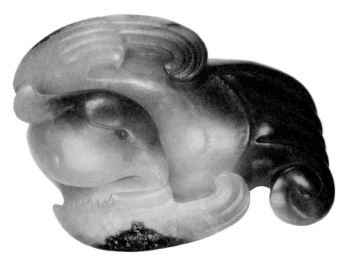

## 81. Bird

*Yellow jade with brown markings*
*Late Sung–early Ming (13th–14th*
*    centuries A.D.)*
*Height: 26mm; Length: 82mm;*
*    Width: 66mm*
*Mr. and Mrs. B.H. Tisdall*

This highly stylized bird turns its head back toward the curled tail. The wings are spread and turn in at the tips toward the body, which has two lines of fine hatching. The grooved lines of the beak, eyebrow, and jaw all echo each other, as do the parallel lines of the wings and tail.

The mannered pose of the bird with head folded backward and resting on its back echoes the pose of certain animal carvings of the Sung-Yüan periods (see nos. 35, 44). A jade goose in The British Museum, which has been published many times (see Rawson and Ayers, *Chinese Jade,* no. 243) and dated to the Sung period, is styled in much the same spirit. The attractive chestnut-yellow jade is also common in the thirteenth and fourteenth centuries.

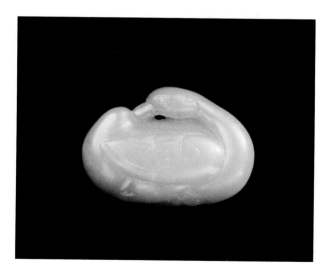

## 82. Goose

*White jade*
*Late Sung–early Ming (13th–15th*
*    centuries A.D.)*
*Height: 30mm; Length: 42mm;*
*    Width: 26mm*
*Guan-fu Collection*

The small pebble is carved in the form of a goose swimming, its neck and head turned back, its beak resting on its tail. The wings are finely carved, with a C scroll at the joint. Wave patterns are incised on the base.

The pose of this bird is reminiscent of the very early stone weights of Mesopotamia. Whether there is any connection over such a vast gap of time and distance is still to be proved. The pure translucent white jade, which has the appearance of the flesh of the lichee fruit, as opposed to the opaque "mutton-fat" white jade of the early eighteenth century, is more commonly found in the thirteenth to fifteenth centuries.

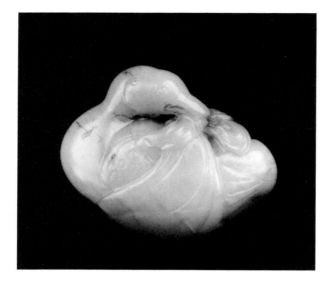

## 83. Duck with a Scarf

*White jade with brown flecks*
*Ming*
*Height: 43mm; Length: 54mm;*
*Width: 50mm*
*Victor Shaw*

A duck in swimming position is wrapped in a scarf and turns its head back to hold the tied ends in its beak. The front of the wing is ornamented with small spirals. The folds of the scarf are incised, and the knot has considerable volume.

As observed in entry no. 60, animals, birds, and inanimate objects in cloth wrappers constitute one of the most salient mannerisms of the Ming decorative artist.

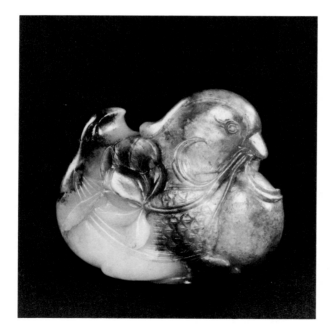

## 84. Mandarin Duck

*Brown and white jade with yellow*
*mottling*
*Late Ming*
*Height: 47mm; Length: 63mm;*
*Width: 29mm*
*Gerald Godfrey, Esq.*

This duck, with webbed feet beneath it, carries a lotus branch in its beak, the flowers resting on its wings. The hatching on the breast and the eyes, beak, and wings are all clearly carved.

The mandarin duck with a lotus flower is a favorite theme of the Ming jade carver. However, the motif is carried on well into the Ch'ing period.

See also d'Argencé, *Brundage Jades*, pl. XLV, for another Ming carving of the same subject.

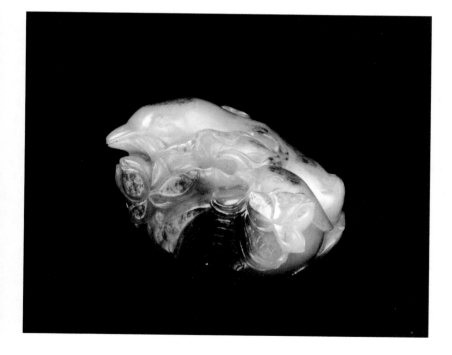

## 85. Ducks with a Lotus Plant

*Gray jade with iron-rust markings*
*Ch'ing (probably 18th century A.D.)*
*Height: 49mm; Length: 71mm;*
*    Width: 63mm*
*B.S. McElney Collection*

A pair of mandarin ducks rests on a lotus leaf, the larger duck having a branch of the lotus flower in his beak, the smaller nestled at his side with a smaller flower in an identical position. The details of the beaks, eyes, wings, heads, and tail feathers are finely carved, as are the veins of the lotus leaf on the base.

The motif of a mandarin duck with a lotus plant receives a much more naturalistic treatment in this case than in no. 84. The clever use of the skin of the pebble, the elaborate lines, and the comparative lack of three-dimensional modeling all suggest a Ch'ing date.

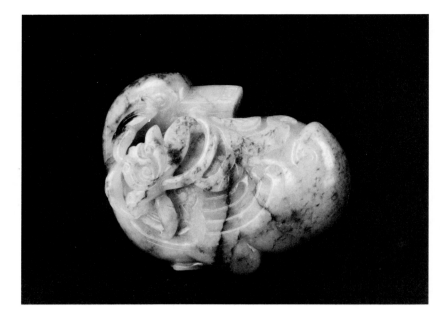

## 86. Mandarin Duck

*White jade with brown mottling*
*Late Ming*
*Height: 54mm; Length: 74mm;*
*Width: 36mm*
*Victor Shaw*

A mandarin duck holds a peony branch in its beak. The beak and wings are highly stylized, being almost geometrically rendered. The beak has a band of key patterns and the wings have three zones of design: thunder patterns, scrolls, and serried bars that sweep upward toward the scrolled tail. The webbed feet, shown in relief underneath, are more naturalistic than other details of the formalized bird.

As observed in entry no. 78, jade carvers from the Sung period onward often decorated naturalistic birds with archaistic design patterns. The late Ming carver, however, went one step further and formalized certain parts of the bird itself, such as the beak of this piece. The stylized treatment of the peony is characteristic of the Ming period but also survived into the Ch'ing era.

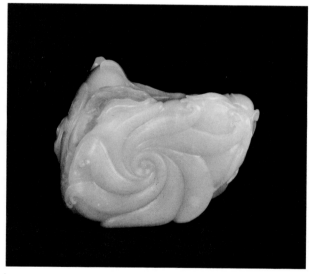

base

## 87. Ducks with Lotus Plants

*White jade*
*Late Ming (early 17th century* A.D.*)*
*Height: 130mm; Length: 100mm;*
*Width: 82mm*
*Joseph E. Hotung*

A pair of mandarin ducks, one recumbent and the other standing alongside, gaze at each other as they both hold a lotus branch with flowers. The heads are square and stylized, with strong grooved lines that begin at the beak and flow back to form a single crest. The feathers of the wings and bunched tails are indicated by finely incised lines, with an archaistic design pattern decorating the upper part of the outer wing of one of the birds. The base is a whirlpool of beautifully incised waves.

Carvings of largish pieces of white jade are usually ascribed to the Ch'ing period. Stylistically, however, this piece can be placed at the end of the Ming era, extending at most to the Ming–Ch'ing transitional period. The fine plastic modeling of the lotus leaves and pods, and this particular treatment of the base of waves, are common characteristics of carvings of the early seventeenth century when larger pieces of jade, mined from mountains rather than collected as pebbles from river beds, began to make their appearance (see Introduction).

See frontispiece.

101

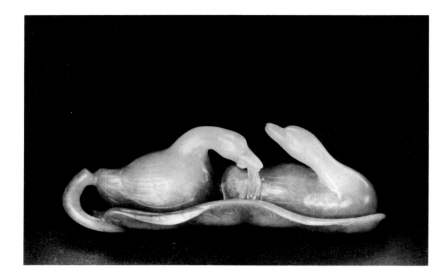

## 88. Ducks on a Lotus Leaf

*Gray jade with darker markings*
*Ch'ing (probably 18th century A.D.)*
*Height: 27mm; Length: 79mm;*
*    Width: 24mm*
*Chih-jou Chai Collection*

The two ducks rest on a lotus leaf, one in front of the other. One turns its head backward and the other leans forward to munch a waterweed. The wings of both birds are incised with fine lines.

As in the case of no. 85, the naturalistic design with rather summary treatment of details and lack of fine modeling suggests a Ch'ing date.

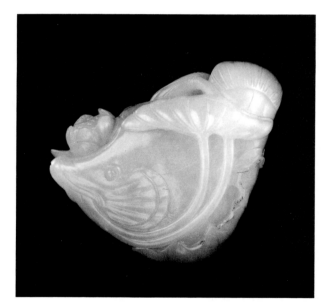

## 89. Lotus and Fish

*Greenish white jade*
*Late Ming–early Ch'ing (17th century*
*    A.D.)*
*Height: 49mm; Length: 61mm;*
*    Width: 28mm*
*B.S. McElney Collection*

The fish holds in its mouth a lotus branch whose leaves curl back on its spine, while one rests beneath it. The flower of the lotus rests on its snout. The veins of the leaves, the fin of the fish's tail, and the gills are all in low relief.

Like the motif of mandarin ducks with lotus plants, the fish-and-lotus motif goes back to the Yüan and even earlier periods, but was popularized in the Ming period when large numbers of such pieces were produced. Again, this motif continued into the Ch'ing period, but the fine relief carving of the veins of the lotus leaves and fish fin suggests a date not later than the seventeenth century.

See also the jade fish with lotus leaf and reeds of the Chin period excavated in Chung-hsing, Heilungkiang Province, and reproduced in pl. VII of *Wen Wu* 1977.4.

### 90. Carps

*Green jade with iron-rust markings*
*Early Ch'ing, probably K'ang-hsi period*
*Height: 55mm; Length: 110mm;*
*Width: 50mm*
*B.S. McElney Collection*

A large carp, with flat lustrous sides and prominent dorsal fin, is followed by a smaller carp across a base of waves.

This masterpiece of jade carving employs as much as possible of the original stone and turns it into a most realistic representation of two carps among waves. The waves, both mannered and realistic, exhibit the first signs of the Ch'ing style of treating the wave base, better exemplified in no. 91, which is of a later date.

See color illustration p.106.

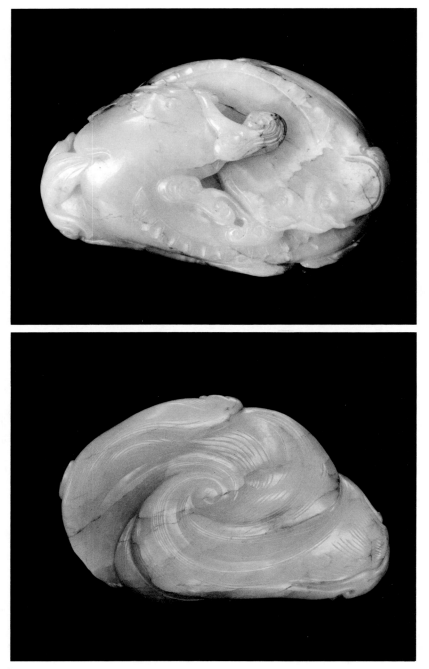

base

## 91. Double Fish

*Mottled white jade*
*Ch'ing (18th century* A.D.*)*
*Height: 28mm; Length: 88mm;*
 *Width: 56mm*
*B.S. McElney Collection*

The fish are coiled around so that the tail of one touches the other's head. Each has a flat face with round eyes, and each holds a fungus in its mouth. The base is a schematized whirlpool.

Stylistically, this carving has much in common with no. 24, the double *huan,* symbolic of double happiness. Carvings of double animals, especially the catlike *huan,* and fish abounded in the eighteenth century and continued to the very end of the Ch'ing period. The treatment of the whirlpool on the base, with the waves divided into segments in the Ming manner but with only part of the surface incised and with no breaker coming out of the sides, is typical of the mid-Ch'ing manner.

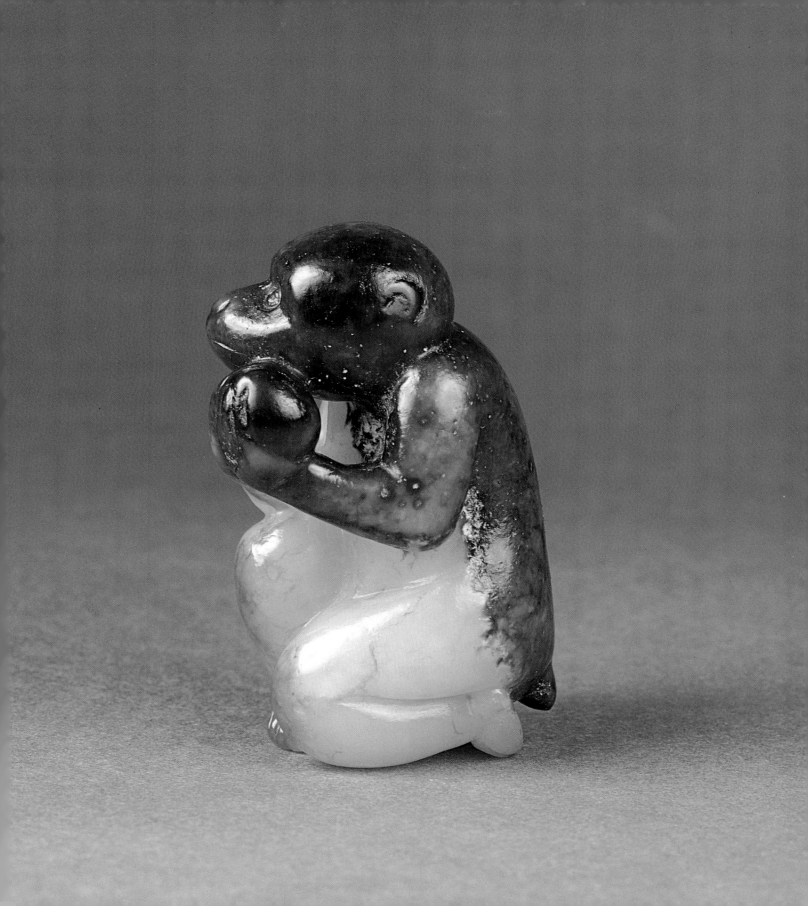

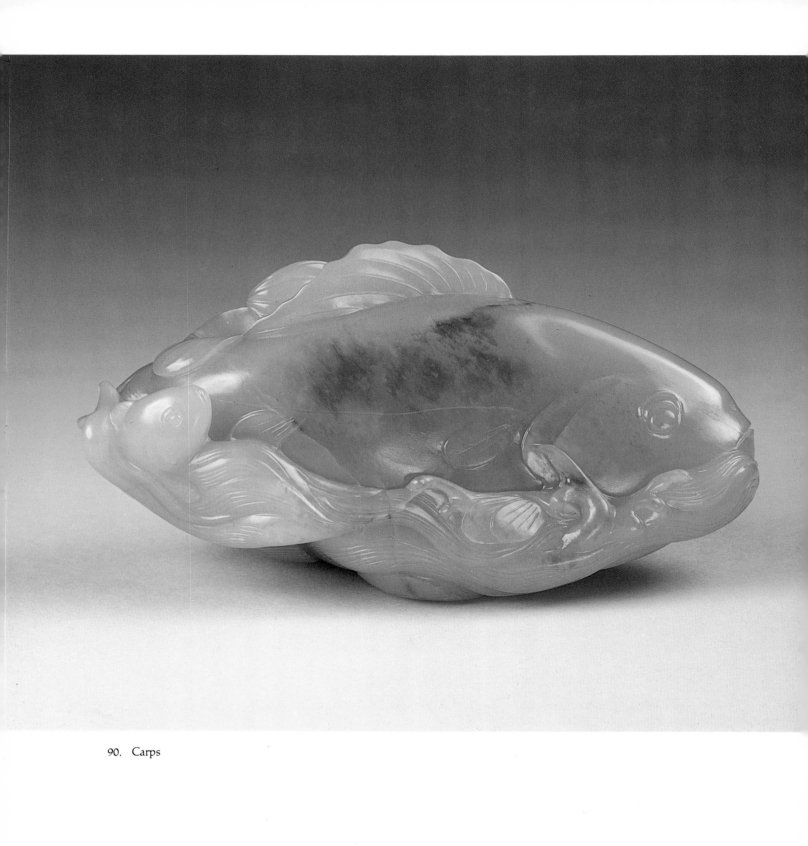

90. Carps

# Figures

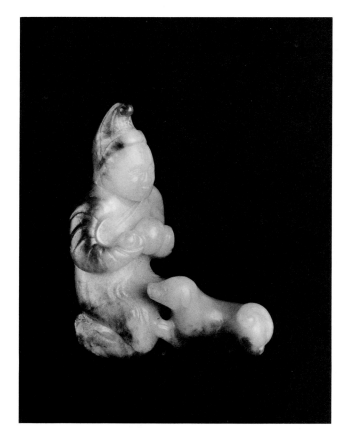

## 92. Tribute Bearer with a Dog

*Grayish white jade with brown markings*
*T'ang*
*Height: 71mm; Length: 53mm;*
*    Width: 30mm*
*Dr. and Mrs. Cheng Te-k'un*
*Published: Rawson and Ayers,* Chinese
    Jade, *no. 211; Hansford,* Chinese
    Carved Jades, *pl. 68.*

A kneeling foreign figure, dressed in a long belted coat and a pointed hat, is holding a ball with both hands. The dog is clambering at his knee as if trying to catch the ball. There is a perforation under the man's left arm and between his knee and the dog's front legs.

It is often difficult to give precise dates to jade carvings of figures of foreigners. This particular figure with his pointed cap and narrow sleeves, however, agrees well with the representation of the Iranian in T'ang pottery figurines. The association with the dog enhances the certainty of the dating, for Iranians were known to have brought dogs as "tribute" to China in the eight century.

See also a T'ang pottery figure illustrated in Mahler, *Westerners,* pl. XIX a, b.

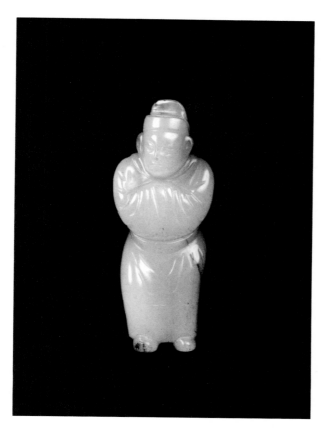

## 93. Standing Figure

*Grayish white jade with brown veins*
*T'ang or Sung*
*Height: 67mm; Length: 27mm;*
  *Width: 17mm*
*Dr. and Mrs. Cheng Te-k'un*
*Published: Rawson and Ayers,* Chinese
  Jade, *no. 213*

This figure is dressed in a long robe belted at the waist, the hands tucked into the sleeves and held high in front, and he wears a peaked hat with pendants at the back. He looks slightly to one side, with a serious expression on his face. There is a perforation from top to bottom.

The figure has been dated to the T'ang period by comparison with a stone figure from the tomb of Yang Ssu-hsü near Sian dated to A.D. 740 (*Wen Wu* 1961.12, p. 59, pl. VI). However the resemblance does not go beyond the style of dress, and this piece could possibly be of a slightly later date.

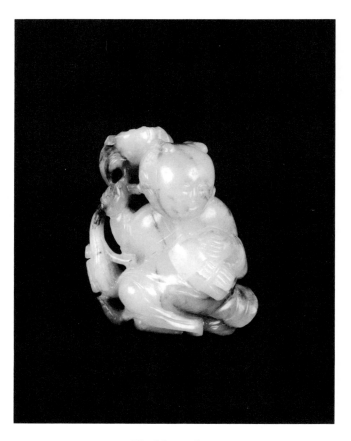

## 94. Child with a Lotus Plant

*White jade with brown veins*
*Yüan*
*Height: 55mm; Length: 46mm;*
*Width: 23mm*
*Guan-fu Collection*

The kneeling figure holds a lotus plant in one hand and a *sheng* (a mouth organ with bamboo pipes) in the other, his smiling face looking toward the left. The long coat and trousers, the musical instrument, and the plant are modeled in detail.

During the Sung period, on the festival of *Ch'i-hsi,* the seventh evening of the seventh lunar month, when the constellations of the Cowherd and the Weaving Maid met, the streets of the cities, especially in the capitals (Pien-ching, present day K'ai-feng, in the Northern Sung period and Lin-an, present-day Hang-chou, in the Southern Sung) would be filled with playing children dressed in waistcoats and holding a lotus leaf or plant. They were, as the records tell us,[1] imitating the *mo-hou-lo,* the cult-object of the festival. The *mo-hou-lo,* which were sold everywhere in the days leading up to the festival, were in the form of a boy with a lotus leaf or plant and were most commonly made of clay, either unbaked or fired to various degrees of hardness. The expensive ones were made of ivory, gold, and aromatic substances like ambergris. Some of these dolls would be dressed in finery. In Southern Sung times, the imperial workshop, the Hsiu-nei-ssu, would produce ten trays for the court on this occasion (Chou Mi, *Wu-lin Chiu-shih*). Each tray would hold thirty of these figurines made of exotic materials, and the largest one would stand about one meter high. Individual workmen, especially in the Su-chou area, would become famous for making these dolls. A certain Yüan Yü-ch'ang, who lived in Yüan times in Su-chou, made *mo-hou-lo* that had moving parts, and became one of the very few artisans (artists other than painters) who left his name in the historical records of comparatively early times (see Wang Ao, *Ku-su Chih*).

There is no doubt that some *mo-hou-lo* were made of jade. In one of the most well-known popular stories, *hua-pen,* of the Sung–Yüan period entitled "Kuan-yin of Carved Jade,"[2] the owner of the jade consulted his artisans as to what to carve the jade into. After much discussion, during which one of the artisans suggested that the shape of the jade would lend itself well to that of a *mo-hou-lo,* it was decided to make it into a Kuan-yin. The *mo-hou-lo* cult continued well into the Yüan period, for it also figured prominently in one of the best-known Yüan dramas.[3] However, it seemed to have ceased rather abruptly in the Ming period, and although the image of the boy holding a lotus remained as popular as ever in Ming decorative art, the name *mo-hou-lo* was lost and Ming authors simply referred to these figures as "boy holding lotus" (see Chang Ying-wen, *Ch'ing Pi Tsang,* section on jade). In Su-chou present-day makers of clay images of boys for use in Taoist ceremonies in the seventh month call them "confectionery boys" but do not know of the name *mo-hou-lo* (Ku Kung-shuo, "*Mo-hou-lo,*" in WWTKTL 1958.7, p. 55).

The present figurine is a good candidate for identification as a *mo-hou-lo* of the Yüan period. The whole piece is carved with a degree of detailed modeling seldom seen in carvings of any other age. The artist cleverly employs the skin of the pebble to give brown edges to the leaves of the lotus plant, which are artistically pierced with "worm holes" very much as they are in academic paintings of the Sung and Yüan periods. This is also evident on some Yüan blue-and-white porcelains. The shoes are well modeled, whereas in later periods the treatment of shoes or feet is usually rather summary, even in otherwise well-carved pieces.

The musical instrument, the *sheng,* is a rebus for birth and further enhances the association of this carving with the Seventh Night, which is very much a women's festival. For, although the derivation of the name *mo-hou-lo* remains obscure,[4] there is no doubt that these images of boys were associated with the idea of birth, rebirth, and incarnation. Stylistically this figurine can be compared to the childlike figures playing or carrying musical instruments that are common in Taoist paintings of the Yüan period, as seen, for example, on the walls of Yung-lo Kung.

1. All the late Sung and early Yüan writers who reminisced about life and fashion in Sung times recorded the use of *mo-hou-lo* in the festival of the Seventh Night. Five of these "notebooks" are collected in the 1962 Chung-hua Shu-chü edition of the *Tung-ching Meng-hua Lu.*

2. This story is collected in the *Ching-pen T'ung-su Hsiao-shuo* and under a different name in the *Ching-shih T'ung-yen.* Neither of these collections of tales from the Sung period appear before the Ming period, but the stories themselves seem to preserve much of the original Sung versions.

3. *Chang K'ung-mu Chih-k'an Mo-ho-lo,* "Chang the Scribe Cleverly Investigates the Case of the *Mo-ho-lo,*" by Meng Han-ch'ing, collected in *Yüan-ch'ü Hsüan.*

4. Many scholars have attempted to find the Sanskrit derivation for the word *mo-hou-lo.* Teng Chih-ch'eng in his annotated edition of the *Tung-ching Meng-hua Lu* (Hong Kong Commercial Press ed., 1961) quotes his friend Sun K'ai-ti in suggesting that *mo-hou-lo* is a corruption of *lo-hou-lo* (Rāhula), the son of Sākyamuni in his earthly existence. Herbert Franke in a review of André Levy's "L'Antre aux fantômes des collines de l'Ouest" (*T'oung Pao,* vol. 60, 1974, pp. 194–195) suggests that it may be a transliteration of makara, whereas Levy himself proposed Mahākāla as a possibility. Other scholars have put forth different theories, none of which appears to the present author to be completely satisfactory. The most common usage of the characters *mo-hou-lo* in Chinese Buddhist texts is for the transliteration of *muhurtā,* meaning a brief moment.

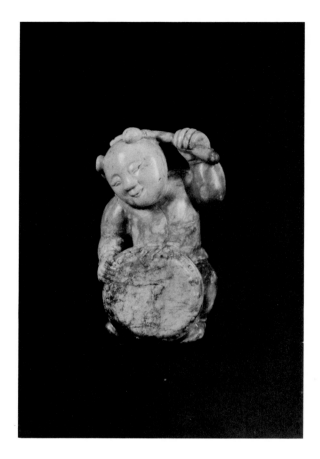

## 95. Boy with a Drum

*Burnt greenish yellow jade*
*Sung-Yüan*
*Height: 53mm; Length: 34mm;*
*Width: 26mm*
*Guan-fu Collection*

A boy in a sleeveless tunic or waistcoat and trousers holds a drum in one hand and a drumstick behind his head in the other. A *ch'ing* or sonorous stone—a musical instrument—is tied to his back. His hair is arranged in two topknots; the details of his face, fingers, toes, and the pins on the circumference of the drum are all in relief. He wears bangles on his wrists and ankles.

Not all the boy images of the Sung and Yüan periods carry lotus plants. Some of them are associated with drums. Ceramic figurines of boys holding or playing drums are illustrated in Nils Palmgren's *Sung Sherds* and are dated to the Sung period. A large number of such boys in jade have survived to this day, some of them, as in the case of this piece, having suffered a literal baptism by fire. The original color of the jade could have been an attractive greenish yellow. The *ch'ing* on the back is a rebus for "joyous event" or "celebration." Boys in paintings and sculptures of the Sung to Ming periods usually wear bracelets and anklets.

## 96. Child with a Lotus Plant

*Light green jade with brown markings*
*Ming*
*Height: 45mm; Length: 42mm;*
*    Width: 21mm*
*T'ing-sung Shu-wu Collection*

A young boy holds a lotus leaf by its stem with one hand while the large leaf acts as a base for the boy to sit on and lean against. His other hand rests on his leg, both legs curled to the side, one knee being slightly raised. The face, hair in two knots, robes, hands, and feet are all beautifully detailed, as are the incised veins of the leaf. The carver has made use of the brown skin of the jade to form the lotus leaf.

This is an excellent example of the survival of the boy-with-lotus motif into the Ming period.

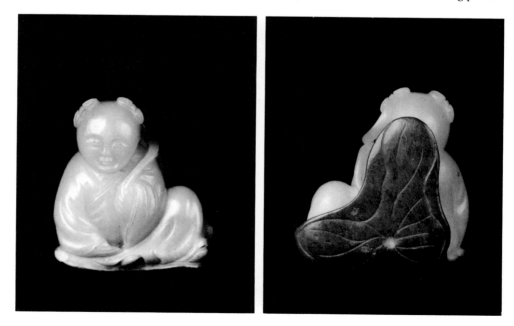

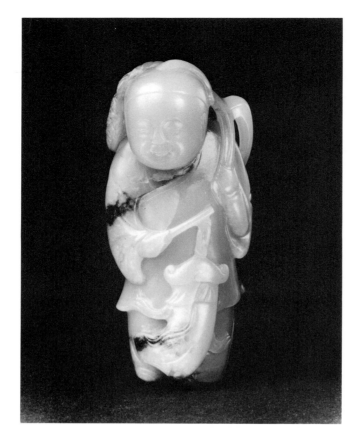

## 97. Child with a Lantern

*Gray jade with brown markings*
*Late Ming*
*Height: 111mm; Length: 49mm;*
*Width: 39mm*
*Chih-jou Chai Collection*

A standing figure holds a lantern in one hand and an ear of rice in the other. He is dressed in a three-quarter length coat over trousers.

Children with lanterns figure quite prominently in the decorative arts of the late Ming period. The modeling of minor parts such as hands and bracelets is not as fine and detailed as that of earlier figures.

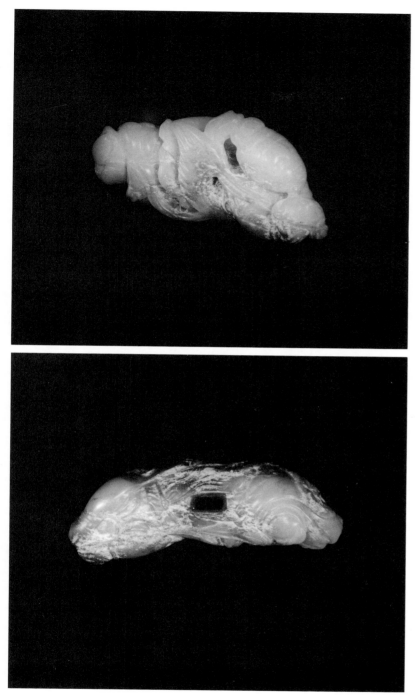

base

## 98. Winged Figure

*Light green jade, calcified in part*
*Liao–Chin*
*Height: 33mm; Length: 74mm;*
*Width: 23mm*
*K'ai-hsüan Studio Collection*

This female figure has been modeled in the round with high chignon, wings, and flowing scarf. Her legs are crossed and her hands hold what looks like a peach. The underside of the piece shows a girdle tied over the top part of a *dhoti* in the same manner as in Sung and Yüan Buddhist sculptures. A rectangular perforation, similar to those in the horses (nos. 63, 65), goes through the center of the piece.

Other comparable jade figures, such as the one discussed by Desmond Gure ("Some Unusual Early Jades," pp. 54–55, pl. 43), are usually called *apsaras* and attributed to the T'ang period. However, a number of such figures have been found in Liao period (A.D. 916–1125) sites in northeastern China in recent years (WWTKTL 1952.2, p. 39, and *K'ao-ku* 1979.4, p. 333). Unfortunately, no photograph has been published, but the descriptions mention flowing scarves and clouds. A piece of the Chin period, found in Chung-hsing, Heilungkiang Province, has been published and illustrated (*Wen Wu* 1977.4, p. 36, pl. VII). This is also a female figure with elaborately coiffured hair. Some years ago, Torii Ryuzo postulated that the scarf was the national dress of the Po-hai people who occupied the Liao-ning area in T'ang times (Torii, "Vases of the Sassanian Style"). He based his evidence on the discovery of a stone belt-plaque in the city of Liao-yang that is similar to no. 157 in the present exhibition. Such belt-plaques are now known to occur in T'ang sites over much of north China and are not restricted to Manchuria. Nevertheless, flying figures in jade with wings, flowing scarves, and clouds (optional) do seem to belong to the Liao-Chin cultural tradition, and their association is not necessarily Buddhist. If anything they may have more to do with the winged figures of an earlier period such as the hat ornaments (nos. 73, 74) in this exhibition. From the Yüan period onward, these female flying figures metamorphosed into flying figures of boys that are perhaps Taoist creatures (see no. 99).

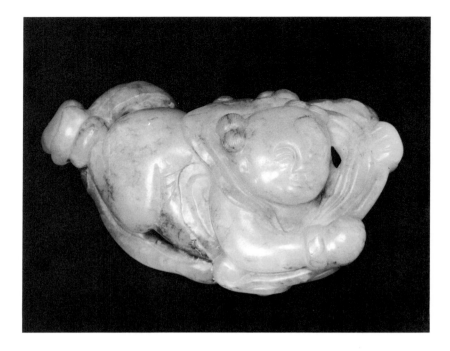

## 99. Boy with Flowing Scarf

*Light green jade with brown markings,*
*    some calcification*
*Yüan–early Ming*
*Height: 18mm; Length: 96mm;*
*    Width: 56mm*
*Chih-jou Chai Collection*

A boy with his face in the round but his body in profile has his legs drawn up and is entwined in a flowing scarf suggesting a state of flight. One end of the scarf is under his belly, his braceleted hands and legs are wrapped around it, and the tail end is seen in full relief on the reverse side. Spirals of clouds rest in the small of his back and under his chest. His smiling face is carved in low relief, his hair braided into two knots over each ear.

As noted in the previous entry, the flying figure of a boy with a scarf on clouds is a Yüan transformation of a Liao–Chin tradition. This type of carving persisted into the Ming period.

## 100. Children at Play

*White jade*
*Late Ming–early Ch'ing*
*Height: 60mm; Length: 73mm;*
*        Width: 23mm*
*Guan-fu Collection*

The pebble is carved to represent a rocky landscape where two boys are playing with a wheeled horse; the boy at the back holds a lotus leaf. The reverse is decorated with the back of the same rocks and a fungus.

The subject of boys playing with bamboo horses, with a boy on a horse dressed up as an official and another boy holding over his head a lotus leaf as if it were a silk umbrella used in official processions, is common in the decorative art of the Ming period and may derive ultimately from the *mo-hou-lo* processions of the Sung and Yüan periods. The particular arrangement of the horse and boys in this piece is identical to the decoration found on certain sixteenth-century blue-and-white ceramics and to a part of the design of "nine children" from the set of woodblock prints *Ch'eng-shih Mo-yüan,* which are designs stamped on cakes of ink made by Ch'eng Chün-fang, the famous manufacturer of ink cakes in the Wan-li period.

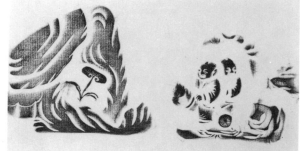

rubbing of front and back

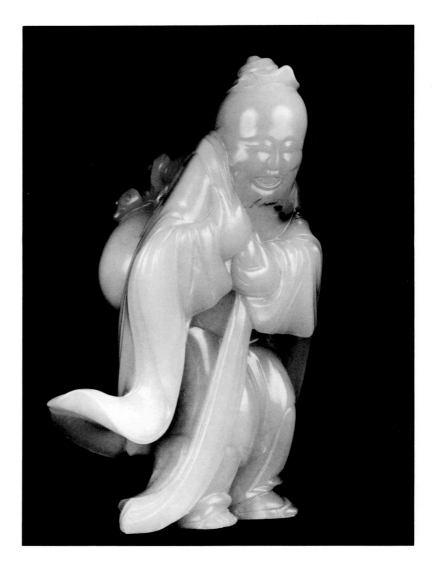

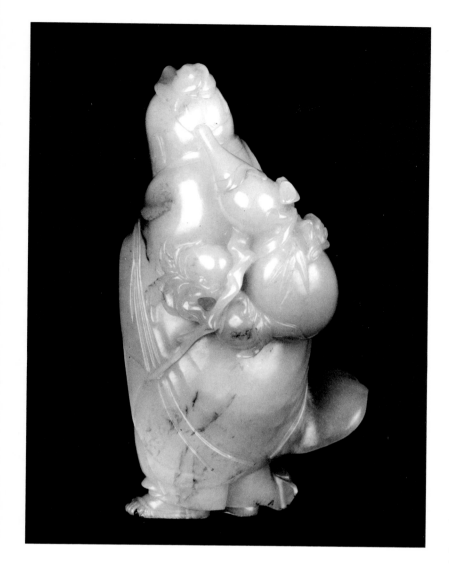

## 101. Tung-fang Shuo with Peaches

*White jade with reddish brown markings*
*Late Ming–early Ch'ing*
*Height: 110mm; Length: 56mm;*
    *Width: 41mm*
*B.S. McElney Collection*

A laughing old man, dressed in a long robe and sandals, stands holding on his back a large gourd and two peaches, which are secured by a sash whose knot also holds a sprig of bamboo and fungus. His head, covered with a cloth cap, is tucked to one side; his beard, finely incised, falls onto his chest.

Tung-fang Shuo was a historical figure who was a member of the court of the Emperor Wu-ti in the Western Han period. He was known for his wit and somewhat unconventional behavior. Later he was canonized by Taoists and also given mischievous roles such as stealing the peaches of immortality from the Queen Mother of the West. From the middle of the Ming period, the subject of Tung-fang Shuo and his stolen peaches of longevity became a popular one for paintings and the decorative arts such as embroidery and sculpture. These paintings and objects were often given as birthday presents.

The style of this piece and the cloth cap that the figure wears suggest a late Ming dating. The use of a cloth cap as opposed to a hat became fashionable from the middle Ming period onward, as recorded in volume 27 of the *Ch'i-hsiu Lei-kao* by Lang Ying, who flourished in the first half of the sixteenth century. Many paintings and figure carvings of the late Ming period show scholars and Taoist immortals wearing a small cloth cap. The gourd is further indication of Taoist association.

It may be noted that the technique of carving the robe in this piece is very similar to the treatment of the rock in no. 100.

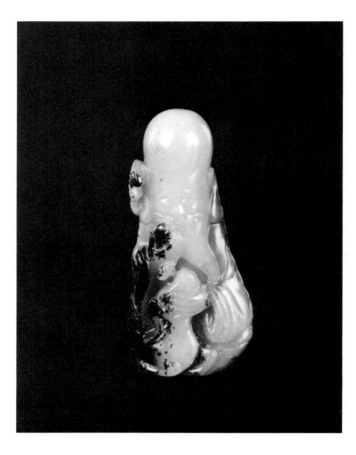

## 102. Shou-lao with Deer and Bats

*White jade with mottled brown markings*
*Late Ming*
*Height: 73mm; Length: 33mm;*
    *Width: 20mm*
*Victor Shaw*

The immortal Shou-lao has an elongated head, well-defined eyebrows, nose, and mouth, a long drooping moustache, and a finely incised long beard. One hand holds a peach, the other the head of the deer, in whose mouth is the *ling-chih* (fungus of immortality). One bat rests on Shou-lao's large earlobe and another on the fold of his draped sleeve, while three others are attached to the back of his robe.

Shou-lao, the god of longevity, achieved his elongated head toward the end of the sixteenth century, as can be seen on the decorative arts of this period. The bats, deer, and the god with his peach form a rebus for the three blessings: good fortune, riches, and longevity (*fu, lu,* and *shou*). The iconography of this piece agrees well with that of a carved brick Shou-lao found in the tomb of a certain Hsü Yü-fu who died in the year 1610 in Su-chou (see *Wen Wu* 1977.3, pp. 78–79, fig. 2).

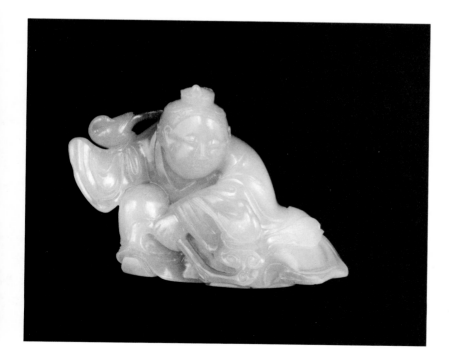

## 103. Figure with Birds

*White jade, mutton-fat type*
*Late Ming–early Ch'ing*
*Height: 53mm; Length: 76mm;*
  *Width: 30mm*
*Chih-jou Chai Collection*

A young boy in semi-kneeling position, with one bird on his outstretched right arm, holds with his left hand another bird on a scepter-shaped *ling-chih* branch. He turns his head to look at the second bird.

The style of this carving is similar to no. 101 and the piece can be given a similar date. *Ju-i* scepters carved in the form of a branch ending with a *ling-chih*-shaped head were particularly popular in the seventeenth century. Many of such *ju-i* scepters carved in wood have survived to this day.

detail

## 104. Lohan in a Grotto

*Pale greenish yellow jade*
*Ch'ing (late 17th–early 18th*
*centuries A.D.)*
*Height: 184mm; Length: 168mm;*
*Width: 61mm*
*Fogg Art Museum, Harvard University;*
*gift of Ernest B. and Helen P. Dane*

The piece depicts a lohan seated in a grotto framed by an old, leafless tree. The lohan holds a book in his left hand and gestures with his right. His mouth is open as if chanting. He wears a long monk's robe that leaves his chest bare; on his feet are sandals. Circular earrings hang from his earlobes. At the right of the composition is a large, rectangular rock on which a monkey sits alongside the lohan's alms bowl. The monkey was carved separately and is attached with a small wooden peg.

The lohan sitting in a grotto was a favorite subject of the decorative artist in the late Ming and early Ch'ing periods and was employed by wood and bamboo carvers as well as by those who worked in jade. The apocryphal book *Ku-yü T'u-p'u,* published in the late eighteenth century and purporting to be the catalogue of the Emperor Kao-tsung (1127–1162) of the Southern Sung period, illustrates an "old carving" on the same subject entitled "Old Jade Naturalistic Buddha Image Representing Samantabhadra." Whereas the piece illustrated in the *Ku-yü T'u-p'u* must have been carved in the late Ming period, this example is stylistically an early Ch'ing piece—but not too early, for the carving of the rock (see detail), with the rugged parallel lines, already exhibits the mannerism of Su-chou jade carvers of the eighteenth century.

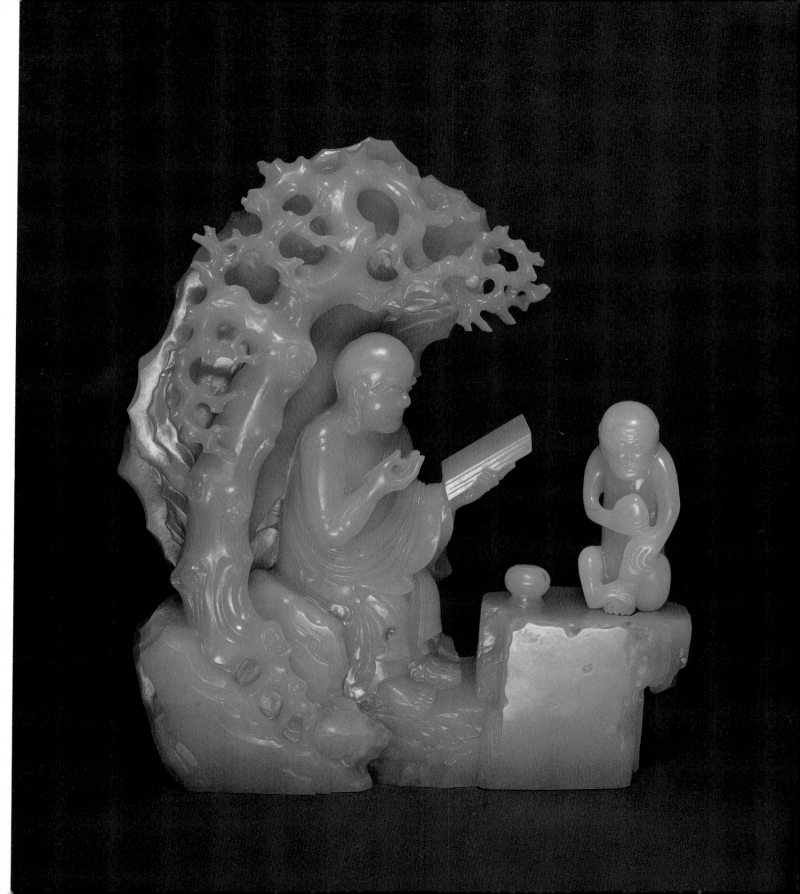

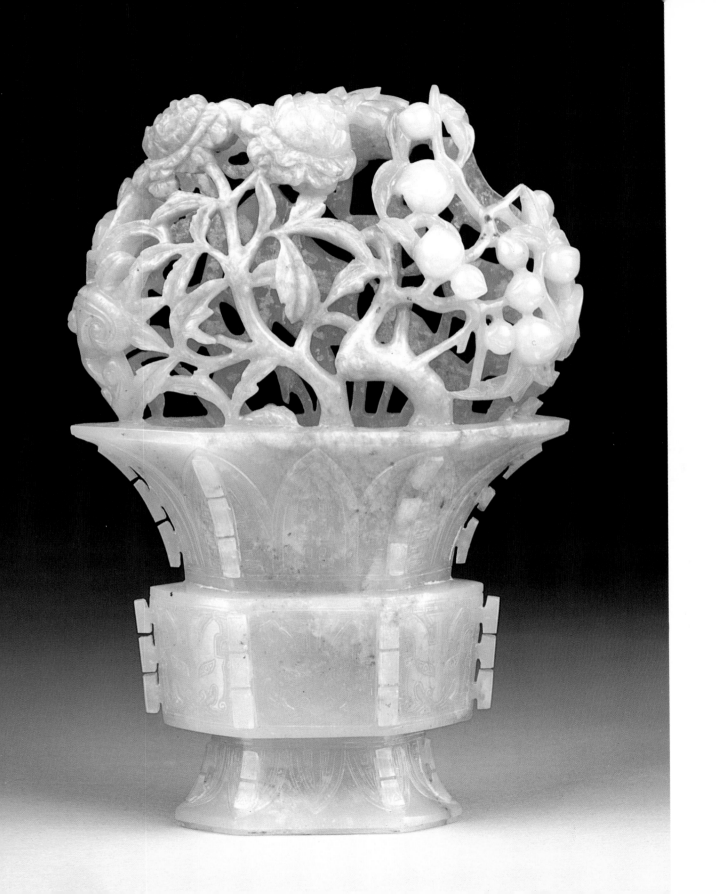

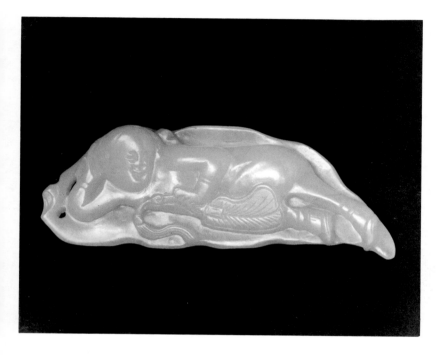

## 105. Recumbent Courtesan

*Grayish white jade*
*Late Ming–early Ch'ing*
*Height: 13mm; Length: 34mm;*
*Width: 10mm*
*Guan-fu Collection*

A nude female figure reclines on one elbow. She wears slippers, an elaborate coif, and bracelets on both wrists, and holds a fan with a tassel in her hand. She is represented in front-facing profile, resting on a pointed leaf whose veins are incised on the rear of the carving.

This figure is most expressive of the fin de siècle ethos of the late Chia-ching to Wan-li eras of the Ming period. Erotic art of the late Ming carried into the early Ch'ing period and gradually disappeared underground.

132.   Vase with Flowers

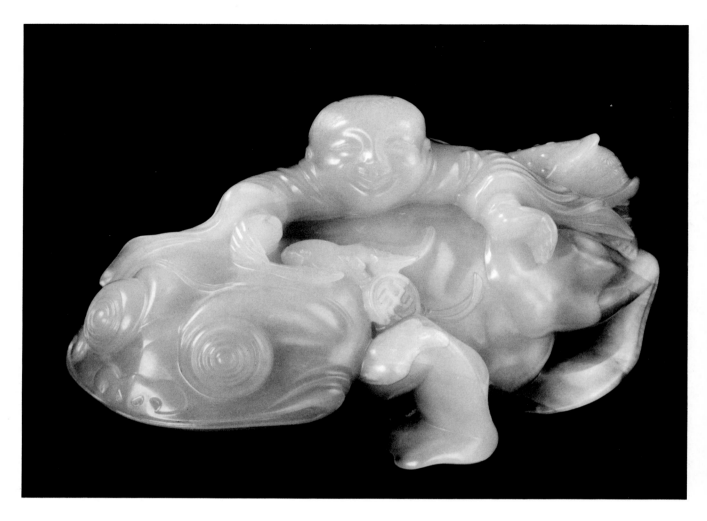

## 106. Liu Hai and Toad

*Grayish white jade*
*Late Ming–early Ch'ing*
*Height: 68mm; Length: 122mm;*
*Width: 69mm*
*Victor Shaw*

A large three-legged toad sits on its haunches, its head and jaw aggressively thrust forward, its eyes large and protruding. A youthful figure lies on the toad's back with outstretched cupped hands as if to catch a bat that has a ribbon with a "cash" attached in its mouth. The boy is dressed in long flowing robes and brocade trousers.

It is difficult to sort out fact from fiction in the legend of Liu Hai and his toad (*ch'an*). In the first place, it is unclear whether there ever existed a historical figure by the name of Liu Hai or whether the whole episode was invented as a play on words using the name of Liu Hai-ch'an (properly named Liu Hsüan-ying, Hai-ch'an being his *hao*), the Taoist priest who founded the Southern School of Taoism in the tenth century. One of two local gazeteers of the Feng-hsiang district (quoted in TSCC) did record the existence of a certain Liu Hai who "called the toads from the well," like the pied piper. However, Feng-hsiang is exactly the district where Liu Hai-ch'an was active according to other records. In any case by the second

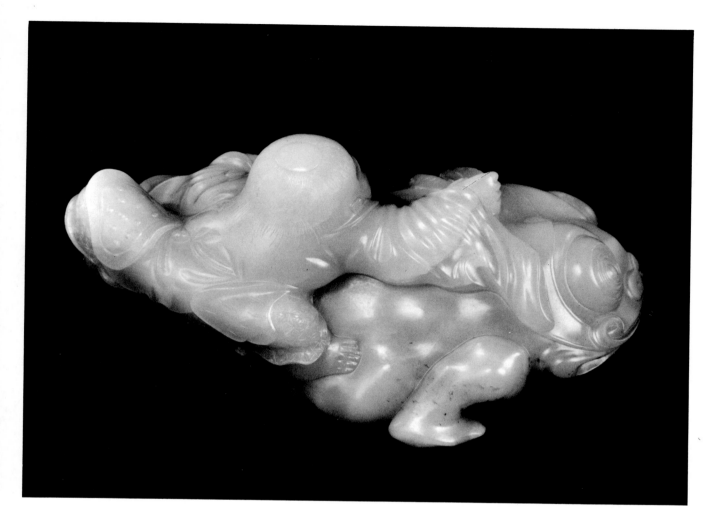

half of the sixteenth century, the figure of Liu Hai and his three-legged toad was one of the most common motifs in the art of popular Taoism. There is even a painting of Liu Hai and his toad in the Palace Museum collection attributed to the Ming painter Chou Ch'en and painted in the style of his figure paintings. However, the iconography for "Liu Hai and Toad" may be traced to an earlier period. There are a pair of paintings by Yen Hui of the Yüan period in the Chion-ji, Kyoto, which is traditionally given the title *Li T'ieh-kuai and Toad*, and the three-legged toad is portrayed as sporting on the back of a youthful figure of a Taoist immortal who is sometimes called Hsia-ma, or toad (see Tokyo National Museum, *Chinese Paintings of the Yüan Dynasty*, no.

50). Later representations of Liu Hai closely followed this figure.

By the end of the Ming period, Liu Hai was given a string of cash, possibly because of the corruption of the term "golden toad" to "copper cash" (*chin ch'an* to *chin ch'ien*). He was also sometimes confused with one of the so-called *ho-ho* fairies that derived from the images of the Ch'an Buddhist monks Han-shan and Shih-te (for Yüan paintings of Han-shan and Shih-te, see *Chinese Paintings of the Yüan Dynasty*, no. 51).

Carvings in jade of Liu Hai and his toad, of which the present piece is an excellent example, abounded in the late Ming and early Ch'ing periods. The piece is also unusual for its size.

# The Scholar's Desk

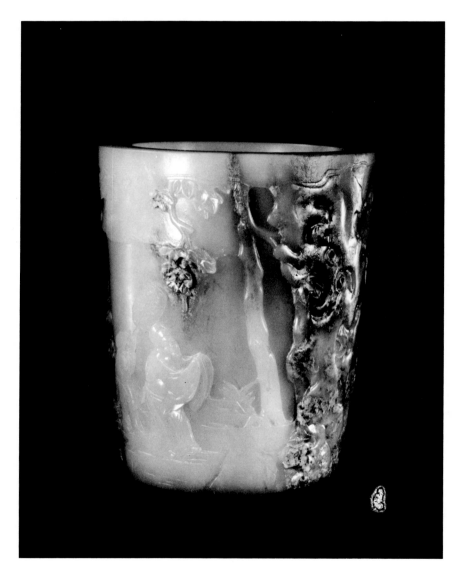

## 107. Brush Holder

*Greenish white jade with brown markings*
*Late Ming (first half 17th century A.D.)*
*Height: 123mm; Diameter (outer): 105mm; Diameter (inner): 83mm*
*Ch'eng Chai Collection*

A brush holder in the form of an inverted truncated cone is decorated in high relief. A circular depression in the base is inscribed with four characters, *Ch'eng-chai chen-wan.* The central subject of the decoration is Mi Fu worshiping a large T'ai-hu-type rock of an interesting shape. In the background between him and the rock is a *wu-t'ung* tree. Behind him stands a boy holding a ceremonial fan. Beyond the large rock is a plantain plant and a boy walking away from it on a rocky ground toward bamboo plants and another rock. In the upper part of the landscape are indications of swirling clouds. Both rocks are carved on the brown patches of the jade.

The whole concept of this decoration and each and every element in it, not least the swirling clouds, suggest the late Ming to the Ming-Ch'ing transitional period. Five centuries after his death, Mi Fu's reputation rose higher than ever. The late Ming literati admired his eccentric elegance and shared his love for unusual forms, especially in stones. These two aspects of his personality are best expressed in an episode of his life when he made a formal obeisance to a particularly strange and beautiful rock, and he is usually depicted in this act by decorative artists of the late Ming period.

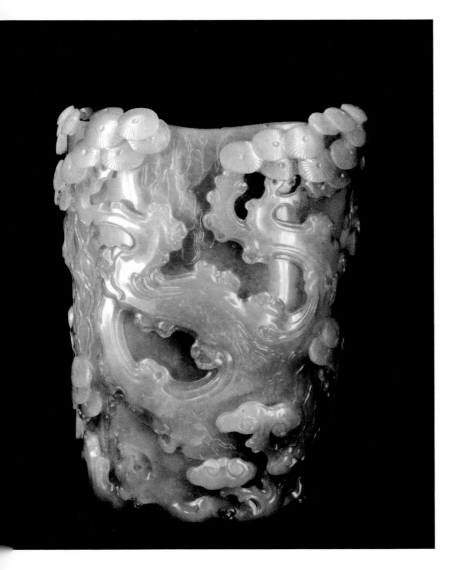

## 108. Brush Holder

*Pale green jade*
*Early Ch'ing (late 17th century A.D.)*
*Height: 178mm; Length: 133mm;*
*  Width: 109mm*
*Fogg Art Museum, Harvard University;*
*  gift of Ernest B. and Helen P. Dane*

A brush holder, of deep form, has slightly flared, irregular sides, almost rectangular in section. It is decorated with stylized pine trees whose gnarled branches bear small, umbrella-shaped clusters of needles in scattered bunches. *Ling-chih* fungi encircle the base.

The treatment of pine trees on the outer wall of this brush holder is familiar to students of Chinese bamboo carving as being typical of the Anhui school of bamboo carving in the late Ming and early Ch'ing periods. Perhaps the jade carver in this case was influenced by contemporary carvings in bamboo. Another piece carved in very similar style and with exactly the same subject, also in irregular section, is in the Nanking Museum (Kiangsu Provincial Museum). The Nanking piece bears the inscribed "signature" of Lu Tzu-kang, the most famous jade carver of all time, who lived in the Chia-ching to Wan-li reigns of the Ming period (see Introduction), and it was recovered in recent years as part of a supposed late Ming hoard. Whereas the date of the Nanking piece may be earlier than the Fogg Museum piece, the latter is incomparable in its workmanship and must be rated as one of the finest examples of jade carving of its kind.

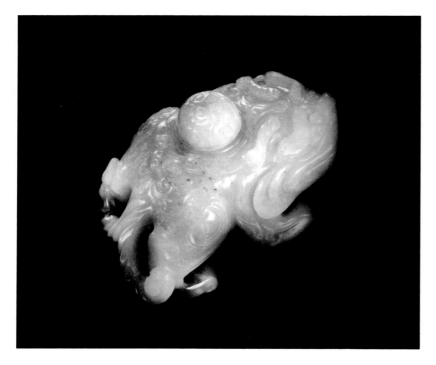

## 109. Water Pot in the Form of a Pi-hsieh

*Grayish white jade with brown markings
and calcification
Ming (15th–16th centuries A.D.)
Height: 53mm; Length: 92mm;
Width: 63mm
Ch'eng Chai Collection*

A water pot has been shaped in the form of a fanged crouching feline (see entry no. 11). Large striated eyebrows curve back toward the shoulders; the two on the right side are elaborately carved with a pointed-nose dragon motif with a scrolled body. Fine hatching on the edges of the legs resembling fur comes down to well-delineated paws and claws. The same dragon motif is found also on the left hindquarter. The bifurcated tail curls up in serrated ridges ending in C scrolls on either rump. Central to the feline's back, at the rear of the hollowed container, is a square-snouted *ch'ih*-dragon's head with a flamelike branch issuing from its mouth. The mushroomlike top of the combination dropper-stopper has a central perforation and is connected to a tunneled tube that extends into the hollowed container.

Water pots of this type are mentioned in every notebook by late Ming scholars, and archaeological finds from Ming tombs in the provinces of Kiangsu and Chekiang in recent years confirm the popularity of this form of water pot at the time. Although they are seldom published, one such example from a Ming tomb, very similar to this piece, was on display in December 1978 in the Provincial Museum of Chekiang in Hang-chou.

This piece is a good example of Ming archaism. The ubiquitous appearance of the *ch'ih*-dragon, whether in profile (as on the haunches of the *pi-hsieh*) or full-face (as in the center of the animal's back), is characteristic.

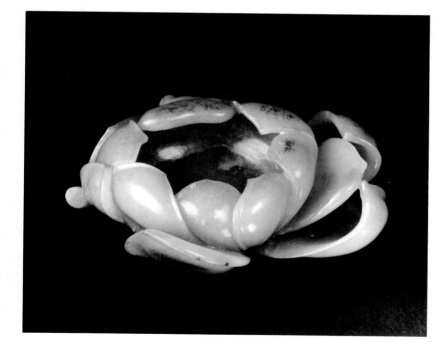

## 110. Water-Container in the Form of a Lotus

*Grayish green jade with iron-rust*
*   markings*
*Ming (probably 15th century A.D.)*
*Height: 31mm; Length: 92mm;*
*   Width: 66mm*
*Dr. and Mrs. Cheng Te-k'un*
*Published: Rawson and Ayers,* Chinese
*   Jade, no. 354; Cheng Te-k'un,* Jade
*   Flowers, p. 251.*

This piece is in the shape of a lotus flower and stem; the sepals and petals enclosing a hollowed receptacle.

The naturalism combined with detailed modeling could have been achieved only by a Ming carver. Another characteristic of Ming carving of this kind is that the leaves and petals are comparatively thick, giving the carving a quality of robustness.

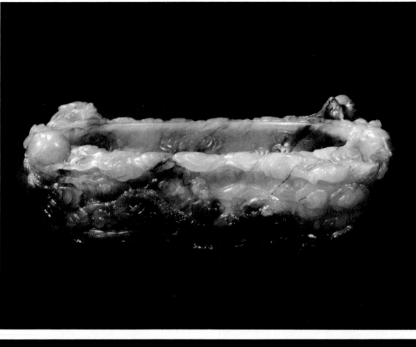

## 111. Brush Washer

*Green jade with reddish brown markings*
*Ming (15th century A.D.)*
*Height: 58mm; Length: 160mm;*
*    Width: 123mm*
*Hong Kong Museum of Art, Urban*
*    Council, Hong Kong*
*Published: Wills,* Jade of the East,
*    p. 106.*

A more or less rectangular basin has on the outer wall deeply carved cloud formations and three dragons whose heads appear over three of the corners; the remaining corner is occupied by a flaming pearl. The inside is more oval in shape and is decorated with incised cloud forms, the lines following the natural cleavages so as to disguise them. The base is a scene of churning waves and breakers, in parts slightly calcified.

This is a magnificent example of an early Ming jade vessel. The design is energetic and the carving refined. Stylistically, this piece belongs to the family that traces its ancestry to the fabulous large "black jade" wine bowl in the Round Fort in Peking (see Introduction). The large black jade wine container is also decorated with dragons among clouds and waves, as far as one can tell from descriptions and photographs. Individual elements of the design such as the incised clouds on the inside walls and the dragons on the outside walls are consistent with a fifteenth-century dating and the treatment of the waves on the base reminds one of the wave borders of early blue-and-white porcelain dishes. There is little doubt that this piece occupies a venerable place, in terms of both age and workmanship, in its class of jade carvings. Later versions of this washer, usually of the eighteenth century, are much less attractive on account of the stiffness and formalization of the design.

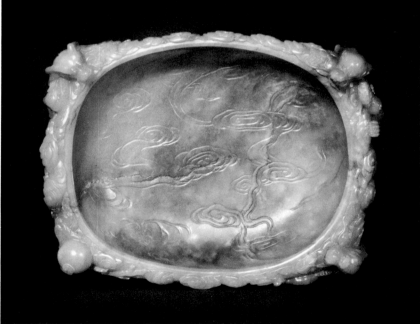

interior

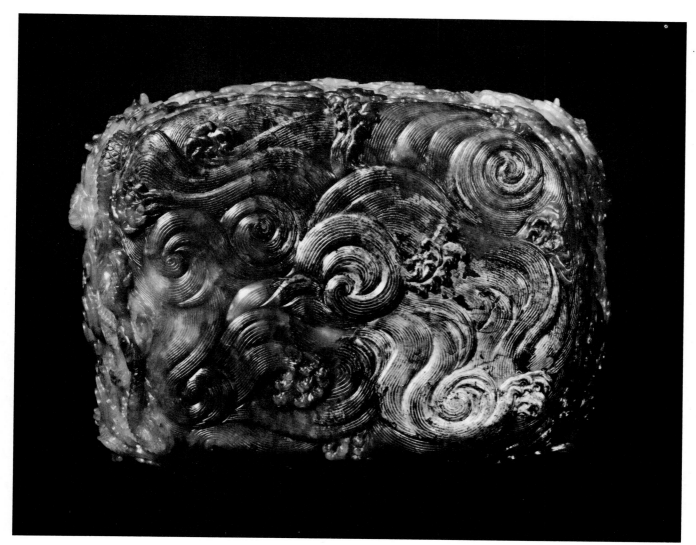

base

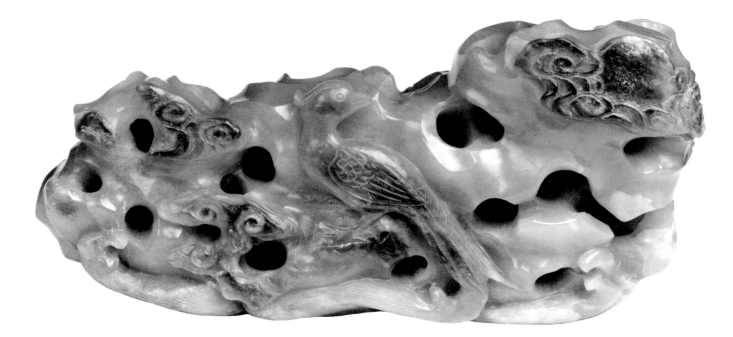

## 112. Brush-Rest

*Green jade with iron-rust markings*
*Late Ming (first half of 17th*
  *century A.D.)*
*Height: 68mm; Length: 142mm;*
  *Width: 54mm*
*Guan-fu Collection*

A rocky landscape with the motif of "phoenix facing the sun" has been carved from a boulder using extensive tubular drills. The pheasant-like bird, sun with clouds, and fungus are all carved from the brown skin of the boulder. The base is carved in the form of a whirlpool with breakers coming up on the sides.

The representation of the phoenix and sun is very much in the style of late Ming woodblock prints. The treatment of the whirlpool is also consistent with a late Ming date.

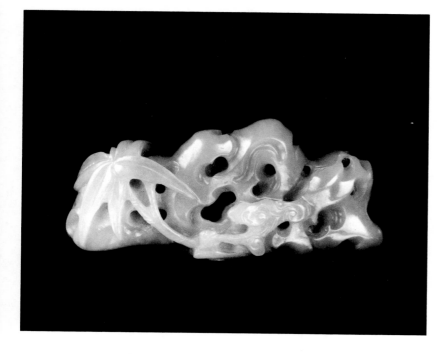

## 113. Brush-Rest

*White jade*
*Late Ming–early Ch'ing*
*Height: 38mm; Length: 82mm;*
    *Width: 18mm*
*T'ing-sung Shu-wu Collection*

This piece is carved with drilled holes to represent a rock with narcissus, bamboo, and fungus.

Rocks constitute an important part of the Chinese garden and the art of building up rockeries was highly developed in the seventeenth century. This piece and no. 112 reflect the great love for rock forms among scholars of this period that is epitomized in the image of Mi Fu worshiping a rock (no. 107).

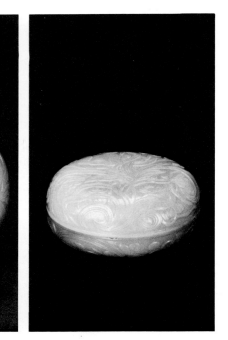

rubbing of top and bottom

## 114. Covered Box

*White jade*
*Ming (probably* A.D. *1561)*
*Height: 21mm; Diameter: 45mm*
*Bei Shan Tang Collection*
*Published: Rawson and Ayers,* Chinese
Jade, *no. 386.*

This covered box is carved all over with a design of sprays of flowering narcissus. The center of the base is incised in seal script with the inscription: made by Lu Tzu-kang in the *hsin-yu* year of Chia-ching (A.D. 1561).

Of the thousands of jade carvings which bear a Lu Tzu-kang signature, this one deserves to be considered most seriously as one of the very few pieces that might have come from the hand of the master. The seal script, which is mostly correct and partly invented, is typical of the Ming period. The design is artistically excellent and the execution has been extremely well carried out but with relatively primitive tools; thus it is technically not comparable to the many supposed Tzu-kang pieces made in the second half of the seventeenth century (Ming–Ch'ing transition to K'ang-hsi). Lu Tzu-kang was reputed to be a good painter and was particularly famous for his rendering of narcissus in jade carvings.

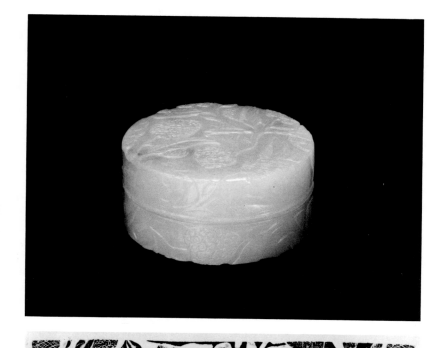

## 115. Covered Box

*Light green jade*
*Ming (16th century A.D.)*
*Height: 28mm; Diameter: 58mm*
*Chih-jou Chai Collection*

The flat sides of this cylindrical box are decorated in low relief with lichees and leaves. The lichee fruits are decorated with brocade patterns; only one of the fruits on the side is given its proper skin.

Similar covered boxes in carved lacquer are common in the sixteenth century. A lacquer box in the collection of the late King Gustav VI Adolf of Sweden is a good example (see Gyllensvard and Pope, *Chinese Art*, no. 125).

rubbing of top, bottom, and sides

## 116. Two Boxes for Seal Vermilion

*Green and amber jadeite*
*Ch'ing, Ch'ien-lung period*
*Height: 23mm; Diameter: 45mm*
*Dr. and Mrs. Cheng Te-k'un*
*Published: Rawson and Ayers,* Chinese
    Jade, *no. 458.*

Two circular boxes, with rounded sides and slightly domed tops, are each engraved with twenty characters in four lines, the green box in gilt, the amber box in bright green. The eight lines of five characters each on the two boxes comprise the opening lines of a well-known poem, "On Drinking Alone" by the T'ang poet Li Po. On both bases are the four-character reign-marks of Ch'ien-lung (1736–1795).

Seal boxes from the Ch'ien-lung period onward have slightly domed tops, as opposed to the flattened tops of early periods. The style of the inscription and the marks are standard for Ch'ien-lung pieces.

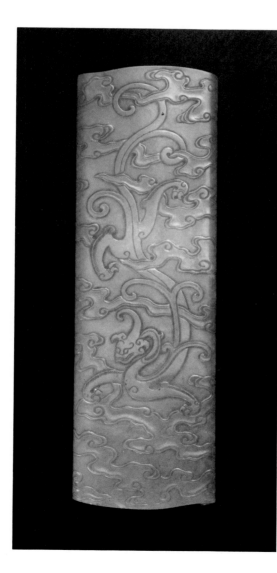

## 117. Armrest or Ink-Bed

*White jade*
*Early Ch'ing (late 17th–early 18th*
*centuries A.D.)*
*Length: 169mm; Width: 53mm*
*Asian Art Museum of San Francisco,*
*The Avery Brundage Collection*

A flat armrest or ink-bed (for the ink slab while its end is still wet after grinding) has wavy ends and sides curving into a scroll underneath. The upper surface is decorated with relief carving of a *ch'ih*-dragon among clouds, and the flat underside is inscribed with two lines of seven characters each in seal script. The two lines comprise an adulatory couplet on a royal presence and the fragrance of the imperial ink, indicating perhaps that this object might have been used as an ink-bed although the shape is that of an armrest.

There is a similar piece in the Nanking Museum with a floral decoration on the upper surface and also a seven-character couplet incised on the back. The calligraphy, in clerical script, is signed by Wan Shou-ch'i (A.D. 1603–1652) and the carving is signed Lu Tzu-kang. As Wan Shou-ch'i was more than sixty years younger than Lu Tzu-kang, it is highly unlikely that Lu would have done the carving for an inscription by Wan. It is far more probable that the Nanking Museum piece was carved in the K'ang-hsi period, when the reputations of both Wan and Lu were very high. The San Francisco piece can be stylistically dated to the same period.

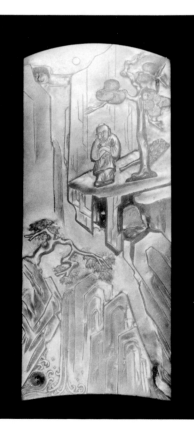

rubbing of reverse

## 118. Armrest or Ink-Bed

*White jade*
*Ch'ing (18th century* A.D.)
*Length: 132mm; Width: 59mm;*
  *Thickness: 7mm*
*Quincy Chuang, Esq.*

This nearly rectangular piece has curved upper and lower ends. The upper surface is decorated with a figure of a woodcutter standing under a pine tree by a precipice near a waterfall. The reverse is carved with bamboos, a rock, and a four-character seal.

The treatment of the slightly incoherent landscape is typical of the eighteenth century, the depiction of the rock and water being highly mannered and the figure occupying less of the pictorial space than it would have in an earlier period.

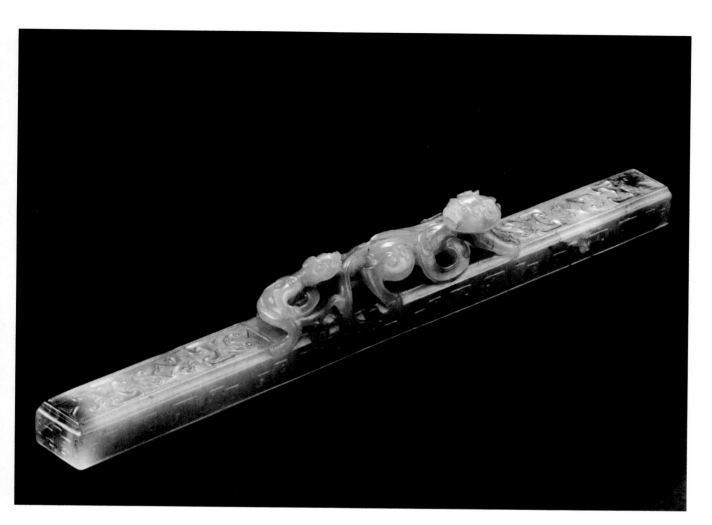

### 119. Paperweight with Carved Dragons

*White jade with brown markings*
*Ming*
*Height: 37mm; Length: 240mm;*
   *Width: 36mm*
*Charlotte Horstmann*

The formalized *ch'ih*-dragon is rampant, paws and elongated claws grasping the edges, the front joints emerging out of the shoulders as scrolls. The legs have hatching for fur; long ribbons (a mane?) bifurcate into two curved ends and inverted C scrolls. Head reversed, jaw open, a horn with curved striations down its back, the dragon looks toward a small *ch'ih,* whose head rests on the large dragon's long bifurcated tail. The rest of the upper surface is decorated with an archaistic pattern of *ju-i* scrolls and cross-hatched diamonds. The sides have a series of joined key-patterns.

This form of paperweight occurred as early as the Sung period.[1] Bronze equivalents to the present piece were found in a Yüan context in Inner Mongolia.[2] Similar paperweights in wood and jade are in the Shanghai Museum, having been excavated from Ming tombs.

1. A pair of ruler-shaped bronze paperweights with button knobs were found in the tomb of Chang T'ung-chih of the Southern Sung period and reported by the Nanking City Museum in *Wen Wu* 1973.4, pp. 59–65 and p. 55.

2. Nei-meng-ku Tzu-chih-ch'ü Wen-wu-kung-tso-tui, *Nei-meng-ku Ch'u-t'u Wen-wu Hsüan-chi,* p. 124.

figs. a, b.    Group of white jades inscribed with various texts and
               Northern Sung dates. The British Museum.

# A Group of Inscribed Jades: Nos. 120–123

Nos. 120 to 123 represent a very special group of objects of the purest translucent white jade, impeccably worked and delicately inscribed all over with well-known texts in minute characters cut in the *shuang-kou* (outline) style in hair-fine lines. The most common inscribed texts are the *Hṛdaya* or Heart Sutra (see entry no. 120), the *Miscellaneous Poems* by T'ao Ch'ien (see no. 121) and *Nineteen Ancient Poems* (see no. 122). The inscriptions also give the place of manufacture as the Jade Workshop of the Office of Hsiu-nei-ssu and a date in the Cheng-ho (A.D. 1111–1118) or Hsüan-ho (1119–1125) eras of the reign of Emperor Hui-tsung of the Northern Sung dynasty. There is a set of eight of these pieces in the British Museum (figs. a and b) that came in a box with a Ch'ien-lung inscription (Palmer, *Jade,* no. 16). One in the Palace Museum in Peking is in the form of an octagonal bead identical to one of the British Museum pieces. A ring, again similar to one in the British Museum set, is in a private collection in Hong Kong. A long scepter *(kuei),* similar but not identical to one in the British Museum, is in the collection of the Cleveland Museum of Art; and two pieces, a bracelet and a bell pendant, are in the collection of the Art Institute of Chicago. The bell pendant is similar but not identical to one in the British Museum.

So far there has been no firm attribution of dates to any of these pieces except for the one in Peking, which has been accepted as a "standard piece of Sung jade carving" (Yang Po-ta, "On Sculptural Art in the Exhibition,"). However, there are certain difficulties in accepting these pieces as being of the period of the inscribed dates.

The first problem is connected with the supposed workshop. According to official records of the Sung period, the Hsiu-nei-ssu was a section in the Department of Constructions, the Chiang-tso-chien, whose chief function was to construct and maintain royal ancestral halls, palace buildings, and walls. It was also known to have produced its own building materials such as bricks and tiles. In late Southern Sung and Yüan times several writers recorded that the Hsiu-nei-ssu also produced fine objects of precious materials for palace use, such as *mo-hou-lo* for the festival of the Seventh Night (see entry no. 94). One thirteenth-century writer, Yeh Chih, even asserted that in early Southern Sung times the Hsiu-nei-ssu supervised the production of the "official porcelain ware," *kuan-yao,* in Hang-chou.[1] It is quite possible that the reputation of the Hsiu-nei-ssu in late Sung times (and surviving into the Yüan) rather exceeded its actual achievements in making fine objects for palace use. It is also possible that the anecdotal records of wonderful objects made by the Hsiu-nei-ssu workshops—which the writers themselves never saw—inspired jade carvers to try their hand at making objects that might have been the work of the Hsiu-nei-ssu. In this connection one might mention that the cyclopaedia *Yü Hai,* compiled by Wang Ying-lin in the early part of the twelfth century, mentions only the Wen-ssu-yüan, a section of the Shao-fu-chien, as the workshop for the carving of jades for imperial use,[2] and this agrees with the record of the function of Wen-ssu-yüan in official historical writings such as the *Sung Shih* and *Sung Hui-yao.*[3]

Second, the choice of the texts is highly unusual for inscriptions on jades for imperial use. The Heart Sutra, a Buddhist scripture, does not seem a very suitable text for inscription on a piece made for the occasion of the birthday of Hui-tsung (no. 123), who was a confirmed Taoist. The sentiments of the *Nineteen Ancient Poems* and T'ao Ch'ien's poems are also too melancholic and eremitic for inscribing on objects of this kind.

Third, in the inscription on the Cleveland scepter, the *Miscellaneous Poems* by T'ao Ch'ien, the word *hsüan* (black) in the line "(my) black hair has long ago turned white" is in its original form, whereas in the Sung period, especially in the Northern Sung, it would probably have been changed to a homophonic character or written with one stroke less so as to conform to the practice of *pi-hui,* or avoiding the use of characters that are part of the personal names of royal personages. This practice would have been strictly adhered to in an inscription executed in the palace workshop, for slips might lead to dire consequences. The character *hsüan* forms part of the name of one of the ancestors

of the Sung royal family, and Hui-tsung him-self meticulously avoided writing this charac-ter in its original form in his own calligraphy.[4] However, the character *hsüan* was not always avoided in the Southern Sung period. In the early Southern Sung edition of the collected works of T'ao Ch'ien printed by Tseng Chi in A.D. 1132,[5] the character *hsüan* in this poem and elsewhere in the book appears unchanged whereas other characters connected with the personal names of all the Sung emperors were avoided. The first emperor of the Southern Sung, Kao-tsung, did not avoid this character in his own calligraphy.

On the other hand, in the inscription of the *Nineteen Ancient Poems* on the Chicago bracelet the character *hsüan* in *hsüan-liao* (black bird) is changed to *yüan* (the character *hsüan* was also pronounced *yüan*). Interestingly enough, in the Southern Sung edition of Hsiao T'ung's *Wen Hsüan,* printed by Yu Mao in 1181, the character *hsüan* is avoided by omitting the final stroke. Thus we have a parallel in both the inscriptions and Southern Sung texts of avoidance and nonavoidance of royal names. The inference from the evidence of the books is that the character *hsüan* was not strictly avoided in the Southern Sung period even if Hui-tsung, late in the Northern Sung period, made a point of avoiding it.

The matter is further complicated by the fact that the character *hsüan* is also part of the personal name of the Emperor K'ang-hsi of the Ch'ing dynasty, and this character was assidu-ously avoided in all writings and publications of the eighteenth century. The avoidance of this character in the Chicago inscription could thus be used as an argument in favor of an eigh-teenth-century date for the piece, but then this leaves the question of the nonavoidance of the same character in the Cleveland inscription unanswered.

Other forms of textual analysis of these in-scriptions present even greater difficulties, for there must be hundreds of editions of the Heart Sutra and the various well-known poems printed throughout the ages. It would be vir-tually impossible to locate the actual editions from which these texts were copied, if indeed they were copied from printed books. Suffice it to say that all the variant readings in the inscribed texts would have occurred by the Sung period.

Leaving aside textual and calligraphic consid-erations, the jade itself is of a quality that is seldom found in the eighteenth century or the entire Ch'ing period for that matter. The white jades of the eighteenth century are nearly always opaque, or translucent with opaque fibrous veins, whereas white jades of earlier periods, especially from the Sung to the Ming (e.g., no. 82) often are uniformly translucent as are these inscribed pieces. White jades were by no means uncommon in the Sung period. A cursory search through the *Sung Hui-yao* re-veals numerous records of tributes of jade (and abrasives), often specified as white jade, in the Northern Sung period. The *Chin Shih* (History of the Chin) records the capture of white jade ceremonial objects from the sacking of the Northern Sung capital Pien-ching (modern K'ai-feng). Some of these were used in Chin court ceremonies (T'o T'o, *Chin Shih,* pp. 763–765).

At present the shapes of the jades also offer very little clue to the dating, for comparatively few post-Han jades have been published with illustrations in Chinese archaeological jour-nals. Judging from the published material, it would seem that the standard *kuei* (scepter) shape with the triangular apex, as exemplified by the smallest of the British Museum *kuei*, were most prevalent in the Yüan to Ming periods.[6] The most interesting shape is that of the knife-coin piece in the British Museum.

The origin of this shape may well be traced to a confusion in reading classical texts on Chou rites in which the term *yü-pi,* jade ceremonial objects (or presents), often occurs. The word *pi*, however, has another meaning of currency or coinage and this may have given rise to a jade piece in the shape of an ancient coin. The eleventh-century scientist Shen Kua was most critical of illustrated books on rites in common use in his time that were full of such invented shapes (see Hsia Nai, "Shen Kua and Archae-ology"). The bell pendants are another curios-ity that might have a similar origin. The rings, with the convex sides, are also uncommon. In the Ch'ing period it is likely that the rings would have been made in the shape of the perfectly cylindrical thumb-ring.

Although no firm conclusion can be drawn from the above considerations, one can nevertheless put forth several hypotheses in order of probability. The first possibility is that these pieces were carved during the time of the late Chin–Southern Sung or Yüan periods when the (perhaps undeserved) reputation of the Hsiu-nei-ssu was high and the era of Hsüan-ho was seen in the popular imagination as an age of elegance and refinement, or at least as an age of extravagant and reckless living which, though it was morally to be condemned, was not without attraction to the romantically minded. Notebook writers of the Southern Sung period, in their nostalgia for the old times, tended to attribute the finest white jade pieces to the Hsüan-ho palace.[7] This nostalgia is not confined to the Southern Sung era. In the north, many treasures of the Chin royal collection were reputed to be from the Northern Sung palace and from the reign of Hui-tsung. A curious find from a tomb of the Chin period in Peking, which produced numerous pieces of white jades, is a piece shaped like a copper coin and inscribed with the date of Cheng-ho (*Wen Wu* 1977.6, pp. 79–90). This is as good a proof as any of the high esteem in which the reign of Hui-tsung was held as far as the production of precious objects was concerned, it being highly unlikely that the piece could have been actually made in the era of Cheng-ho. This piece, of course, has a bearing on the inscribed white jade pieces in this exhibition. Finally, it may be noted that the relative confusion in the avoidance of royal names in the inscriptions is not out of keeping with a thirteenth–fourteenth century date for these pieces.

Then there is the possibility of a Ming carver, perhaps not too late in the period, who copied the T'ao Ch'ien poems from a contemporary edition and the *Nineteen Ancient Poems* from a Sung edition.

An eighteenth-century date is by no means out of the question, but the quality of the jades and their shapes are not typical of this period. Also the nonavoidance of one of the *hsüan* characters is more difficult to explain in an eighteenth-century piece, for the practice of *pi-hui* was vigorously enforced from the K'ang-hsi era.

1. Yeh Chih, "T'an-chai Pi-heng," collected in T'ao Tsung-i's *Shuo Fu, chüan* 18. This incidental note by a late Sung writer has led students of Chinese ceramics on a wild goose chase since the 1930s for the location of the Hsiu-nei-ssu kilns and for the identification of the ware. However, Chinese scholars in recent years are beginning to cast doubt on the existence of the Hsiu-nei-ssu official ware; see Ching-te Chen T'ao-tz'u Yen-chiu-so, *Chung-kuo ti Tz'u-ch'i* (Chinese Porcelain), pp. 140–142. In December 1978 the present author was informed by archaeologists of the Provincial Museum of Chekiang that no kiln has been found in the Hang-chou area that could possibly be identified as that of the Hsiu-nei-ssu.

2. *Yü Hai, chüan* 87, recorded several instances in the Northern Sung and early Southern Sung periods of orders for jade carvings from the Wen-ssu-yüan.

3. T'o T'o, *Sung Shih, chüan* 165, pp. 3917–3919; Hsü Sung, *Sung Hui-yao Chi-kao,* vol. 75, p. 2988.

4. As in the copies of the *Chien-tzu-wen,* the Thousand Character Essay, by Hui-tsung in regular script of his own style and in cursive script, both reproduced many times in recent years. The former is in the Shanghai Museum, the latter in the Liaoning Provincial Museum.

5. Reprinted by Huang Pao-hsi, Hong Kong, 1970.

6. A white jade *kuei* was found in the tomb of Chang Shih-ch'eng's mother, who died in 1365; see *K'ao-ku* 1965.6, pl. 5. Examples from Ming royal tombs are reported in *K'ao-ku* 1965.5, p. 319, fig. 1.1; *K'ao-ku* 1959.7, p. 365, fig. 4; and *Wen Wu* 1973.3, p. 37, fig. 8.

7. Among a number of such stories is one collected in P'an Yung-yin, *Sung Pai Lei-ch'ao.*

### 120. Ring

*White jade*
*13th century* A.D. *or later*
*Height: 28mm; Diameter (outer): 34mm;*
*Diameter (inner): 20mm*
*Anonymous loan*

A large ring with an outer wall curved like that of a drum and a straight inner wall, is covered with an inscription of Hsüan-tsang's translation of the *Hṛdaya* or Heart Sutra in minute *shuang-kou* (outline) characters in fine lines, possibly cut with a diamond point. The inscription also records that it was made by imperial order at the jade workshop of the Hsiu-nei-ssu in the second year of the Hsüan-ho era (A.D. 1120). The identical one in the British Museum is dated in accordance with A.D. 1121.

The shape and size of the ring suggest that it might have been used as a kerchief or scarf ring.

The Heart Sutra, especially the version as translated by Hsüan-tsang in the seventh century, was a favorite with calligraphers, perhaps partly because of its comparatively short length. The T'ang calligrapher Chang Hsü copied this version of the sutra in cursive script and began a tradition of copying it by subsequent calligraphers.

### 121. Kuei

*White jade*
*13th century* A.D. *or later*
*Length: 214mm*
*The Cleveland Museum of Art; Gift of*
*Mrs. John Lyon Collyer in memory of*
*her mother, Mrs. G.M.G. Forman.*
*Published: Riddell,* Dated Chinese
Antiquities, *fig. 141, p. 169.*

This *kuei* (scepter) is of elongated shape with a slanting sharp edge at one end and a circular perforation near the other end flanked by saw-tooth decorations on either side. The area below the perforation is covered with an inscription in minute characters in *shuang-kou* style cut in very fine lines. The text is the *Miscellaneous Poems* by T'ao Ch'ien, the poet of poets, who lived in the second half of the fourth century to the early decades of the fifth century A.D. The inscription also indicates that the piece was made by the jade workshop of the Hsiu-nei-ssu in the twelfth month of the third year of Hsüan-ho, corresponding to early in A.D. 1122.

The appearance of the character *hsüan* makes it highly unlikely that the piece was actually made during the reign of Hui-tsung. However, as observed in the general note to this group of inscribed jades, this does not rule out the possibility of a Southern Sung date.

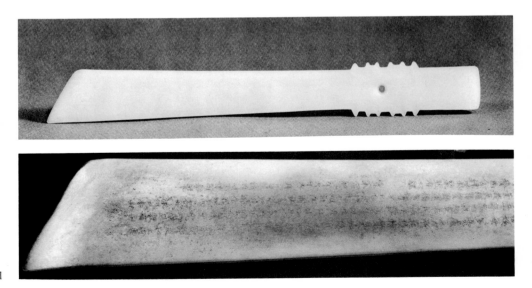

detail

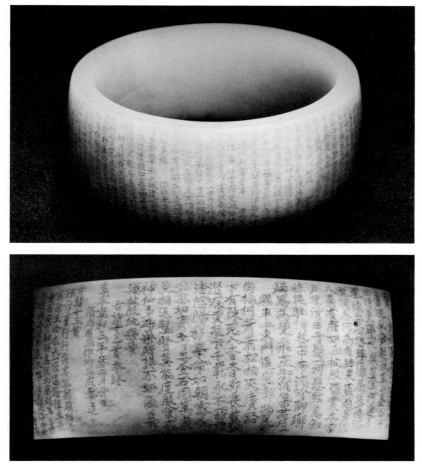

detail

## 122. Bracelet-Shaped Object

*White jade*
*13th century* A.D. *or later*
*Diameter: 75mm*
*The Art Institute of Chicago;*
    *Russell Tyson Collection*
*Published: Riddell,* Dated Chinese
    Antiquities, *fig. 140, p. 168.*

This bracelet-shaped object has a straight inner wall and a slightly convex outer wall inscribed all over with thirteen of the *Nineteen Ancient Poems* in *shuang-kou* style cut in very fine lines. The date given in the inscription is the third year of the era of Hsüan-ho (A.D. 1121) and the carver is given as Wang Ch'eng of the jade workshop of the Hsiu-nei-ssu.

The *Nineteen Ancient Poems,* probably composed in the Eastern Han period, was collected in the anthology *Wen Hsüan* edited by Hsiao T'ung (A.D. 501–531), the eldest son of the Emperor Wu-ti of the Liang dynasty. This group of poems has ever since occupied a special position in early Chinese literature and was a favorite text for calligraphy in subsequent periods, especially in small regular script.

## 123. Bell Pendant

*White jade*
*13th century* A.D. *or later*
*Height: 73mm; Diameter: 45mm*
*The Art Institute of Chicago;*
*Russell Tyson Collection*
*Published: Riddell,* Dated Chinese
Antiquities, *fig. 139, p. 168.*

A bell-shaped object, called a bell pendant, has an inscription which is in the style of nos. 120–122. The text is the Heart Sutra and a short portion of an oath by a monk on his ordination that is translated by a monk called Ming-kuo. The date of the piece is given as the first year of the era of Hsüan-ho (A.D. 1119) on the occasion of the birthday of the emperor, and the workshop is given as the jade workshop of the Hsiu-nei-ssu.

It has not been possible so far to trace the origin of the shorter piece in the inscription, the function of which is to fill up the small space left by the Heart Sutra, or to identify the monk Ming-kuo.

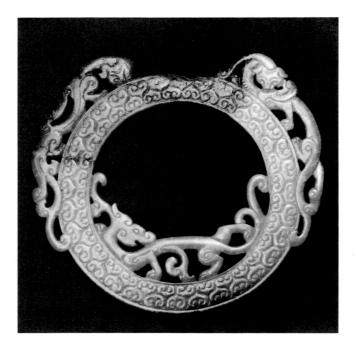

## 124. Openwork Dragon Ring

*Semi-translucent pale green jade with*
*brown markings*
*Sung or later*
*Diameter (outer, excluding dragons):*
*98mm; Diameter (inner): 73mm;*
*Thickness: 6mm*
*Dr. Shing-yiu Yip*
*Published: Li Feng-kung,* Yü Ya, *p. 24.*

Carved in two-sided openwork in archaizing style, this piece is decorated with three dragons, two on the outer circumference and one on the inner, and a relief carved on both sides with a *ju-i*-shaped pattern repeated evenly all around the ring. The two dragons on the outside face each other with large noses and phoenix-like horns. The dragon on the inside turns its head backward to bite at its shoulder,

its crest and tail extending in sweeping curves to span over half the inner circumference.

The archaistic design of this piece, which is modeled after one type of Warring States *pi*, may have its origin in the Sung period as evidenced by the *ju-i*-head pattern. However, the actual work may be that of a later period. Its semi-translucency and reddish brown staining were especially attractive to late Ch'ing collectors.

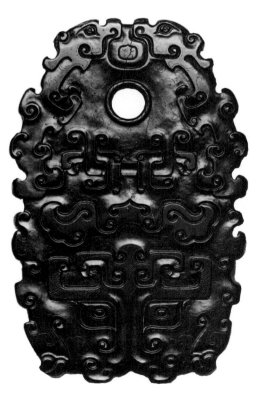

## 125. Axe-Shaped Kuei

*Opaque jet-black jade*
*Probably 18th century* A.D.
*Length: 146mm; Width: 93mm;*
    *Thickness: 8mm*
*Dr. Shing-yiu Yip*
*Published: Li Feng-kung,* Yü Ya, *p. 12.*

The form of this piece is based on an ancient, plain, axe-shaped stone tablet with one relatively large drill-hole near the top. Here it is ornately carved with a fanciful rendition of ancient motifs such as a *t'ao-t'ieh* mask, dragons, and cloud-scrolls. Both sides are identical.

Half a century ago, this archaistic piece was highly regarded in jade-collecting circles in Canton. A piece like this, with its exact workmanship, elaborate ornamentation, and uniform staining to jet black, was probably more attractive to the collectors of the late Ch'ing than were genuine archaic pieces. These late Ch'ing products are nowadays not without interest as the expression of an age of intense antiquarian studies that has created its own artistic style of archaism. This piece is comparable in many ways to certain beautifully stained and elaborately carved pieces in the collection of the Palace Museum, Taipei, that were dated to the Chou period in the old catalogues.

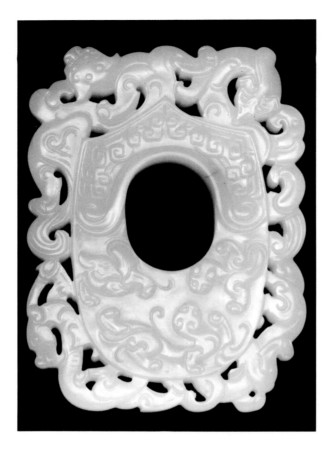

## 126. Perforated Plaque with Dragons in Openwork

*White jade*
*20th century* A.D.
*Length: 84mm; Width: 63mm;*
  *Thickness: 8mm*
*Dr. Shing-yiu Yip*

This plaque is decorated in openwork and relief with seven dragons of varying size and type, and one bird-headed creature, as well as engraved angular standard and reverse C spirals. The surfaces are polished to a subdued glow.

Based on the Han-period shield-shaped *chüeh* (see no. 156), this is an early twentieth-century carving that copies the original archaic design with minimum stylistic innovation. There are a number of such pieces in recent collections, mostly in this milky white jade, and they represent one of the highest technical achievements of the modern jade carver.

Vessels

## 127. Wine Jar

*Pale yellowish green jade*
*Han*
*Height: 120mm; Diameter: 170mm*
*Anonymous loan*

Of nearly cylindrical form, this wine jar has walls slightly tapering inward, and stands on three feet in the form of bears. The outer wall is finely carved and incised with two writhing dragons among clouds, divided by a pair of *p'u-shou* mask handles with loose rings. The dragons are three-clawed and decorated with finely incised markings of circles and parallel lines suggesting fur; all deep cuts are marked by parallel finely incised lines along the edges. The bears are in a kneeling position, some with one foreleg up as if supporting the jar.

Other early wine vessels in jade are known, such as the Winthrop piece in the Fogg Art Museum (Loehr, *Ancient Chinese Jades*, no. 521). The form of this vessel is identical to a well-known type of bronze jar of the Han period that was used for warming and serving wine.[1] Most of these cylindrical jars have bear-shaped supports [2] and lids with three standing birds,[3] and it must be assumed that this piece had a similar lid originally.

The style and technique of carving and the motifs employed are all consistent with a Han date. The *p'u-shou* mask handles are very similar in treatment, even down to the details, to those of the pair of bronze cylindrical wine jars dated in accordance with 26 B.C. and found at Yu-yü,[4] and the technique of bold modeling and fine incising is comparable to that of the large jade *p'u-shou* mask found near the tomb of Emperor Han Wu-ti that was exhibited in Manila, Nagoya, and Hong Kong in 1976–1978 (*Selection of Archaeological Finds,* no. 65).

1. Antiquarians of the Sung period identified these vessels as *lien* (toilet boxes) and they have been so called until recently. Wang Chen-to was the first to identify this type correctly as a wine vessel (see Wang Chen-to, "The Restoration of the *hou-feng ti-tung i* (continued)," *Wen Wu* 1963.4, pp. 1–20.) At about this time a group of wine jars of the Western Han period was discovered at Yu-yü County in Shansi Province. The group included two cylindrical jars with inscriptions giving their weight, function (as "warm wine jar"), place, and year of manufacture (see Kuo Yung, "The Western Han Bronzes Unearthed at Yu-yü County, Shansi Province," *Wen Wu* 1963.11, pp. 4–22, pls. I–IV).

2. Many Han vessels are fitted with bear-shaped feet. According to the *Po-ku T'u, chüan* 20, "The feet are decorated with bears. From the time of the Ts'in and Han, the vessels called *lien* and the knobs of seals were made into such figures. The bear was a good omen for securing male offspring, owing to its symbolical significance of strength and endurance" (translation by B. Laufer in his *Chinese Pottery of the Han Dynasty,* p. 57).

3. As in the Winthrop vessel and in the Yu-yü bronze vessels referred to in note 1. Another bronze cylindrical jar with a similar lid is in the Tenri Museum and was published in the Osaka Municipal Museum catalogue, *Arts of the Han Period,* no. 43.

4. See note 1.

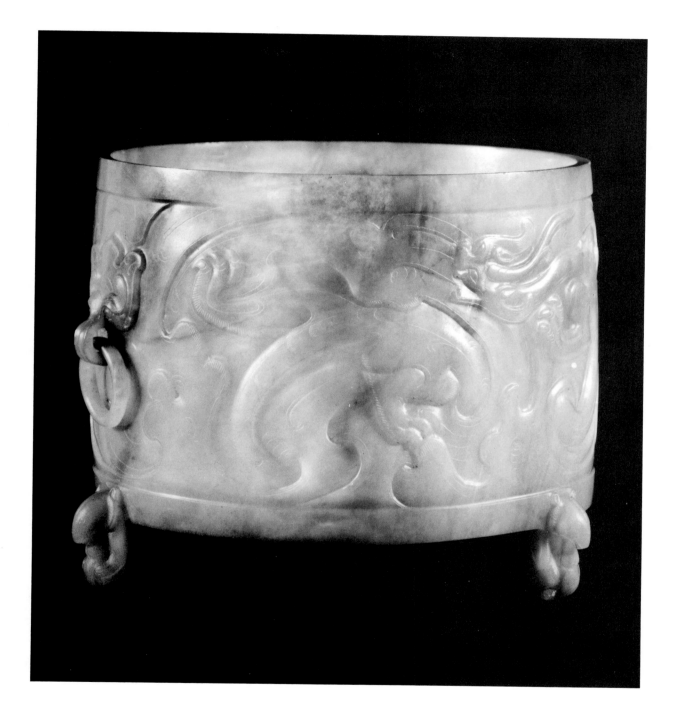

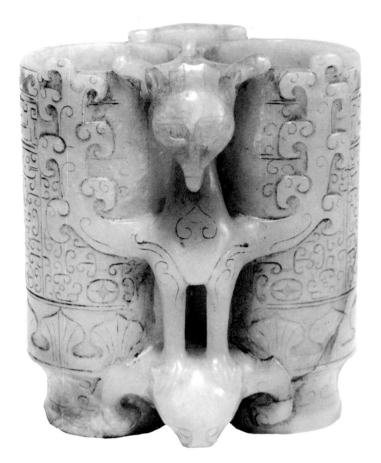

## 128. Champion's Vase

*Grayish white jade*
*Sung (12th–13th centuries A.D.)*
*Height: 90mm; Length: 80mm; Width:*
*79mm*
*The St. Louis Art Museum; purchase,*
*W.K. Bixby Fund*

This vessel is formed of two adjacent cylinders. On one side an animal with one front paw on the base of each cylinder supports a standing bird with its wings spread on the upper part of the cylinders. Ornament carved on the sides consists mainly of standard and reverse C scrolls and a band of petals near the base, each petal decorated with five incised lines fanning out from the vertical.

This vessel is nowadays commonly known as a champion's vase or hero's vase, translations of the Chinese name, which, as previous writers have explained, is a pun on the words *ying*

(falcon) and *hsiung* (bear), the falcon and the bear supposedly being the bird and the animal decorating the side of the vessel. However, the actual examples usually feature a feline rather than a bear, although the bird does possess hawkish aspects because it has to hold a ring in its back. The name of champion's vase is probably not a very old one. There is a Ming record of such a jade vessel and the author calls it a nuptial cup, a designation perhaps even more appropriate if just as fanciful, and dates it to the Han period.[1]

Quite a number of such vessels are known in various public and private collections, and some of them are obviously of considerable age. Those that have been published so far have been assigned dates varying from T'ang to early Ming. Most have been given a date from the late Sung to the fifteenth century.

Whatever the dating of individual specimens, the form of this vessel can be traced to at least the Western Han period. In the tomb of Liu Sheng, Prince Ching of Chung-shan (d. 113 B.C.), excavated in 1968, was a gilt bronze double cup linked by a bird standing on a feline in exactly the same style as that of these champion's vases,[2] except that the cups are chalice-shaped. Cylindrical cups in both pottery and jade dating to Han times are also known.[3] A cylindrical cup with a ring handle in the Palace Museum, Taipei, is not dissimilar in form to the excavated late Han jade cup (which is plain), and the decoration is acceptably Han (see National Palace Museum, *Masterworks of Chinese Jade,* no. 22). It must therefore be given a tentative Han date. The decoration on the cylinders of this piece follows quite closely that of the Taipei piece, except that there are archaistic elements such as the square-snouted dragon (top band of decorative pattern on cylinder), which cannot predate the Sung period. It is interesting to observe that the Taipei cup is also decorated with a band of petals in the lower part that must be the predecessor of the petal band that appears on quite a few later pieces, including this one. This petal band was once thought to be an innovation of the Sung period (Gure, "Jades of the Sung Group," p. 45).

A comparison between the form of the earlier and later cylindrical cups is also instructive. The Han cylindrical cups seem to follow a

156

western Asiatic model whereas the later ones are more strictly cylindrical with a curved-in foot.

A Sung date has been given to this piece on account of archaistic elements in the decoration and the shape of the cylinders, but it is more remarkable for the otherwise accurate representation of genuinely early features. The whole series of these champion's vases provide one of the most fascinating group of jades for study by art historians, for this form must have persisted in a continuous tradition for nearly two thousand years.

See also Rawson and Ayers, *Chinese Jade*, nos. 319–321 and 442; Hansford, *Chinese Carved Jades*, p. 88 and pl. 77; Gure, "Jades of the Sung Group," no. 276; and Gure, "Some Unusual Early Jades," pp. 56–57 and pl. 44.

1. Hu Ying, *Chia-i Sheng-yen*, in *Li-tai Hsiao-shuo Pi-chi Hsüan*, Hong Kong Commercial Press edition, 1959 reprint, Ming vol. I, p. 98.

2. Ch'u-t'u Wen-wu Chan-lan Kung-tso-tsu, *Wen-hua Ta-ko-ming Ch'i-chien Ch'u-t'u Wen-wu* (Cultural Relics Unearthed during the Cultural Revolution), p. 22.

3. For pottery examples, see WWTKTL 1956.6, p. 46, and for a jade example see KKTH 1958.7, p. 53. The former were found in a tomb dated to about the first century A.D. and the latter in a tomb dated to the early third century A.D.

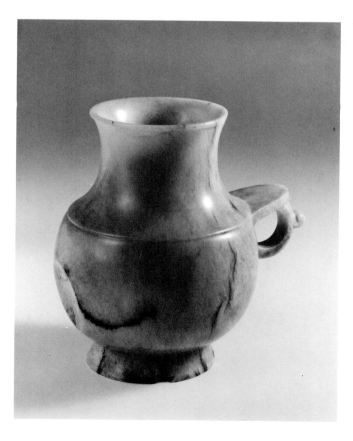

## 129. Cup

*Grayish green jade with brown and black markings*
*Liao (10th–12th centuries A.D.)*
*Height: 112mm; Diameter: 90mm*
*Asian Art Museum of San Francisco,*
    *The Avery Brundage Collection*
*Published: d'Argencé,* Brundage
    Jades, *pl. XXXV, p. 84; Rawson*
    *and Ayers,* Chinese Jade, *no. 273.*

Above splayed foot and full rounded sides, the waisted neck rises from a groove around the shoulder. Below the groove is a knobbed ring handle with a flat thumb-piece.

In the first edition of *Chinese Jades in the Avery Brundage Collection*, d'Argencé compared the form of this piece to metalware of the Sung period. His observation was confirmed several years later when a silver jug of identical shape was discovered in a Liao context in Ao-han Banner in Liaoning Province (see *Wen Wu* 1978.2, p. 117 and pl. IX). In view of the relative abundance of jade articles recovered from Liao and Chin sites in recent years, a Liao date and provenance is now proposed for this piece.

## 130. Dish

*Mottled light green jade with iron-rust*
  *veins*
*Yüan*
*Height: 11mm; Diameter: 106mm*
*Dr. and Mrs. Cheng Te-k'un*
*Published: Cheng Te-k'un,* Jade
  Flowers, *pp. 297–298 and fig. 3a;*
  *Rawson and Ayers,* Chinese Jade,
  *no. 352.*

This flat-based dish takes the form of a six-petaled flower, the interior modeling following the outside shape.

A Yüan date is given to this piece by comparing its form with those of ceramic and lacquer dishes of the Yüan period discussed by Hincheung Lovell in "Sung and Yüan Monochrome Lacquers in the Freer Gallery," pp. 121–130 and figs. 27, 28.

## 131. Bowl with Taoist Designs

*White jade*
*Chin–Yüan (13th–14th centuries* A.D.*)*
*Height: 63mm; Width: 159mm*
*The Cleveland Museum of Art;*
   *anonymous gift*
*Published: Lee, "Chinese Carved Jades,"*
   *pp. 67–68; Lee and Ho,* Chinese
   Art Under the Mongols, *no. 298.*

The rim of this bowl has a cloud collar border outside and a slanting key fret inside; an upright key fret encircles the foot ring. The main decoration is a Taoist procession scene above a cloud formation, all carved in relief. Two female immortals riding on clouds and wearing scarves form the two handles.

As observed by Sherman Lee and Wai-kam Ho, the iconography of the decoration on this cup can be traced to thirteenth-century Taoist art of north China. The pair of immortals serving as handles may well relate to the Liao-Chin tradition of carving "flying figures" in jade as discussed in entry no. 98.

## 132. Vase with Flowers

*Greenish white jade with brown mottling*
*Ming*
*Height: 133mm; Length: 89mm;*
*Width: 35mm*
*B.S. McElney Collection*

This hexagonal *ku* beaker is decorated with animal masks and blade patterns in low relief, and surmounted by an arrangement of peonies, lotus, fungus, peaches, magnolia, bamboo, and prunus carved in openwork. Flanges come out from the corners of the vase.

Flower arrangement probably became popular during the Southern Sung period, as is evident in part from the fact that vases with flowers appeared as a common decorative motif on ceramics of the Southern Sung era,[1] and jade vases are known in the thirteenth century.[2] The art of flower arrangement reached a peak in the late sixteenth century and several "treatises" on flower arrangement written in this period have survived to this day.[3] Most late Ming writers on the subject mention the use of archaic bronzes, especially the *ku* and the *tsun* beakers, as the most suitable vases for the winter and Sung and early Ming ceramic vases for the summer. This piece is likely to be a Ming jade carver's free interpretation of an arrangement (the actual combination of plants being impossible) in an archaistic *ku*-like vase. The animal masks on the vase are in the style of masks in "Sung" catalogues of bronzes and jades, but they could easily be Ming.

1. See Jan Wirgin, "Sung Ceramic Designs." Flower arrangements in vases also appear on wall paintings in a tomb dating from the end of the Liao period in the early twelfth century; see Cheng Shao-tsung, "Excavation of the Wall Painting Tomb of the Liao Dynasty in Hsüan-hua, Hopei Province," *Wen Wu* 1975. 8, pp. 31–39.

2. The thirteenth-century writer Chou Mi records a jade vase that was supposed to be from the palace of the Southern Sung emperor Li-tsung. See his *Yün-yen Kuo-yen Lu* and *Chih-ya-t'ang Tsa-ch'ao*, both collected in Yang Chia-lo (ed.), *I-shu Ts'ung-pien*, Taipei: Shih-chieh Shu-chü, 1962.

3. The most famous of these treatises are Yüan Hung-tao's *P'ing Shih* and Chang Ch'ou's *P'ing-hua P'u*, both collected in the *I-shu Ts'ung-pien*.

See color illustration p.124.

and vertical combinations of dragons' heads, paws, and claws, and varying spiral motifs. The lid is also decorated in two bands, one of a rope pattern, the other of waves and scrolls with fine cross-hatching in the troughs, and is surmounted by a knob formed by two segments of a cylinder.

The *ch'ih*-dragon on the side is very similar in both style and treatment to those serving a similar purpose on a number of so-called libation cups of archaistic form that are usually given a Sung to early Ming date (Rawson and Ayres, *Chinese Jade,* nos. 310, 311). The finely incised scrolling lines constitute another common feature of this group also shared by this piece. However, the geometrized dragon profiles in the lowest decorative band relate this vessel strongly to another group of vessels, represented by no. 140 in this exhibition, which are much more firmly dated to the late Ming period. A Ming date is suggested for this piece, but it is recognized that much more work needs to be done on these beautifully carved archaistic vessels with *ch'ih*-dragon handles before they can be dated with any certainty (see also the discussion of archaistic carvings in the Introduction).

Two features deserve attention in future studies of this piece: the walls, which are extraordinarily thin even for a Ming piece; and the very interesting comma pattern decorative band, which can be regarded as a tightly packed series of either S curves or *ju-i* heads.

## 133. Gourd-Shaped Vessel with Cover

*White jade with reddish brown markings*
*Probably Ming*
*Height (with cover): 134mm; Length (at*
*        base): 52mm; Width (at base): 36mm*
*B.S. McElney Collection*

This vessel, in the shape of a gourd-shaped *hu,* has four bands of archaistic decoration and stands on a tall foot with a raised ridge. The handle is in the form of a *ch'ih*-dragon, with fine hatching on the forepaws and C scrolls on the body. Its jaws open in a snarl.

The bands of archaistic motifs in low relief are an initial band of hatching on the rim, set off by an incised line from a plain band; a band of comma patterns in tight formation bounded by double incised lines; another band of incised C scrolls; and a final band of alternating inverted

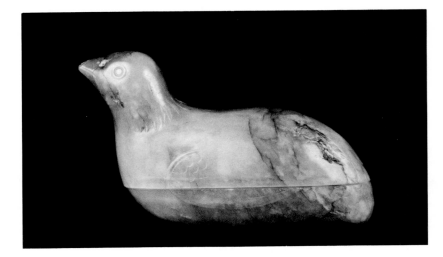

## 134. Covered Box in the Form of a Quail

*White jade with reddish brown mottling,*
*some calcification*
*Probably Ming*
*Height: 51mm; Length: 82mm;*
*Width: 33mm*
*Gerald Godfrey, Esq.*

The top of the box is the head and half of the body of the quail, whose feet are shown in relief on the bottom half. The wings and tail feathers, finely hatched, overlap. The beak, the eyes, and the neck feathers are all delicately incised.

In terms of quality of jade, workmanship, and thinness of walls, this piece is remarkably similar to no. 133 and probably dates from the same period and was carved in the same area.

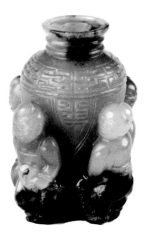

## 135. Tsun with Four Boys

*Yellowish green jade with dark brown*
*markings*
*Yüan–Ming (13th–15th centuries A.D.)*
*Height: 63mm; Length: 76mm;*
*Width: 20mm*
*Bei Shan Tang Collection*

This small *tsun* vase is decorated with a cicada pattern and supported by four boys carved in full round, two seen in front view, two in back view, wearing bracelets, anklets, and children's vests.

Small jade vessels, usually in archaistic form and supported or surrounded by images of boys, are known throughout the Ming period. There is a vessel of this type in the Asian Art Museum of San Francisco, The Avery Brundage Collection that is one of the finest of the series (see d'Argencé, *Brundage Jades,* pl. XLII and p. 98). In terms of workmanship and style, this piece appears to be an early piece in the tradition.

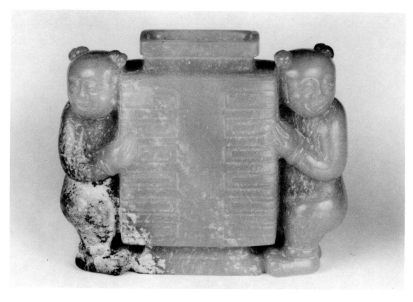

## 136. Tsun with Two Boys

*Yellow green jade with calcification*
*Yüan–Ming (13th–15th centuries A.D.)*
*Height: 54mm; Length: 77mm;*
*Width: 20mm*
*Chih-jou Chai Collection*

A rectangular *tsun* with equal rim and foot is supported by two boys wearing bracelets, anklets, and topknots. The *tsun* is incised with a repeated geometric pattern.

In terms of iconography this piece is very similar to no. 135.

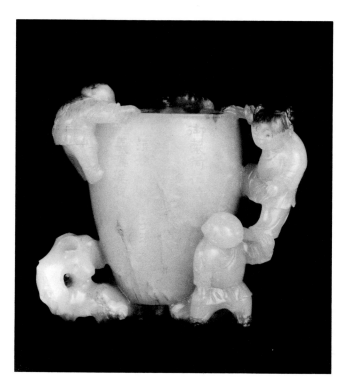

## 137. Vase with Rockery and Three Boys

*White jade with brown staining*
*17th century A.D.*
*Height: 67mm; Diameter (at rim):*
*30mm*
*Sammy Chow Collection*

The vase stands on a rockery base that is stained brown. A *ling-chih* fungus grows out of the rocks at the rear, and above it a bat perches on the rim of the vase. One boy, with a "cash" tied to his back, holds the rim of the vase with both hands, his feet bracing against the sides. Opposite him another boy stands on the shoulders of a third, his knee supporting him against the vase, his right hand clasping the rim. All three are dressed in tunics and trousers; whereas the two who are together have topknots, the third has a circlet with striated lines representing hair.

The outer wall of the vase is inscribed with a poem by Ch'ien-lung on the lotus flower that is likely to be a relatively recent addition.

This piece is a seventeenth-century interpretation of the theme of nos. 135 and 136. The style of the carving, especially the treatment of the rocks, is typical of the period.

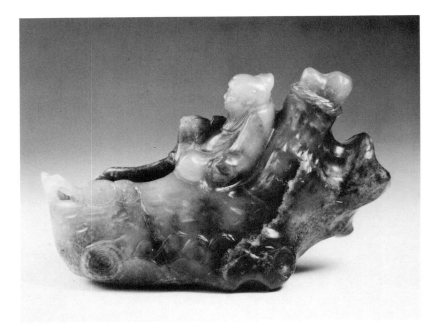

## 138. Raft Cup

*Gray green jade with brown and black*
*markings*
*Late Ming period (15th–17th*
*centuries* A.D.)
*Height: 67mm; Length: 108mm*
*Asian Art Museum of San Francisco,*
*The Avery Brundage Collection*
*Published: d'Argencé,* Brundage Jades,
*p. 96 and pl. XLI; Rawson and*
*Ayers,* Chinese Jade, *no. 357.*

This vessel depicts a man in a cloth cap sitting on a raft in the form of a hollow log, from the "bow" of which issues a prunus branch. The rope around the upper end of the log serves to secure a gourd. Carvings on the side of the log depict waves, and the back of the log is perforated with two suspension holes.

The legend of the magic raft began in about the fourth century, when it was mentioned in the book *Shih-i Chi* by Wang Chia, who was himself a magician of sorts, as well as in another book, the *Po-wu Chih,* written roughly in the same period or slightly later and attributed to the third-century writer Chang Hua. People who rode on this raft were supposed to go round the four seas, circulate the firma-

ments, and visit the Weaving Maid and the Cowherd at the Milky Way. A few centuries later the legend amalgamated with that of Chang Ch'ien, the explorer of the Western Han period who sought the source of the Yellow River, said to flow from the Milky Way. However, the magic raft also retained its independent existence and there were supposed to be flying rafts in the T'ang palace (as recorded in the *Tung-t'ien Chi* and quoted by Teng T'o in *Yen-shan Yeh-hua*).

Such a fabulous vehicle could not have been passed over by Taoists and at the latest by Yüan times Taoist immortals were depicted riding on rafts. Vessels of various materials were made in this form in the Yüan period, but none has survived to this day, with the possible exception of a few silver cups (Lee and Ho, *Chinese Art under the Mongols,* no. 37, and Cheng Min-chung, "Chu Pi-shan Lung-ch'a Chi," pp. 165–169.) The real vogue for making vessels in this form and for using the motif of a Taoist immortal riding on a raft as decoration on jades and porcelains was toward the end of the Ming period in the early seventeenth century. There is, for example, a jade buckle in the Shanghai Museum that is decorated on one side with Mi Fu worshiping a rock (as in no. 107) and on the other side with a Taoist on a long raft (as in 207). Students of Chinese blue-and-white porcelain are all familiar with the frequent occurrence of the man-in-raft motif on pieces of the Ming–Ch'ing transitional period. Erudite scholars in the early Ch'ing period, in their discussion of the silver raft cups, contested the identification of the Taoist in the raft as Chang Ch'ien. Wang Shih-chen (Yü-yang Shan-jen, 1634–1711) positively identified the Taoist as T'ai-i Chen-jen (quoted in Cheng Min-chung, "Chu Pi-shan Lung-ch'a Chi"), but there is no doubt that in popular lore and in the minds of the makers of these raft cups and of the decorators using this motif, Chang Ch'ien is the man in the raft. An illustrated book like the *Wu-shuang P'u,* which was published in the K'ang-hsi era and immediately gained great popularity as a pattern book, also actually names Chang Ch'ien as the man in the raft and refers to Chang Ch'ien's visit to the Milky Way at the source of the Yellow River and his meeting with the Weaving Maid. No. 207 in this exhibition also depicts the raft on one side and the Weaving Maid on the other.

There is no doubt that the vast majority of all objects made either in the form of the raft or decorated with a representation of a Taoist riding on a raft were made in the seventeenth century, and this piece should be no exception. The raft has survived in the decorative art of later periods in the Ch'ing dynasty, but the passengers are more numerous and the Eight Taoist Immortals are usually all depicted taking a ride on it.

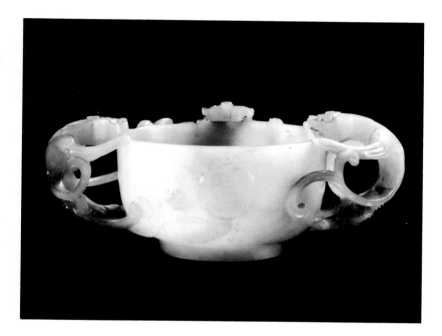

## 139. Dragon-Handled Cup

*White jade*
*Ming (late 16th–early 17th*
    *centuries* A.D.)
*Height: 44mm; Diameter: 144mm*
*The Cleveland Museum of Art*

A cup with nearly vertical sides and a low foot has as handles on opposite sides two *ch'ih*-dragons with their jaws and front paws on the rim, and a third *ch'ih*-dragon on the opposite side from a *shou* (longevity) character in low relief within a double-line circle. Below the *shou* is a three-character mark "made by Tzu-kang," and within the foot-ring on the base is a four-character mark of *wan-shou ch'ang-ch'un,* "ten thousand [years of] longevity and eternal spring," in seal script cut in double lines within a cartouche.

This piece is of a fairly common type. There is, for example, as almost identical piece in the Victoria and Albert Museum (Rawson and Ayres, *Chinese Jade,* no. 382). However, the Lu Tzu-kang mark makes it a piece of unusual interest, for this means that it was likely to have been made in the Su-chou area even if it is not the work of Lu Tzu-kang himself.

This type of cup is of interest in another connection. It is certainly related to an earlier piece in the Musée Guimet that formerly belonged to Cardinal Mazarin (d. 1661) and Louis XIV of France (Pirazzoli-t'Serstevens, "Un Jade Chinois").

As previous authors have observed, the form of the Guimet cup resembles that of a certain type of *ch'ing-pai* porcelain cup of the late Sung to Yüan periods and this form survived throughout the Ming period (Pirazzoli-t'Serstevens, "Un Jade Chinois," and Rawson and Ayres, *Chinese Jade,* note on no. 326). The Guimet cup is in turn unmistakably related to one of the unsolved problems in the study of Chinese and Central Asian jades, the Ulugh Beg cup in the British Museum (Pindar-Wilson and Watson, "An Inscribed Jade Cup from Samarkand"). This cup is of an olive green jade and has a single *ch'ih*-dragon handle. On it is inscribed the name of Ulugh Beg, followed by the title "Gūrgān" in *ruq'a* script. As pointed out by Pindar-Wilson and Watson, Ulugh Beg, the son of Timur's son Shah Rukh, acquired the title Gūrgān in 1417, and the cup could have come into his possession by this date. The question remains whether the cup was carved in China, because the *ch'ih*-dragon motif has always been presumed to be an exclusively Chinese creation, or in Samarkand (Hansford, *Chinese Carved Jades,* p. 89).

As discussed in the Introduction, archaeological excavations of late Ming sites in China have produced the interesting evidence that jade pieces found in northern sites are often of an olive green color with thick walls that are relatively undecorated, whereas the many jade pieces from the provinces Kiangsu, Chekiang, and Kiangsi are almost exclusively of white jade and are more intricately carved, although the quality of workmanship varies to a very large degree. The Ulugh Beg cup answers to the northern style of carving while the Guimet

piece is more typical of the southern jades. This observation does not solve the basic problem, but it does mean that if the Ulugh Beg cup was carved in China it was probably done in Peking, or somewhere between Peking and the actual source of the jade. The Cleveland cup provides evidence that the more elaborately carved pieces were done in the south.

The dating of the Cleveland cup to the late sixteenth or early seventeenth century is fairly secure both on stylistic grounds, including the four-character "auspicious mark" and the treatment of the character *shou*, and on account of the signature of Lu Tzu-kang. The workmanship of the cup is perhaps not fine enough for a genuine Lu Tzu-kang piece, but Lu Tzu-kang achieved unique fame in his time and forgeries of his work began in his own lifetime and proliferated in the seventeenth century, as discussed in the Introduction and in the notes on plaques and pendants in this exhibition (nos. 211–215).

## 140. Cylindrical Cup (Chih)

*White jade with brown markings*
*Ming (late 16th–early 17th*
*centuries* A.D.)
*Height: 84mm; Diameter (outer): 67mm;*
*Diameter (inner): 58mm*
*Quincy Chuang, Esq.*

This cylindrical cup has a ring handle after the style of a Han drinking cup, or *chih*. The chief decoration consists of a mask and two stylized mythical animals both with raised forepaw, claws outstretched. The rear limbs become part of the geometric pattern. The whole is on a background of thunder patterns with a border of reversed clawlike spirals at top and bottom. The cup stands on three feet carved in the form of animal masks. The handle, with upturned flange, has an incised *t'ao-t'ieh* mask; the base is incised with a writhing dragon emerging from clouds.

There are two cups very similar to this one, both of which have lids and bear the signature of Lu Tzu-kang.[1] It is presumed that this piece must also have had a lid in its day. Instead of the mark on the base, it bears an incised *ch'ih*-dragon that is typical of the late Ming period.

One of the Lu Tzu-kang marked cylindrical cups comes from a tomb near Peking dated in accordance with A.D. 1676. The tomb, which is that of a seven-year-old daughter of the early Ch'ing statesman Songgatu, also contained other precious objects of the Ming period such as official porcelain ware of the Ch'eng-hua to Wan-li eras. Judging from the photographs, at least the Wan-li pieces are genuine, and the quality of all the porcelains and jades is superb. Whether the Lu Tzu-kang cup is genuine or not, it must have been believed to be so in the early Ch'ing period. This cup and others like it can thus be dated safely to at least the Ming–Ch'ing transitional period and provide important reference material for the study of late Ming archaistic patterns and jade working techniques.

1. One was included in the 1975 Oriental Ceramic Society jade exhibition; see Rawson and Ayers, *Chinese Jade*, no. 326. The other is from an early Ch'ing tomb; see Su T'ien-chün, "Excavations of the Ch'ing Tombs at Hsiao-hsi-t'ien, Peking," *Wen Wu* 1963.1, pp. 50–58, plates on pp. 40–42, color plates on p. 3.

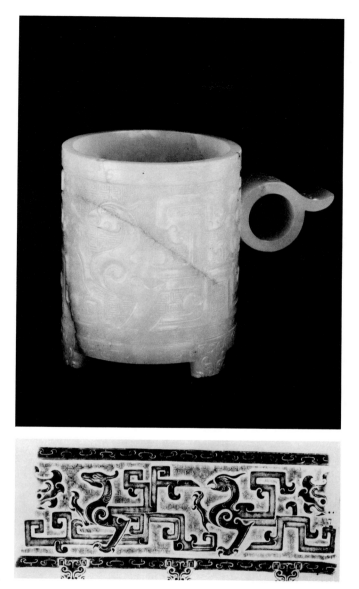

rubbings of exterior and base

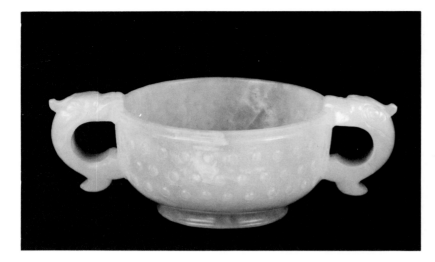

## 141. Dragon-Handled Cup

*Greenish white jade with beige veining*
*Late Ming (probably first half 17th*
*   century* A.D.)
*Height: 31mm; Length (with handles):*
*   102mm; Width (at mouth): 63mm*
*T'ing-sung Shu-wu Collection*

This double-handled cup is modeled after the early bronze vessel *kuei* with handles in the form of small dragons biting the rim. The bowl is decorated with three rows of grain patterns; the foot and rim are grooved.

Late Ming archaistic pieces can take on very simple forms, as demonstrated by this piece and no. 142. The carving is by no means the finest, and the grooved rim and the splayed foot ring are characteristic features of Ming carving.

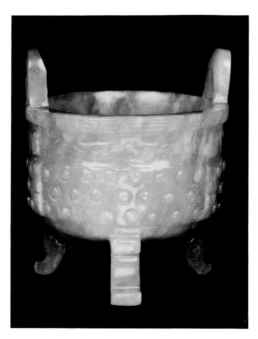

## 142. Ting

*Mottled grayish green jade*
*Late Ming (probably first half 17th*
*   century* A.D.)
*Height: 66mm; Diameter: 55mm*
*T'ing-sung Shu-wu Collection*

This vessel has a circular body with two handles and three animal-snout shaped legs, and is decorated with a grain pattern in the lower part and a frieze of opposed *k'uei*-dragons in the upper part. Three flanges divide the space between the legs. The rim and handles are decorated with key patterns. See entry no. 141.

## 143. Tsun with Dragon and Phoenix

*Yellow jade with brown markings*
*Ch'ing (first half 18th century* A.D.)
*Height: 102mm; Length: 171mm;*
*   Width: 58mm*
*Fogg Art Museum, Harvard University;*
*   gift of Ernest B. and Helen P. Dane*

The vase follows the shape of the archaic bronze vessel type *tsun;* it is of flattened form and is quatrefoil in section. A dragon climbs up one side of the vase, its head rising over the rim

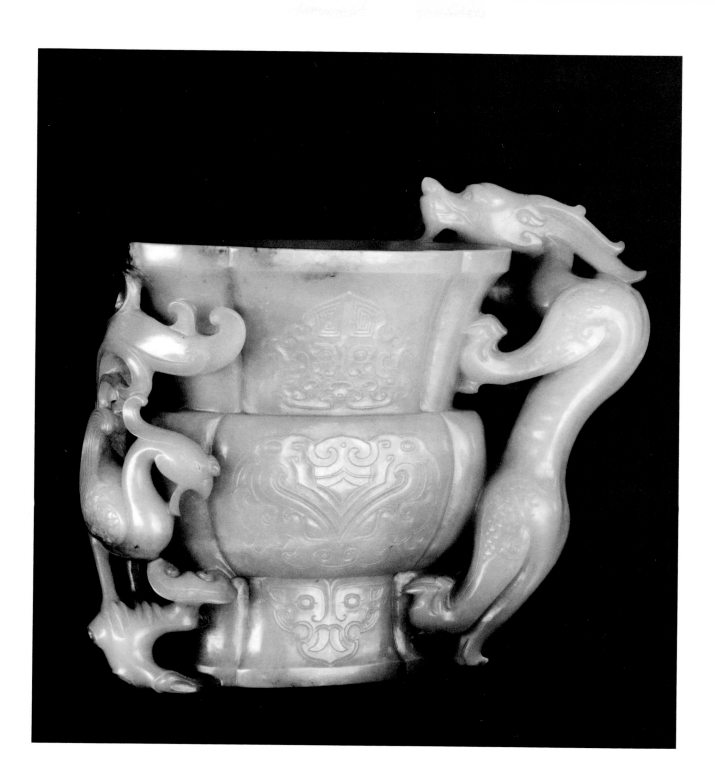

of the vase proper; a phoenix standing on a branch of *ling-chih* fungus appears on the other side. Three stylized *t'ao-t'ieh* masks appear in low relief on each side, one in each horizontal register of the vase proper.

The superb workmanship of this piece makes it unlikely that it was executed after the middle of the eighteenth century, but the spirit of the piece and in particular of the grotesque animal masks is that of the eighteenth century.

## 144. Tsun

> *Pale greenish white jade*
> *Ch'ing (18th century A.D.)*
> *Height: 114mm; Length: 37mm; ,*
> *Width: 31mm*
> *T'ing-sung Shu-wu Collection*

A tall *tsun*-shaped vessel has a quatrefoil shape with a long neck and foot. It is decorated with cicada patterns and *ju-i* heads.

The shape and decoration of this piece are very similar to those of seventeenth and eighteenth-century bronze holders of implements for managing the incense burner—a spatula and a pair of sticks. The workmanship is characteristic of the eighteenth century.

## 145. Dish with Two Fish among Reeds

> *Greenish white jade with slight brown*
> *mottling on rim*
> *Ch'ing (probably early 18th*
> *century A.D.)*
> *Height: 39mm; Diameter: 170mm*
> *Joseph E. Hotung*

This shallow-sided dish has carved in the center two carps with freely flowing fins and tails facing each other beside a bunch of reeds. Fifty four-petaled flowers with coronas are carved in high relief on the edge; long blades of sea grass flow around the right edge of the dish and down the side to the base, where lotus leaves and blossoms are entwined. Three button-shaped protrusions form small feet.

This uncluttered naturalistic style of carving is a direct continuation of a late Ming tradition. During the reign of Ch'ien-lung the naturalistic carvings become so overcrowded that the gen-

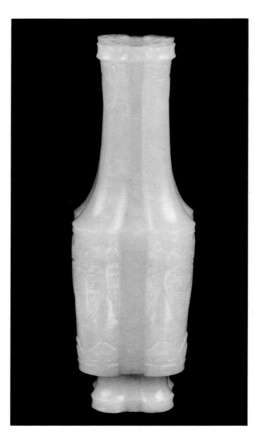

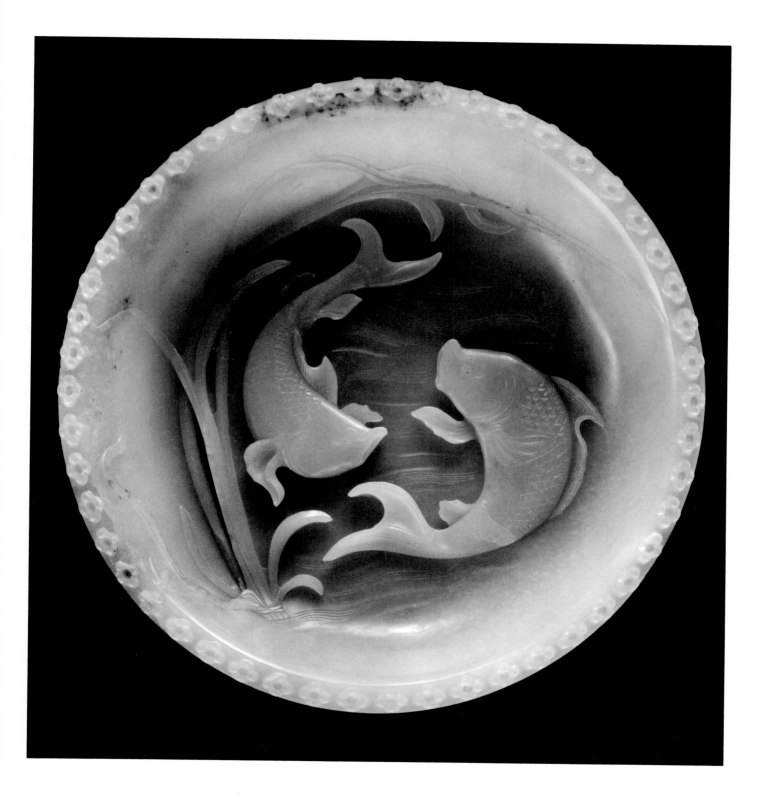

eral effect of a "naturalistic" scene is not much different from that composed of archaistic or other stylized decorative patterns.

The ring of four-petaled flowers on the rim also suggests a residual Ming tradition.

## 146. Two-Handled Cup with Stand

*White jade*
*Late Ming*
*Cup: Height: 44mm; Diameter (with*
*    handles): 101mm*
*Stand: Height: 40mm; Length: 148mm;*
*    Width: 90mm*
*Sammy Chow Collection*

The cup has two handles with *ju-i*-shaped tops composed of three florets with the seal characters for *shou,* or longevity, in the center. The rim flares gently outward, curving down to the tall foot. The base is in the form of a double pointed arabesque indented at the center with an incised line along the rim. The foot of the cup fits into a raised grooved and ringed holder. The base is supported by four carved feet in the form of *ju-i* scrolls.

Two-handled cups with fitted dish-shaped stands seem to have been popular in the late Ming period. Most of the cups extant today have been separated from their original stands. A two-handled cup without stand has been found in an early sixteenth-century tomb in Ch'eng-tu (see WWTKTL 1956.10, pp. 42–49).

## 147. Cup with Stand

*White jade*
*Ch'ing (Ch'ien-lung or later)*
*Cup: Height: 52mm; Diameter: 65mm*
*Stand: Height: 10mm, Length: 172mm;*
*    Width: 114mm*
*Sammy Chow Collection*

The cup has a band of triangular thunder patterns along the rim, above a larger band of intertwined "foliage masks" enclosed by double lines. The stand is a rectangle with rounded corners and has a border of intertwined foliage in relief on the rim. In the center of the stand, which has a highly polished surface, is a raised base with a chrysanthemum form for the cup. Underneath the stand are two incised marks in clerical script, one reading, "For Imperial Use of Ch'ien-lung," the other, "For Imperial Use of Chia-ch'ing." The cup bears a similarly styled mark of "For Imperial Use of Tao-kuang" inside the foot ring.

In spirit this is the Ch'ing equivalent of no. 146, except that this cup is carved without handles and the gently flaring mouth and the base have lost their intricate outline, making the shaping of the pieces much easier for the carver. The animal masks on the cup formed by a bunch of acanthus-type leaves represent a kind of ultimate eclecticism in Chinese decorative design of the premodern period, reflecting the style and sensibility of many periods and culture areas of China from the Shang to the eighteenth century.

The three "imperial use" marks are credible, especially the ones on the stand, but they are not absolutely beyond doubt.

rubbings of inscriptions

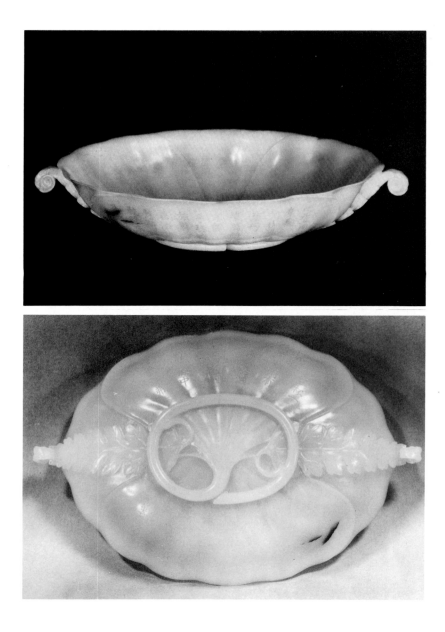

## 148. Bowl

*White jade*
*Probably India, 17th century* A.D.
*Height: 41mm; Length: 214mm;*
*    Width: 140mm*
*Seattle Art Museum; Eugene Fuller*
*    Memorial Collection*

This bowl is in the form of a four-petaled flower resting on its coiled stem. Acanthus leaves originating from the stem extend on either side and form the handles at the ends. The inside center is decorated with a ten-petaled flower. The bowl is engraved with an inscription by Ch'ien-lung dated in accordance with A.D. 1770.

This piece is included in the exhibition in order to facilitate the discussion of the difference between Chinese and Moghul jades. The style of this piece is Moghul and the inscription by Ch'ien-lung describes in accurate detail its form, stating clearly that the "Hindustan cup" is "thin as paper" which "only the jade worker of that country is capable of [making]," and "the jade worker of the interior acknowledges his inferiority." This is followed by a panegyric on the piece in the form of an eight-line poem with five characters to the line. In spite of the fact that the coiled stem serving as ring-foot may not be a particularly Moghul feature,[1] the rest of the piece answers to the standard descriptions of the Moghul style and Ch'ien-lung's information as to the origin of the piece must be given the benefit of the doubt. There is another piece in the Bishop Collection referred to by Robert Skelton in "The Relations between the Chinese and Indian Jade Carving Traditions" which is similar in style, but with a more standard Moghul base, also inscribed in 1770 by Ch'ien-lung, who called it a Hindustan cup.

Previous discussions on Moghul jades have been based mainly on two misconceptions. The first is the belief that the eighteenth century was a great period in Chinese jade carving and the seventeenth century was not.

As explained in the Introduction, this was not the case. The second misconception is that all the finest jade carvings have to be the work of the Chinese jade carver. When one adds up these two misconceptions, it is easy to postulate that the best carvings in Moghul style must be the work of eighteenth-century Chinese jade carvers, especially when it is known that the Ch'ien-lung emperor had a workshop to carve "Hindustan" jades in his palace. When Robert Skelton wrote about the relation between Moghul and Ch'ing jade carving, he had to marshal arguments against hypotheses that were groundless in the first place. This piece in the Seattle Art Museum, together with the one in the Bishop Collection, should be evidence enough that the finest carvings in Moghul style were indeed carved by Indian craftsmen in Moghul India and later acquired by Ch'ien-lung, perhaps after his campaigns in the Western Regions. The Chinese carver did produce some very fine pieces in the Moghul style, but they were very different in spirit from the Indian ones and exhibited the characteristics of all carvings of the Ch'ien-lung period— superabundant ornamentation without underlying unity and maximum effect for minimum work. A careful examination of Moghul pieces and Chinese carvings in Moghul style would reveal the real difference between the two. Moghul jades were carved with great labor and care, using much more primitive techniques comparable to those used for the finest pre-Ming Chinese carvings; the Chinese versions were cut with much more efficient tools and harder abrasives.

1. The use of stems of plants, especially those of the lotus and in twining form, as the feet of vessels is a Ming convention. Robert Skelton states that "such [twining] stems do not appear in any known Moghul jades" ("Relations between the Chinese and Indian Jade Carving Traditions," p. 107). However, the coiled-stem foot of the present vessel is considerably simpler than those of Ming pieces, and one could perhaps allow the possibility of a small degree of influence of the Ming jade-carving tradition on Moghul jades.

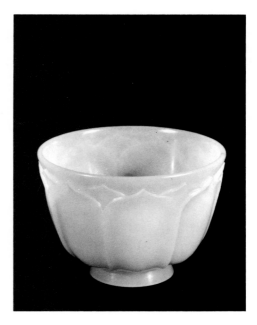

## 149. Bowl

*White jade*
*Ch'ing (first half 18th century A.D.)*
*Height: 50mm; Diameter: 66mm*
*Philadelphia Museum of Art; Collection*
*of Major General and Mrs. William*
*Crozier*

Two layers of seven lotus petals decorate this bowl, which has a four-character seal, "appreciated by Ch'ien-lung."

The bowl is a believably early eighteenth-century piece that must have been inspired by Moghul models. The edges are relatively sharp by comparison with Moghul pieces.

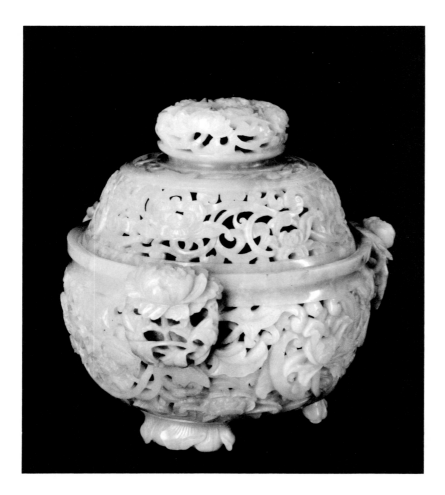

## 150. Covered Censer

*Pale grayish green jade with brown flecks*
*Ch'ing (18th century A.D.)*
*Height: 105mm; Diameter: 149mm*
*Fogg Art Museum, Harvard University;*
*gift of Ernest B. and Helen P. Dane*

This covered censer, of circular form, is elaborately pierced and carved with peony blossoms, chrysanthemums, and scrolling leafy stems. The dome-shaped cover has on the top a large circular knob that is pierced and carved with floral designs. Three handles are placed one above each foot, each carved in the shape of a flower with leaves and stem. Each of the three feet is also carved in the shape of a flower, and there is a peony on the base.

This piece is a fine example of eighteenth-century Chinese carving with some attempt at modeling the leaves and petals as in Ming carved lacquer. The representation of the peony follows closely that of the same flower in early Ch'ing paintings and painted enamel decorations on late K'ang-hsi to early Ch'ien-lung porcelain bowls. The leaves exhibit some characteristics of the acanthus, but this may be a survival of the Ming style. Pieces like this, mostly not as fine, are still in the collection of the Palace Museum in Taipei, and a considerable number on the market in London are said to be from the Yüan-ming Yüan.

See also National Palace Museum, *Masterworks of Chinese Jade,* no. 28.

## 151. Covered Dish

*Pale greenish white jade*
*Ch'ing (late 18th–19th centuries* A.D.*)*
*Height: 63mm; Length: 178mm;*
*    Width: 121mm*
*Fogg Art Museum, Harvard University;*
*    gift of Ernest B. and Helen P. Dane*

A shallow, quatrefoil dish is set on four *ju-i*-shaped feet; the projecting foliate rim has a reticulated flower at either end and loose ring handles. The cover has a reticulated border of eight panels, each containing a flower and scrolling stems and leaves; on the crown of the cover are two phoenixes carved in low relief. The knob, carved separately and attached, is of flower shape. The walls of the dish are exceedingly thin.

This piece represents the best Chinese work in Moghul style, with extremely thin walls and much perforation. It is a veritable tour de force for this style of carving. The very thin walls were probably not achieved until the late eighteenth century, and pieces in this style were produced until the early twentieth century.

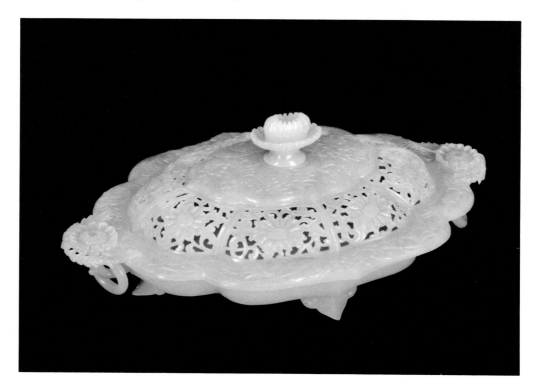

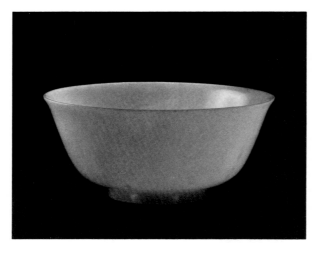

## 152. Bowl

*Pale greenish white jade*
*Ch'ing (18th century A.D.)*
*Height: 62mm; Diameter: 153mm;*
*Width (of rim): 3mm*
*B.S. McElney Collection*

The circular bowl with flaring sides and hipped rim stands on a broad ring-foot of rectangular section. The surface is smoothly polished.

This piece is representative of one of the standard styles of the eighteenth to early twentieth centuries. The piece is sensitively modeled and the lack of ornamentation implies a certain respect for the stone except that much of the original material is wasted in fashioning such a piece. These bowls can have been made only in a period when the stone was in abundant supply.

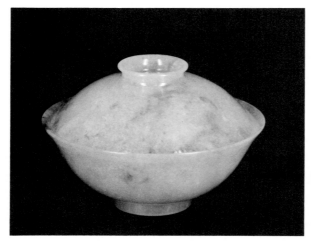

## 153. Covered Bowl

*Green jadeite*
*Ch'ing (late 18th–19th centuries A.D.)*
*Height: 73mm; Diameter: 117mm*
*Fogg Art Museum, Harvard University;*
*gift of Ernest B. and Helen P. Dane*

This bowl of plain, circular form has a slightly domed cover with a hollow ring knob. The stone has been polished to a high gloss. The material is of the finest quality and exhibits all the virtues of jadeite.

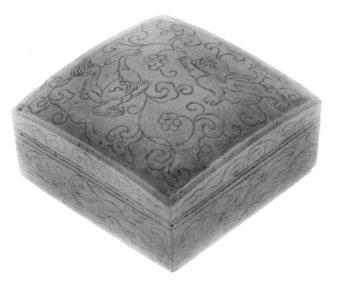

## 154. Carved Box

*Grayish white jade with black spots*
*T'ang*
*Height: 35mm; Length: 68mm;*
*Width: 68mm*
*Ching-yin Watt*

A square box has incised carving on the top and on the four sides. The slightly domed lid has a stepped edge acting as a frame for the interior design of two lions playing among vines. The lions have hatched lines indicating fur on their ears, limbs, and bodies. The faces are almost human, with well-defined noses and grooved mouths.

Each side of the base has an extended lion stretching between vestiges of the floral decoration. The lower edge of the sides is cut away to form a recessed "foot," and the bottom surface has a shallow square well in the center.

A T'ang date is proposed for this piece on account of the style and the workmanship. The lion-and-vine is a common decorative motif in the T'ang period and appears on metalware as well as in stone carving. The incised lines are somewhat crudely executed but artistically well controlled.

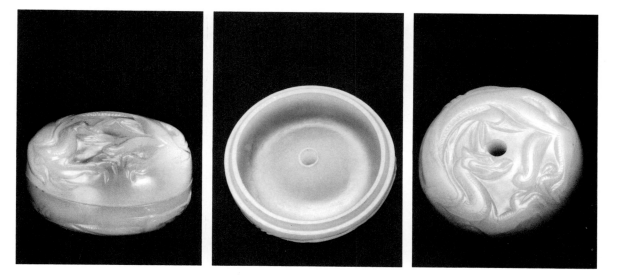

## 155. Annular Covered Box

*White jade*
*Early Sung (late 10th–11th*
*centuries A.D.)*
*Height: 28mm; Diameter: 49mm*
*Chih-jou Chai Collection*

This annular box has two nearly identical halves, each decorated in low relief with a coiling dragon. A conical perforation on each part develops into a chimney shape inside the box.

Annular boxes like this one certainly existed in the tenth century. There is a porcelain box of this form in the Ashmolean Museum that is typical of the Shang-lin-hu variety of celadon ware of the late tenth century (Tregear, *Catalogue of Chinese Greenware*, no. 140). The present box can be dated to the same period by

comparing the treatment of the dragons on both sides of the box to dragons on jades and porcelain of the tenth century. Among numerous examples that can be cited are the dragons on the jade plaques from the belt of Wang Chien, ruler of the kingdom of Former Shu, who died in A.D. 918 and whose tomb just outside the old city of Ch'eng-tu was excavated in 1942. Among the objects in the tomb that escaped looting by robbers of various periods is a belt decorated with seven jade plaques carved with dragon designs (Feng Han-yih, *Ch'ien-shu Wang Chien Mu Fa-chüeh Pao-kao*, plates XXXIII and XXXIV). The dragons on this box are in every way similar to the dragons on the plaques from Wang Chien's tomb. The notable features are the long pointed snout (not as thin and flamelike as the T'ang version, but still much more pointed than the muzzles of the dragons of the thirteenth century and subsequent periods); the parallel latitudinal

lines down the front and underside of the body; the long powerful claws that curve inward but that are not as hooked as the Yüan version; the way the tail becomes entangled with one of the stretched hind legs; and the way the head is held back from a puffed-out chest. Among examples on porcelain one can cite the Yüeh-ware bowl in the Metropolitan Museum, again of the Shang-lin-hu type, which is decorated with three incised dragons of a similar style (Valenstein, *Handbook of Chinese Ceramics,* no. 32). The same dragon appears on a Yüeh-ware ewer excavated from a Five Dynasties tomb in Hang-chou (*K'ao-ku* 1975.3, p. 192 and pl. IX).

This piece is thus one of the few pieces of jade carving that can be dated with some certainty to the early Sung period. It provides excellent material for the study of jade-working techniques in the early Sung period and the type of jade available at that time.

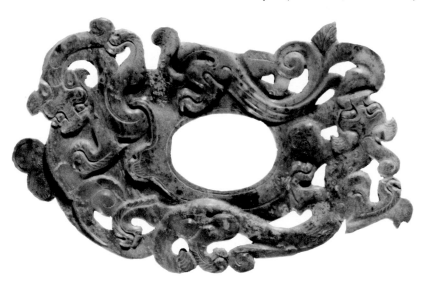

## 156. Chüeh Pendant

> *Mottled green jade, partly discolored, glossy finish*
> *Han period (1st century B.C.–1st century A.D.)*
> *Length: 73mm; Width: 42mm; Thickness: 4mm*
> *The Art Institute of Chicago; Edward and Louise B. Sonnenschein Collection*
> *Published: Salmony,* Sonnenschein Collection, *no. 10, pl. LXXXIV, p. 222.*

"The basic shape is that of an archer's ring, surrounded by a pair of fantastic feline-like animals in relief and openwork. The body of one animal reaches over to the back." Thus Alfred Salmony describes this piece in his catalogue of the Sonnenschein Collection.

Scholars agree that this pendant evolved from the archer's thumb ring of an earlier period (Hayashi Minao, "Haigyoku to Jū," and Loehr, *Ancient Chinese Jades,* note to no. 579, p. 400). Hayashi further points out that this pendant was still known as *chüeh* (the old term for the archer's ring in Chou times) in the Han period even if its purpose was by then purely ornamental. A number of such pendants have been found in Han tombs in recent years, enabling a preliminary hypothesis on the sequence of development to be worked out. The present exhibit is stylistically closest to two pieces both found in Hunan Province and both dated to the first century A.D.[1]

See also Loehr, *Ancient Chinese Jades,* no. 579.

1. KKTH 1957.1, pp. 27–31, reports on an early Eastern Han tomb in Ling-ling County. The jade pendant, called a *hsien-pi* in the report, is illustrated in pl. IX. Also, *Wen Wu* 1960.3, pp. 39–46 reports on a tomb of the Hsin dynasty (A.D. 8–23) in Wu-li-p'ai, Ch'ang-sha. One of the jade pieces from this tomb is a *chüeh* pendant, reproduced as fig. 24 on p. 24.

# Plaques & Personal Ornaments

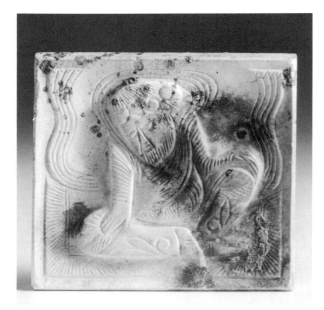

## 157. Belt Plaque

*Ivory colored jade with gray green
markings, largely calcified*
*T'ang*
*Length: 52mm; Width: 45mm*
*Asian Art Museum of San Francisco,
The Avery Brundage Collection*

An almost square plaque is decorated with a low-relief carving of a seated man with curly hair, tight sleeves, boots, and a flowing scarf. There are perforations on the back for attachment to a leather belt.

A complete set of jade belt plaques is in the collection of the Museum of Fine Arts, Boston, and a set in agate is in the British Museum (see Rawson and Ayers, *Chinese Jade*, nos. 221, 222). The tomb of Wang Chien (see entry no. 155) produced a set of seven plaques on a belt. Except for the lack of a musical instrument, this piece is comparable to those in the Boston

set, especially in the treatment of the scarf. It is also similar to a hard stone plaque found in 1931 in Liao-yang in Liaoning Province and reported by Torii Ryuzo, who proposed that the figure represented in the plaque is dressed in the indigenous style of the people of Po-hai ("Vases of the Sassanian Style"). In his other writings Torii has also pointed out the similarity between the dress of the Khitans and that of Central Asians. In any case, the jade belt is probably of Central Asian origin and was used in China from about the sixth century onward, the square solid plaques giving way to openwork pieces in the fourteenth century.[1]

1. Figures appearing on Sung belt plaques have been sinicized; see illustrations in Ch'en Po-ch'üan's report on a Sung jade belt from Shang-jao, Kiangsi Province (*Wen Wu* 1964.2, pp. 67–68). Jade belt plaques in the Nanking Museum from the early Ming (fourteenth-century) tombs are of the openwork variety (see, for example, *K'ao-ku* 1972.4, pl. VII for parts of a jade belt from the tomb of Wang Hsing-tsu).

## 158. Pair of Belt Rings

*Grayish white jade*
*T'ang*
*Diameter: 28mm*
*Dr. and Mrs. Cheng Te-k'un*
*Published, Rawson and Ayers,* Chinese
  Jade, *no. 223.*

A pair of circular rings with nonconcentric perforation is finely worked with concave bevellings and a flat reverse.

These rings are attached to belts for suspending objects. Excavated examples are cited by Rawson and Ayers (see above) and there is a complete set of jade belt ornaments that includes a pair of such rings in the Hakutsuru Museum in Kobe.

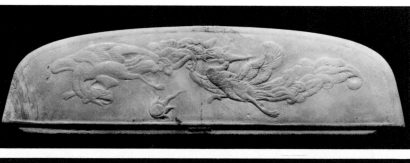

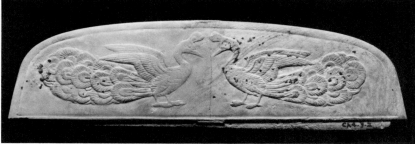

## 159. Comb Top

*White jade, partially calcified*
*T'ang*
*Length: 126mm; Width: 34mm;*
  *Thickness: 3mm*
*Seattle Art Museum; Eugene Fuller*
  *Memorial Collection*

One side of this comb top has a low-relief carving of two phoenixes in apparent chase after a flaming pearl, their elaborate plumage swirling behind them. The reverse side has two peacocks facing each other, voluminous plumage flowing away from them.

A number of such jade comb tops of the T'ang and Sung periods are known, for example, Hansford, *Chinese Carved Jades*, pl. 72; Rawson and Ayers, *Chinese Jade*, nos. 228, 230.

## 160. Sword Pommel

*Pale green jade with brown staining*
*Probably Yüan*
*Height: 13mm; Diameter: 36mm*
  *Diameter (inner, at base): 34mm*
*Gerald Godfrey, Esq.*

The pommel has been carved in the form of a monster mask, with three sets of tunnel perforations in the base and one set on the side. The highly stylized mask has deep furrows on the forehead, grooved eyebrows, and a grimace that spreads across the base of the mask.

The monster mask has been used in north China as a decorative motif, especially for roof tile ends, since at least the third century. In recent years many finds of roof tile ends with monster mask decoration have been made in archaeological sites from the late Han to the Yüan periods,[1] but all in north China and mostly in Liao to Yüan sites.[2] Aurel Stein also found such tile ends in Khara-khoto (Stein, *Innermost Asia*, vol. III, pl. L). It is natural to expect that such a motif would be used by the jade carver of central and northern Asia also for a similar decorative function—ornamenting the end of the handle of a sword. The mask on the present piece, with its wide grimace and lines of the eyes following those of the mouth, is stylistically closest to roof tile end decorations of the Yüan period (see *K'ao-ku* 1972.6, p. 8, fig. 4).

1. For bricks modeled in a monster mask from second–third-century Loyang, see *K'ao-ku* 1973.4, pl. 1; for Sui and T'ang roof tile ends, see *Wen Wu* 1976.2, p. 77 and *K'ao-ku* 1978.6, p. 383; for Yüan pieces see *K'ao-ku* 1972.6, p. 8.
2. Chia Chou-chieh, "Roof Tile Ends of the Liao, Chin, and Yüan periods in Inner Mongolia," *K'ao-ku* 1977.6, pp. 422–425.

## 161. Astragal

*White jade*
*Liao–Chin or later*
*Height: 25mm; Length: 38mm; Width: 19mm*
*Guan-fu Collection*

This smooth-shaped "knuckle-bone" with one perforation in the upper part is probably a pendant.

The astragal, a small bone from the ankle joint of cloven-footed animals, especially the sheep, is one of the earliest forms of dice. It was used in the classical world of the Mediterranean, and in north China it has been used continuously from the Liao period onward for children's games and as dice for gambling. Nowadays it is called the *kuai-tzu* (meaning ankle) by children in Peking (and by Peking children in Hong Kong), and farther north it is known by the name of *ka-ha-la*.

Archaeologically, it has been found in burials of the Okunev culture in southern Siberia. The bearers of this culture, who were Mongoloids of the Central Asian type, made a sudden appearance in the Minusinsk basin at the turn of the third and second millennia B.C., replacing the previous Afanasyevskaya culture whose people were of Europoid stock. According to Mikhail P. Gryaznov, one of the most interesting features of the tombs of the Okunev culture is that they "frequently contained numbers of knuckle-bones—usually at least a handful, sometimes twenty or thirty, and in one case over a hundred" (Gryaznov, *The Ancient Civilization of Southern Siberia*, p. 50). Nearly three millennia later, astragals again became common grave goods in burials of the Liao and Chin periods (tenth to thirteenth centuries) in Inner Mongolia and the northeastern provinces of China. Finds from these tombs include not only the bones themselves but exact imitations in materials such as bronze, jade, and other hard stones,[1] as in the case of finds from the Western classical world. The astragals in precious materials are all perforated for suspension and were probably worn as pendants. It is not known when the production of imitation astragals declined or ceased, but so far they seem only to have been found archaeologically in Liao and Chin sites, and nowhere else.

There also exist a number of astragals of jade and other stones made for the Tibetan market in the eighteenth and nineteenth centuries. They are generally more conventionalized and less exact in naturalistic details.

1. For example, in the province of Heilungkiang a crystal piece was found in a Chin tomb at Chunghsing (*Wen Wu* 1977.4, p. 45), a white jade piece from a Chin tomb on the outskirts of Ao-li-mi (*Wen Wu* 1977.4, p. 58), and a bronze piece from a Chin tomb in O-ch'eng. In Inner Mongolia, real astragals have been found in two pottery jars in a Liao burial at Barin Left Banner, Jou Uda League (*K'ao-ku* 1963.10, p. 561).

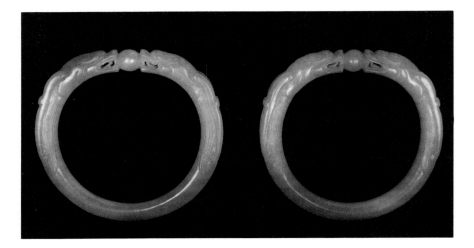

## 162. Pair of Bracelets

*White jade*
*Ming*
*Diameter: 70–75mm*
*Ssu-ch'uan-ko Collection*

On each slightly oval bracelet, two square-nosed dragons hold a round pearl between their snouts. Their open jaws reveal broad tongues and long canines. Their bunched snouts, with faint *ju-i* shaped noses, fall away in low relief to two deep grooves indicating the jawline. Heavy eyebrows curl back above protuberant eyes, while two horns flow along the sides of the bracelet, almost to midpoint. A mane is indicated on either side of each head between the horns.

This form of bracelet, with animal heads at the ends of an arc that almost closes in a circle, has a long history in western and central Asia. However, its first appearance in south China seems to be in the Yüan period as evidenced by a gold bracelet in the same form, but with knobbed band, from the tomb of Chang Shih-ch'eng's mother, who died in the year A. D. 1365 in Su-chou (*K'ao-ku* 1965.6, pp. 289–300, pls. IX–XI). The opposing dragons in this case, with the pearl between their mouths, may well have been derived from the makara, an Indian mythical animal that played a prominent part in the decorative arts of Yüan and Ming China.

This form of bracelet remained popular throughout the Ming and Ch'ing periods. Earlier bracelets retained a more oval shape, which is more difficult to work, and the later versions are strictly circular.

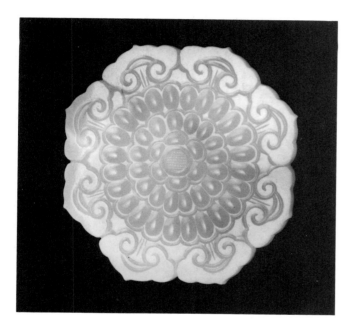

## 163. Floral Disc

*White jade with yellow marks and some*
   *calcification*
*Yüan*
*Diameter: 72mm; Thickness: 7mm*
*Guan-fu Collection*

Eight *ju-i* heads surround rings of twenty-four, sixteen, and then six indented petals, and an androecium that is cross-hatched. The reverse side has eight three-lobed petals overlapping one another in a whirl around a center that has a tunneled perforation.

This piece is very similar to one illustrated by Cheng Te-k'un in his study of jade flowers and reported to be from a "Taoist tomb at Yung-chi, southwest Shansi. The tomb may be dated to the end of the Chin dynasty (1115–1234)" (Cheng Te-k'un, *Jade Flowers,* p. 295 and fig. 2a).

The central part of the floral pattern is similar to the "chrysanthemum" flowers on four-teenth-century blue-and-white porcelain. The overlapping petals on the reverse are also characteristic of the Yüan period. Decorative floral discs with overlapping petals arranged in a whirl are reported from Yüan tombs. A silver floral disc, similar to the jade versions, was found in a Yüan tomb in Wu-hsi in Kiangsu Province (*Wen Wu* 1964.12, pp. 52–60). The universal use of the whirl motif in the Yüan period can be traced to an earlier beginning in north China during the Liao and Chin periods.

See also *Wen Wu* 1961.9, p. 48, fig. 4. A white jade plaque from a Liao tomb in Inner Mongolia is decorated with a central circle with cross-hatching and radial curved lines.

## A Group of Jade Flowers: Nos. 164–174

Jade flowers have been the subject of a detailed study by Cheng Te-k'un based on an extensive collection that is now in the Art Gallery of the Chinese University of Hong Kong. Since the publication of this study in 1969, large numbers of jade flowers have been found in Ming tombs in the Kiangnan area, especially in Shanghai and the province of Kiangsu. Unfortunately virtually none of the Ming examples has been published, but many of them have been on exhibition in the Shanghai Museum and elsewhere in China. Finds from late Ming tombs include relatively elaborate pierced-work carvings, such as no. 172 in this exhibition, which formerly have been assigned a Ch'ing date on stylistic grounds by most art historians.

Another surprising aspect of the archaeological evidence is the comparatively early dates of the composite types of flowers, such as nos. 164–167. A composite prunus flower plaque of soapstone was found in a Yüan tomb in Inner Mongolia (*Wen Wu* 1961.9, pp. 58–61, fig. on p. 4). This means that the composite flowers probably made their appearance at about the same time as the single five-petaled prunus flower (see no. 168), which is known to have existed in the Yüan period.[1]

In view of the lack of more detailed information, the jade flowers in this exhibition have been divided into two groups with the datings of Yüan–Ming and Ming, respectively.

1. A five-petaled jade prunus flower was found in a Yüan tomb in Su-chou in 1959, but unfortunately it was not illustrated in the report; see *Wen Wu* 1959.11, p. 19.

### 164. Five-Flower Rosette

*White jade*
*Yüan–Ming*
*Diameter: 35mm; Thickness: 5mm*
*Art Gallery, The Chinese University of*
*Hong Kong*

This rosette is composed of five perforated prunus blossoms, each with a branched stem joined to the perforated center.

### 165. "Three Friends" Rosette

*Grayish white jade*
*Yüan–Ming*
*Diameter: 37mm; Thickness: 3mm*
*Guan-fu Collection*

This rosette combines the "three friends of winter"—pine, bamboo, and prunus. In this rosette the three elements surround a five-petaled flower with a circular corona and perforation. Carved in openwork, the piece is mounted on a metal clasp.

See also Cheng Te-k'un, *Jade Flowers*, no. 388.

### 166. Six-Flower Rosette

*White jade*
*Yüan–Ming*
*Diameter: 47mm; Thickness: 5mm*
*Chih-jou Chai Collection*

Six five-petaled flowers with coronas and twelve hooks, six being connected in the center to form a whirl, compose this rosette.

See also Cheng Te-k'un, *Jade Flowers*, no. 376.

### 167. Seven-Flower Rosette

*White jade*
*Yüan–Ming*
*Diameter: 49mm; Thickness: 6mm*
*Chih-jou Chai Collection*

A group of six flowers, each with five petals and a central tubular perforation, surround another flower, slightly larger, which has a conical perforation in the center.

See also Cheng Te-k'un, *Jade Flowers*, no. 369.

### 168. Five-Petaled Flower

*White jade*
*Yüan–Ming*
*Diameter: 37mm; Thickness: 7mm*
*Art Gallery, The Chinese University of*
*Hong Kong*
*Published: Cheng Te-k'un,* Jade
*Flowers, no. 4.*

This flower has five concave petals, a foliated outline, and a central perforation. The back is convex and grooved to mark each petal, with a flat center.

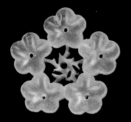

164

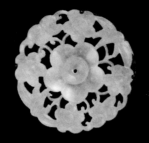

165

166

167

168

169

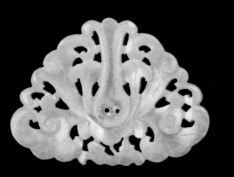

170

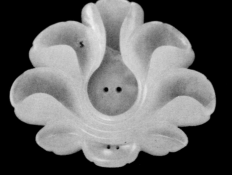

171

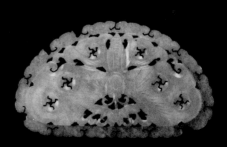

172

The *Ku-yü T'u-p'u* in *chüan* 12 reproduces several of these flowers, which are inscribed with a character in each petal, and calls them "gift coins" of the T'ang period.

## 169. Five-Petaled Flower

*White jade*
*Yüan–Ming*
*Diameter: 34mm; Thickness: 6mm*
*Guan-fu Collection*

The five petals of this flower are hollowed out and the tip of each folded in. The central perforation is circular and there are irregular perforations between each petal.

## 170. Flower

*Pale greenish white jade*
*Yüan–Ming*
*Length: 52mm; Width: 62mm;*
    *Thickness: 4mm*
*Chih-jou Chai Collection*

The side view of a flower with four fungus-like petals as well as hooks, pistil, and footstalk is carved in openwork with a double perforation in the center.

See also Cheng Te-k'un, *Jade Flowers*, no. 348.

## 171. Flower

*Pale greenish white jade*
*Yüan–Ming*
*Length: 64mm; Width; 53mm;*
    *Thickness: 7mm*
*Chih-jou Chai Collection*

This piece shows the side view of a seven-petaled flower with an elongated pistil and pairs of conical perforations in the middle and in the lowest petal.

See also Cheng Te-k'un, *Jade Flowers*, no. 322.

## 172. Openwork Flower and Insect Plaque

*White jade*
*Yüan–Ming*
*Length: 63mm; Width: 37mm;*
    *Thickness: 2mm*
*Chih-jou Chai Collection*

A semi-circular plaque is decorated in openwork with a dragonfly and a lotus flower. Six swastikas in circles ornament the dragonfly's wings, the whole framed by a ring of *ju-i* leaves. Most of the elements are detailed with incised lines.

## 173. Flower

*White jade*
*Ming*
*Diameter: 47mm; Thickness: 2mm*
*Chih-jou Chai Collection*

Two rings of six petals, one inside the other, share a grooved corona. Six slender grooved sepals with pointed ends meet at the two circular perforations on the reverse side. The outer petals are trefoil with pointed centers.

## 174. Flower

*Light greenish white jade*
*Ming*
*Length: 50mm; Width: 29mm;*
    *Thickness: 8mm*
*Chih-jou Chai Collection*

An elongated flower has a corona surrounded by four petals in an inner ring and six petals on the outside; the lowest petal of the inner ring folds over. There is a double perforation in the center.

## 175. Belt Slide

*Greenish white jade with brown veins*
*Yüan*
*Length: 67mm; Width: 46mm;*
    *Thickness: 12mm*
*Dr. and Mrs. Cheng Te-k'un*
*Published: Cheng Te-k'un, Jade*
    *Flowers, fig. 3d; Rawson and Ayers,*
    *Chinese Jade, no. 348.*

Rectangular in shape with open sides and back and a heavy loop at the lower end, this belt slide is decorated in openwork with a flying crane holding a lotus plant in its beak and accompanied by a swallow, both framed by a border of pearls.

This piece is dated to the Yüan period by comparison with a similar piece found in Inner

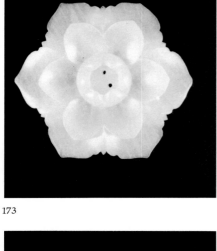

173

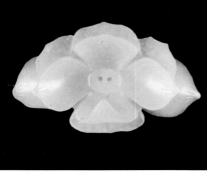

174

190

Mongolia (see Nei-meng-ku Tzu-chih-ch'ü Wen-wu-kung-tso-tui, *Nei-meng-ku Ch'u-t'u Wen-wu Hsüan-chi*, no. 185, p. 142). Like the rings in no. 158, this piece was used to suspend objects from a belt.

## 176. Openwork Plaque

> *Grayish white jade*
> *Yüan–early Ming (14th–15th*
> *centuries* A.D.*)*
> *Length: 67mm; Width: 56mm;*
> *Thickness: 5mm*
> *Chih-jou Chai Collection*

This rectangular plaque, carved in openwork, shows a dragon sporting amid foliage, surrounded by a border of pearls.

The connected-pearls border is similar to that of no. 175, which can be dated with some certainty to the Yüan period.

## 177. Openwork Belt Plaque

> *White jade*
> *Early Ming (15th century* A.D.*)*
> *Length: 52mm; Width: 50mm;*
> *Thickness: 10mm*
> *Chih-jou Chai Collection*

A square belt plaque is decorated in openwork with a playful dragon among five lychee-like fruits with their vines and leaves. The dragon's face, in profile, is grooved and incised.

The workmanship and the treatment of the dragon is very similar to no. 176, and the total effect is similar to several plaques in the Singer Collection (see Rawson and Ayers, *Chinese Jade*, no. 346).

## 178. Openwork Circular Plaque

> *White jade, slight brown mottling*
> *Early Ming (15th century* A.D.*)*
> *Diameter: 61mm; Thickness: 9mm*
> *Victor Shaw*

The motifs emerge in part from, and rest on, a circular band of jade that holds them in a broachlike form. The face of the pendant is carved in two layers of openwork. The top layer consists of a phoenix with outstretched wings and flowing crest and tails, sun and clouds, and peony flowers with grooved petals. The foliage of the peony forms the second layer of openwork. The reverse of the pendant is flat.

The two-layer openwork carving is characteristic of the Ming period, and the plain circular band is indicative of the fifteenth century.

See also the Ming openwork animal plaque with a palace workshop mark illustrated in the Introduction, fig. 3 a, b.

## 179. Openwork Plaque

> *White jade*
> *Ming (16th century* A.D.*)*
> *Length: 43mm; Width: 32mm;*
> *Thickness: 6mm*
> *Victor Shaw*

A rectangular plaque is decorated in openwork with a crane amid clouds, and has a bamboo-like frame.

The crane amid clouds motif is a common one in the decorative arts of the Chia-ching and Wan-li eras of the Ming period. This and the increasing use of a number of other motifs, such as the trigrams, indicate the rise of popular Taoism in the second half of the sixteenth century. The crane itself is a symbol of longevity, and it is often a means of transport of Taoist immortals.

## 180. Openwork Plaque

> *Greenish white jade*
> *Ming (second half 16th century* A.D.*)*
> *Length: 48mm; Width: 35mm;*
> *Thickness: 7mm*
> *Chih-jou Chai Collection*

A rectangular plaque is decorated in two-layer openwork with two flying cranes on a foliage background framed by a border of circles.

In later Ming carvings, the border of "pearls" is usually replaced by a border of circles with concave rather than convex surfaces. The cranes are similar to that of no. 179.

## 181. Openwork Belt Plaque

*Grayish white jade*
*Ming (16th century* A.D.*)*
*Length: 68mm; Width: 67mm;*
  *Thickness: 10mm*
*Chih-jou Chai Collection*

A peach-shaped plaque is decorated with a dragon among a mass of cloudlike floral motifs in openwork. The body of the dragon is slightly contoured giving it a roundish effect; the details of face, body, and claws are achieved by line incision and grooving.

Cheng Te-k'un, in "T'ang and Ming Jades," was the first to draw attention to openwork belt plaques like this one and give them a Ming date. Since the publication of his paper in 1954, many sets of jade belt plaques have been found archaeologically, especially in the provinces of Kiangsi and Kiangsu; unfortunately very few are illustrated in the reports. Judging from the material in the Kiangsi Provincial Museum in Nan-ch'ang, this kind of openwork dragon plaque appeared in the late fifteenth century and remained popular throughout the sixteenth century.

According to Ch'en Po-ch'üan of the Kiangsi Provincial Museum, a full set of jade belt plaques of the Ming period consists of nineteen pieces, of which six are peach-shaped like this piece, two are rectangular, seven are square, and four are narrow long pieces (*Wen Wu* 1964.2, p. 67).

## 182. Pierced Carving with Deer, Stork, and Tortoise

*White jade with yellow, brown, and*
  *black markings*
*Late Ming (second half 16th–first half*
  *17th centuries* A.D.*)*
*Height: 33mm; Length: 39mm;*
  *Width: 38mm*
*Victor Shaw*

An openwork carving depicts three deer in a forest of fruit trees and *ling-chih*. The deer munch on the fruits and the fungus; the stork has one leg raised, its head turned toward the tortoise that follows. Four perforations, in pairs, appear on the base.

Such pierced carvings are the knobs decorating lids of vessels, usually incense burners, in the late Ming period. Many have metal mounts. A good comparative example is in the Nanking Museum and illustrated in Foreign Languages Press, *Historical Relics Unearthed in New China*, p. 212.

The deer, stork, and tortoise are all auspicious animals with Taoist connotations.

## 183. Openwork Plaque

*Greenish white jade*
*Ch'ing (18th century* A.D.*)*
*Diameter: 57mm; Thickness: 11mm*
*Victor Shaw*

A round double-sided plaque is decorated in openwork with a pheasant amid prunus blossoms, the reverse bearing similar prunus blossoms and an orchid.

See also entry no. 145 for comment on jade carving in the eighteenth century.

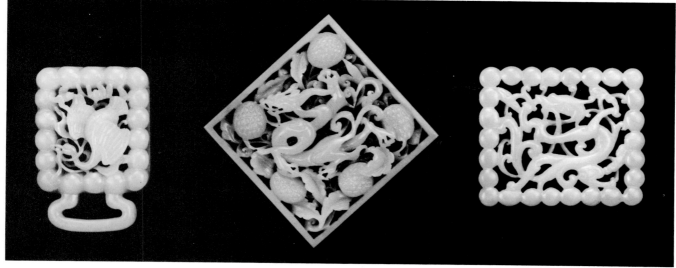

175

177

176

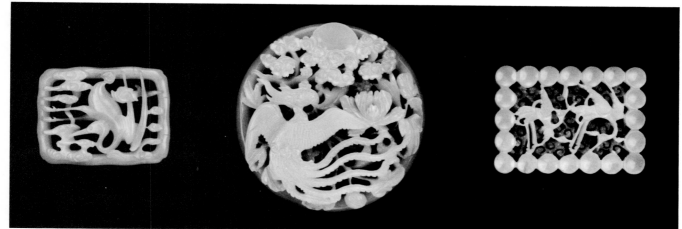

179

178

180

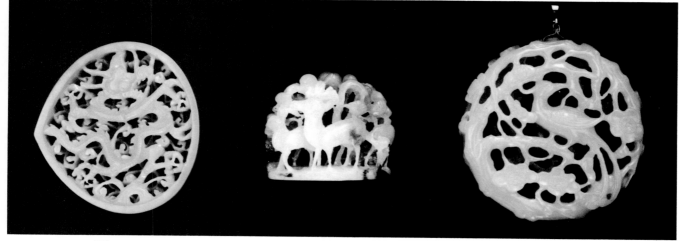

181

182

183

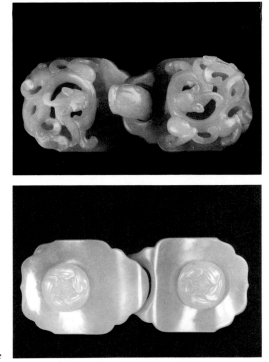

reverse

## 184. Belt Buckle

*Grayish white jade*
*Yüan–early Ming (14th–15th*
*centuries A.D.)*
*Length: 87mm; Width: 32mm;*
*Thickness: 21mm*
*Chih-jou Chai Collection*

A belt buckle has a dragon's head forming the hook and two similar *ch'ih*-dragons in full relief on the surface. The stud is decorated with five overlapping petals enclosing an androecium that is cross-hatched.

Belt buckles like this one have been found in Yüan and Ming archaeological sites. The decoration on the studs is also indicative of a fourteenth-century date; see entry no. 163.

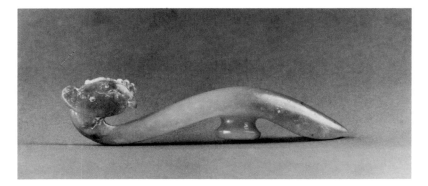

## 185. Belt Hook

*Yellow jade with brown markings*
*T'ang or later*
*Length: 76mm; Width: 9mm;*
*Height: 17mm*
*Chih-jou Chai Collection*

This hook has a slender form with a crested phoenix head; the remainder of the surface is undecorated. The stud is oblong.

Since its first appearance in China in the Eastern Chou period, the belt hook was in continuous use until the Ch'ing period. Jade belt hooks, rather like the scabbard slide, remained one of the standard forms of post-Han jade carving even if they were not often, if at all, put to practical use.[1] A large number of jade belt hooks are still extant today and they are varied in their forms and decorations, as indicated by descriptions and illustrations of them in antiquarian literature. However, there

is at present not sufficient archaeological data for a thorough study of post-Han belt hooks.

This belt hook is tentatively dated T'ang on account of the treatment of the phoenix head.

1. The history of the scabbard slide, including the antiquarian Chinese pieces, has been well expounded by William Trousdale in his study, *The Long Sword and Scabbard Slide in Asia.*

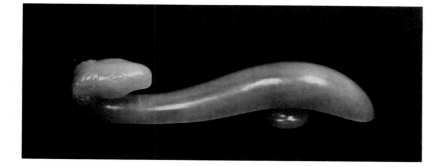

## 186. Belt Hook

*Greenish yellow jade*
*Ming or earlier*
*Length: 88mm; Width: 15mm;*
    *Height: 18mm*
*Guan-fu Collection*

A ram's head forms the hook on this slender piece, which has an otherwise undecorated surface. In basic form this belt hook is similar to no. 185.

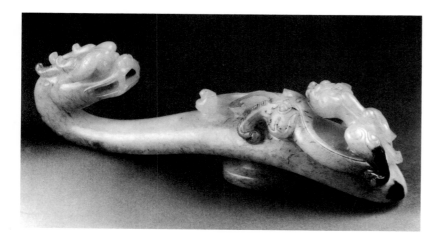

## 187. Belt Hook

*Mottled gray jade with black marks*
*Yüan–Ming*
*Length: 113mm; Width: 26mm;*
    *Height: 31mm*
*Victor Shaw*

An elongated oval shape with a broad dragon's head forms the hook; a *ch'ih*-dragon crawls on the surface of the tail. Underneath there is an oval stud.

The dragon's head and the *ch'ih*-dragon are stylistically dated to the fourteenth–fifteenth centuries.

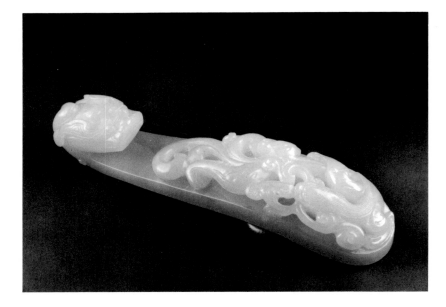

## 188. Belt Hook

*Translucent light green jade*
*Ming–Ch'ing*
*Length: 110mm; Width: 26mm;*
    *Height: 22mm*
*Chih-jou Chai Collection*

The belt hook has a dragon's head at the end; an elongated horned dragon holding a *ling-chih* in its mouth appears in full relief on the surface.

The form of this piece is similar to that of no. 187, but the treatment of the decoration has been conventionalized.

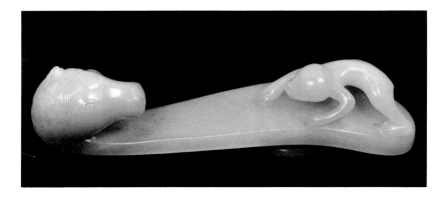

## 189. Belt Hook

*Grayish white jade*
*Ming*
*Length: 120; Width: 25mm;*
    *Height: 29mm*
*Victor Shaw*

The slender shape, with a detailed horse's head as the hook, has a crawling monkey carved in full relief on the surface.

The monkey and horse form an auspicious rebus popular in the late Ming period; see entry nos. 67 and 70.

## 190. Hair Ornament

*Light green jade with brown veins*
*Yüan–Ming*
*Height: 43mm; Length: 60mm;*
*Width: 40mm*
*Victor Shaw*

A hollowed barrel-shaped ornament has spirals in relief decorating the sides, raised ribs with a concave surface on the body, and two side perforations for a hairpin.

In Yüan and Ming times, this type of hair ornament was widely used as a fashionable revival of an "antique" mode of dress; the fashion itself probably began in the Sung period. Several such headdresses, made of various materials including jade, have been found in Yüan and Ming burials. After the fall of the Ming dynasty, these jade headdresses took on an even more antique look, as men were no longer allowed to wear their hair in any form other than in a long queue hanging down their backs.

There is a jade piece very similar to this one, excavated from a Ming tomb, in the museum in Wu-hsi, Kiangsu Province. This excavated piece is complete with the original jade hairpin.

See also Rawson and Ayers, *Chinese Jade,* no. 231; British Museum, *Jewellery through 7000 Years,* no. 305, p. 189.

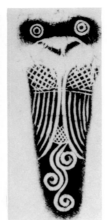

rubbing

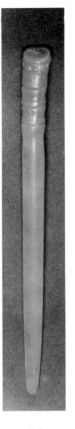

## 191. Hairpin

*Mottled green jade, calcified in parts*
*Yüan or earlier*
*Length: 144mm; Width (at top): 12mm*
*Guan-fu Collection*

This hairpin is decorated with a finely carved arched head of a bird with well-articulated beak and circular incised eyes. The neck moves down to a pair of carved wings on the front of the pin, ending in a series of spirals. The pin, of oval cross-section, tapers off to a gently pointed end.

Stylistically this piece is markedly different from the many Ming hairpins that have been found in Ming burials in recent years, of which nos. 193–195 are good examples. Precise dating will depend on future archaeological data.

## 192. Hairpin

*Grayish white jade*
*Yüan–Ming*
*Length: 120mm; Width (at top): 9mm*
*Guan-fu Collection*

The top of this hairpin is carved in the form of a bamboo root. The shaft of the pin is of oval cross-section.

A very similar hairpin is illustrated in Lung Ta-yüan's *Ku-yü T'u-p'u* (*chüan* 17, p. 7). Like no. 191, it is not in any of the styles of late Ming hairpins and may be accorded an earlier date.

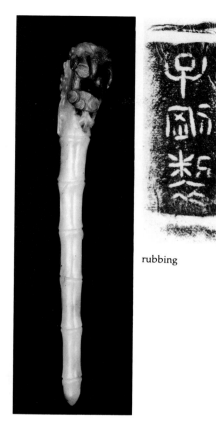

rubbing

rubbing

## 193. Hairpin

*Greenish white jade with brown
   markings*
*Late Ming*
*Length: 146mm; Width (at top): 26mm*
*Chih-jou Chai Collection*

The body of this pin is in the shape of a
bamboo branch with prunus blossoms, pine
needles, and a bamboo leaf on its upper part.
The pin is inscribed, "made by Tzu-kang."

The bamboo, prunus, and pine are the "three
friends of winter." The mark of Tzu-kang is
probably spurious, but the date of the piece
must come close to the lifetime of Lu Tzu-
kang.

## 194. Hairpin

*Grayish white jade*
*Ming*
*Length: 123mm*
*Guan-fu Collection*

The knob head of this fully carved, tapering
hairpin has a round-nosed *ch'ih* with its head
turned to bite into its shoulder. The shaft of the
pin is mainly decorated with one large *ch'ih*
with a finely incised horn, square jaw, and
bifurcated tail. A small *ch'ih* with open mouth
terminates the decoration.

A hairpin found in a Ming tomb in Su-chou
(dated in accordance with A.D. 1613) is de-
scribed as follows: "The length is 112cm, the
knob head bears a *ling-chih* design, and the
shaft of the pin has three *ch'ih*-dragons carved
in relief" (*Wen Wu* 1975.3, p. 53). Unfortunate-
ly, no illustration is provided.

The form of this pin is a standard one for the
Ming period. Another similar pin in a private
collection in Hong Kong bears the mark of Lu
Tzu-kang.

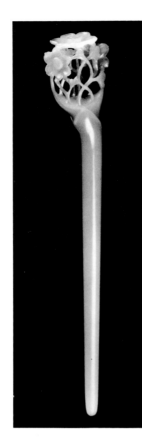

## 195. Hairpin

*Grayish white jade*
*Ming (16th–early 17th centuries A.D.)*
*Length: 200mm; Width (at top): 27mm*
*Mr. and Mrs. Alan E. Donald*

The head of this hairpin has a pierced floral-work design of a central six-petaled narcissus flower with a stalk that descends freely into the neck of the pin. Two other flowers define the narrow ends of the slightly squared head, while entwined stalks and birds decorate the wider sides. The neck of the pin emerges out of a "slipper" fold. The shaft descends to a tapered point.

This piece, like no. 194, is a classic example of a late Ming hairpin. The style and technique of this carving are similar to those of no. 182. In an often quoted poem by the painter Hsü Wei (A.D. 1521–1593) on narcissus flowers, the poet praises the jade carver Lu Tzu-kang for his skill in carving a jade hairpin like this one (Hsü Wei, *Ch'ing-t'eng Shu-wu Wen-chi*).

## 196. Hairpin

*Grayish white jade*
*Late Ming–Ch'ing*
*Length: 104mm; Width (at top): 29mm*
*Victor Shaw*

The head of the pin is a geometric stylization of a rosette with three *ju-i* scrolls and a pair of spirals enclosing a corona of twelve small petals around the seal character *shou* (longevity). The whole pin, with a flat shaft, is shaped rather like a *ju-i* scepter popular in the Ch'ing period.

This is a lady's hairpin as opposed to the narrower pins, which are mostly for men. Although most of the hairpins in this style are probably of Ch'ing date, they certainly began in the late Ming period, for similar pieces have been found in late Ming burials in Kiangsi and Kiangsu provinces.

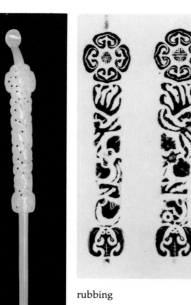

rubbing

## 197. Hairpin

*Grayish white jade*
*Late Ming–Ch'ing*
*Length: 211mm; Width: 18mm*
*Victor Shaw*

The uppermost decorative motif on this hairpin is a rosette consisting of four *ju-i* scrolls in openwork surrounding a corona with the seal script character for longevity; beneath it a "Buddha's hand" citron rests on a branch of peach fruits and a pomegranate flower, and the ornament terminates in a bat. The upper end of the pin is a small scoop for ear wax.

The Buddha's hand citron, the peach, and the pomegranate are known as the "three abundances" (of happiness, longevity, and sons). The decoration of this piece represents a superabundance of good omens. Hairpins with scoop ends also began in the late Ming (there are a few in the Wu-hsi Museum from late Ming burials), but the present piece is more likely to be from the eighteenth century.

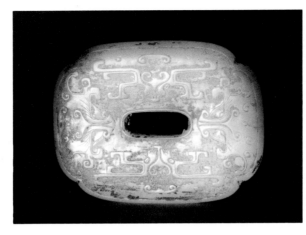

## 198. Pendant

*Pale greenish white jade with red earth
   encrustation*
*Probably Sung*
*Length: 66mm; Width: 52mm;
   Thickness: 4mm*
*Dr. Paul Singer*
*Published:* Gray et al., Arts of the
   Sung Dynasty, *no. 265; Rawson
   and Ayers,* Chinese Jade, *no. 292.*

One side of this pendant has bat and bovine masks worked into a pattern of archaistic design consisting of relief carving of the main features and light incised auxiliary lines at the edge with volute and grain patterns. The back has a stylized design of *ch'ih*-dragons among waves, with the waves indicated by a system of right-angle lines ending in volutes. Large empty areas are decorated with circular knobs in relief. The edge is framed by an incised line.

Close examination shows the surface uneven but laboriously polished very smooth with a soft abrasive that gives it a silken sheen.

The red soil encrustation is indicative of a possible Ch'ang-sha provenance, in which case it is unlikely that the dating can be later than Northern Sung, for the prosperity of Ch'ang-sha declined rather sharply during the Sung period and no Yüan burial site with rich contents has so far been reported in the province of Hunan.

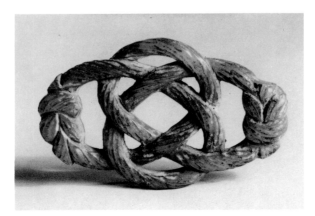

## 199. Pendant

*White jade with red earth encrustation*
*Probably Sung*
*Length: 80mm; Width: 50mm;
   Thickness: 8mm*
*Dr. Paul Singer*

The pendant is in the form of a rope tied into a loose knot. The workmanship of this piece is superb and the carving is of much greater strength than the twisted rope patterns of later pieces.

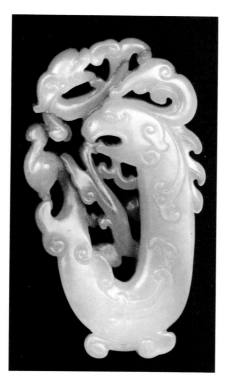

## 200. Openwork Dragon Plaque

*White jade with iron-rust reins*
*Sung–Ming*
*Length: 71mm; Width: 38mm;*
   *Thickness: 10mm*
*Victor Shaw*

This plaque is carved in openwork in the form of a snakelike dragon, whose tail ends in a phoenix head. There is a feline climbing on its side, and the dragon's head is surmounted by another small dragon.

This piece is typical of a large group of archaistic jade pendants usually given a Sung date, but there is relatively little archaeological or stylistic basis for such a dating in view of our lack of understanding of the development of archaistic decorative styles from the Sung to the Ming periods.

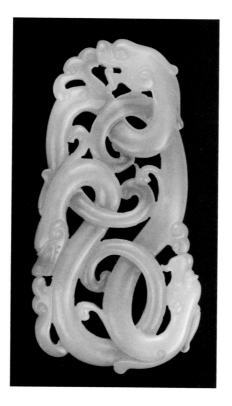

## 201. Openwork Pendant

*White jade*
*Sung–Ming*
*Length: 81mm; Width: 42mm;*
   *Thickness: 34–42mm*
*Charlotte Horstmann*

This pendant is in the form of three entwined dragon-snakes, heads touching a decorative motif that emerges out of each snakelike body. The dragon's head at the narrow end of the pendant has an open mouth, round snout, eyes with carved eyeballs, and a C scroll for the jaw. The whole design is one of fluidity and motion.

The heads of the dragons in this pendant are very similar to that of no. 200.

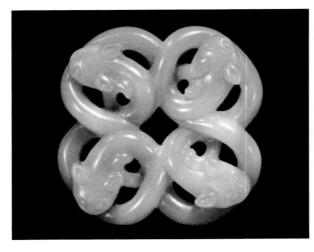

## 202. Pendant

*White jade*
*Sung–Ming*
*Diameter: 64mm; Thickness: 13mm*
*Seattle Art Museum; Eugene Fuller*
*Memorial Collection*

Four sinuous snake-dragons with interlocking bodies and rounded muzzles form this pendant.

Openwork carving with thick round bands certainly existed in the fifteenth century. The present state of knowledge on later jade carvings does not permit a more precise dating than late Sung to early Ming.

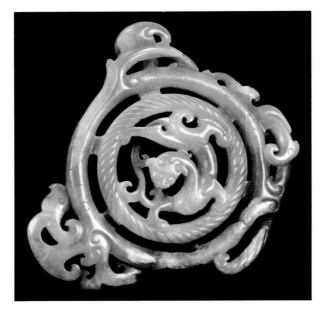

## 203. Pendant

*White jade with brownish mottling*
*Ming*
*Length: 68mm; Width: 66mm;*
*Thickness: 9mm*
*Seattle Art Museum; Eugene Fuller*
*Memorial Collection*

This pendant consists of a coiled *ch'ih*-dragon within a ring of twisted rope that is itself enclosed by a smooth ring decorated with incised scrolls and flanges of animal-like parts.

In terms of style and workmanship, this piece seems to stand halfway between nos. 199–202 and no. 204. The treatment of the dragon in the center is credibly Ming.

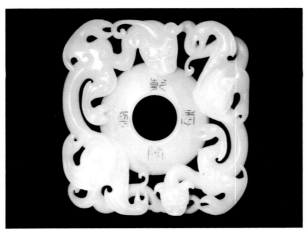

## 204. Pendant

*White jade*
*Ch'ing, Ch'ien-lung period*
*Length: 64mm; Width: 61mm;*
*Thickness: 8mm*
*Seattle Art Museum; Eugene Fuller*
*Memorial Collection*

This pendant has a ring in the center, shaped like a segment of an egg shell and incised with a Ch'ien-lung reign mark in four seal characters, surrounded by two dragons.

This piece is representative of the archaistic style of the eighteenth century and provides, with no. 203, excellent material for comparative study of Ming and Ch'ing archaism in jade.

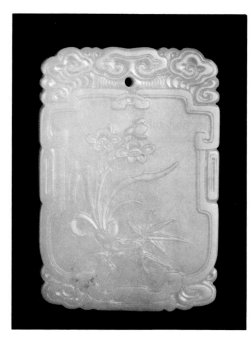

## 205. Plaque Pendant

*White jade*
*Late Ming*
*Length: 61mm; Width: 42mm;*
*    Thickness: 7mm*
*Chih-jou Chai Collection*

This rectangular plaque has a scrolling frame decorated with *ju-i* leaves; the center is decorated with narcissus, bamboo, and *ling-chih* fungus. The reverse bears a seal-like inscription of four characters read *hsien-chih chu-shou* (the fairy *chih* offers his congratulations and wishes you long life). There is one perforation in the upper part of the frame.

In the earliest plaque pendants, the "seal" inscription on one side is an auspicious saying of which the pictorial decoration on the other side is a rebus, as in the case of this piece. The style of these seal marks can be compared to the auspicious and commendatory marks on bronzes and on trade porcelains of the late Ming period. As pointed out in other entries in this catalogue, the late Ming period witnessed a great vogue for the use of rebuses of auspicious sayings in the decorative arts. Many of the rebuses invented in the Ming period have remained in use until today.

The design of the frame is in the style of sign boards of the Ming period. A good example of this design style is the cartouche at the end of the 1498 edition of the play *The Story of the West Chamber* enclosing the date and the name of the printer of the book (see fig. 205a).

fig. 205a.   Cartouche at the end of the 1498 edition of *The Story of the West Chamber.*

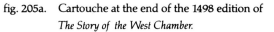

205

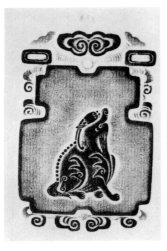

rubbing

## 206. Plaque Pendant

*White jade*
*Late Ming*
*Length: 74mm; Width: 48mm;*
  *Thickness: 8mm*
*Victor Shaw*

An overall rectangular plaque is decorated with a seated *t'ien-lu* with head turned upward and with knobbed spine. The frame is decorated with striations and *ju-i* clouds. There is a four-character mark *shou-t'ien pai-lu* on the reverse and one perforation in the upper part of the frame.

This piece is in exactly the same style as no. 205. The inscription includes the characters *t'ien* and *lu,* which constitute the name of the mythical animal, in an auspicious saying "a hundred favors from heaven."

rubbing of reverse

## 207. Plaque Pendant

*White jade*
*Ming–Ch'ing transitional (17th*
  *century A.D.)*
*Length: 49mm; Width: 40mm;*
  *Thickness: 7mm*
*Victor Shaw*

An oval plaque decorated in low relief shows on one side a man, Chang Ch'ien, on a hollow log raft, and on the other the Weaving Maid. There is one perforation near the top.

For the iconography of this piece, see entry no. 138. The representation of Chang Ch'ien on the raft is very close to that on the jade buckle from a late Ming tomb and now in the Shanghai Museum, referred to in entry no. 138. The style of the pictures is characteristic of the decorative art of the late Ming period, and the swirling cloud is a universal feature of late Ming-early Ch'ing pictorial art that finds its way even into literati painting.

## 208. Plaque Pendant

*White jade with pitted surface*
*Ming–Ch'ing transitional (17th*
*century A.D.)*
*Length: 49mm; Width: 34mm;*
*Thickness: 7mm*
*Wilfred Tyson*

On one side of this rectangular plaque, in low relief carving, is portrayed a mother in long robes holding a fan in one hand, the other hidden behind the form of a small child with a tuft of hair on his head. The other side portrays two children sitting under a plantain tree, playing with a top. The decoration is framed by elements of the picture itself—clouds, rocks, and a fence. There is one perforation near the top.

The general style of this piece is similar to that of no. 207. All the elements of the decoration—the swirling clouds, the rockery, the fence, the plantain, the representation of human figures—are characteristic of the decorative arts of the Ming–Ch'ing transitional period and may also be found in woodblock illustrations, blue-and-white porcelain, and carved decoration on wood, bamboo, and other materials including, of course, jade.

reverse

## 209. Plaque Pendant

*White jade*
*Ming–Ch'ing transitional (perhaps*
*second quarter 17th century* A.D.*)*
*Length: 55mm; Width: 32mm;*
*Thickness: 7mm*
*Guan-fu Collection*

A rectangular plaque is surmounted by two *k'uei*-dragons in openwork and decorated in low relief with a riverbank scene showing a fisherman in a sampan and a long-robed scholar holding a *ju-i* and walking toward a rocky hill. On the hill stands a gnarled tree that is a rather inept representation of a willow tree, judging by the poetic inscription on the reverse. Other elements of the landscape include a distant peak and swirling clouds. The reverse bears an inscription of a four-line poem, with five characters to the line, describing the scene and signed "Tzu-wang."

The decoration is quintessentially of the T'ien-ch'i period (A.D. 1621–1627) but could well extend to the beginning of the Ch'ing in the middle of the century. This is the beginning of the great period of jade carving in Su-chou, not only in technical virtuosity but in sheer quantity of work produced. This piece is also one of the first plaque pendants to be decorated with the double *k'uei* frame that is found on nearly all plaque pendants of the K'ang-hsi period.

The calligraphy, being in a hybrid style between the standard or regular script and the running script, is an invention of the late Ming period and commonly used at this time in decorative inscriptions. The carver is obviously not a well-lettered man, for he has made the rather touching mistake of writing the character *wang* for *kang* (the two characters are very similar) in "faking" the famous Tzu-kang mark.

rubbing

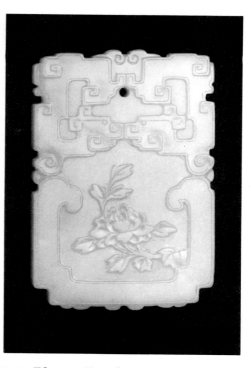

## 210. Plaque Pendant

*White jade*
*Early Ch'ing (second half 17th*
*century* A.D.)
*Length: 59mm; Width: 40mm;*
*Thickness: 5mm*
*Victor Shaw*

A rectangular pendant is decorated in low relief with a double *k'uei* border surrounding a peony flower on one side and a four-character seal mark, *yü-t'ang fu-kuei,* on the reverse that explains the import of the peony. There is one perforation in the upper part.

This piece represents a survival into the Ch'ing period of the late Ming style, although the *k'uei*-dragons are already much in evidence. The peony is the floral symbol of wealth and honor, and the inscription says, "wealth and honor in a jade hall."

The carving and polishing of this piece is of the highest standard.

rubbing

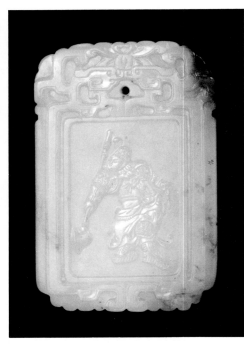

fig. 211a. Woodblock
    illustration of Sun Ts'e
    from the *Wu-shuang
    P'u.*

## 211. Plaque Pendant

*White jade with iron-rust markings
Ch'ing, K'ang-hsi period
Length: 55mm; Width: 36mm;
    Thickness: 7mm
Victor Shaw*

A rectangular plaque decorated in low relief has a warrior holding a shafted axe on one side and an inscription on the other, both surrounded by a double *k'uei* frame. There is one perforation in the upper part.

This is the classic "Tzu-kang plaque," a term which has been traditionally given to plaque pendants of this type because so many of them bear the signature of Tzu-kang, even if he himself may not have carved any. This one surprisingly does not bear the signature, but there is an identical one in the Seattle Art Museum which does, and there is at least one more "signed" piece in another private collection in Hong Kong. The poem and the illustration are taken from the *Wu-shuang P'u,* a

collection of decorative designs first published in the early Ch'ing period using famous or unique (*wu-shuang*) personages from the past as subject matter. The present subject is Sun Ts'e, elder brother of the first ruler of the Wu state in the time of the Three Kingdoms (A.D. 220–265). The four-line poem describes his bravery and bemoans his untimely death. The woodblock illustration in the mid-K'ang-hsi edition of the *Wu-shuang P'u* is reproduced (fig. 211a) for reference.

The K'ang-hsi period was undoubtedly the time when the best Tzu-kang plaques were produced. Until very recently there was almost universal belief among collectors and jade dealers (including the hereditary dealers in Peking) that Lu Tzu-kang lived in the Ch'ien-lung period and that pieces like this one were genuine works by him. This is another example of the amazing reputation, however undeserved, that the reign of Ch'ien-lung achieved in retrospect. This misconception is understandable considering the great decline that China suffered during the period after the Ch'ien-lung era.

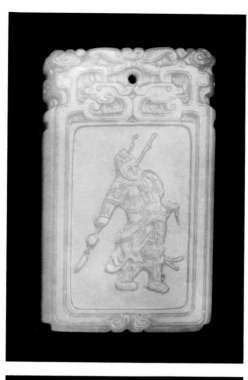

## 212. Plaque Pendant

*White jade with brownish mottling*
*Ch'ing, K'ang-hsi period*
*Length: 54mm; Width: 33mm;*
*Thickness: 7mm*
*Bei Shan Tang Collection*

A rectangular plaque is decorated in low relief with a warrior holding a spear; the reverse bears an inscription with the signature "Tzu-kang," and both sides are enclosed in a double *k'uei* frame. There is one perforation near the top.

This piece is in exactly the same style as no. 211. The design is in the style of the *Wu-shuang P'u* illustrations, but not that of the K'ang-hsi edition extant today. The figure is that of Chao Tzu-lung, a general of the state of Shu in the period of the Three Kingdoms who was known for his bravery.

reverse

fig. 213a. Woodblock illustration of Lady Hsien from the *Wu-shuang P'u*.

## 213. Plaque Pendant

*White jade*
*Ch'ing, K'ang-hsi period*
*Length: 60mm; Width: 40mm;*
    *Thickness: 6mm*
*Bei Shan Tang Collection*

The rectangular plaque decorated in high-relief shows a warrior framed by a double *k'uei* pattern. The reverse bears an inscription and the signature of Tzu-kang. There is one perforation near the top.

The subject of this plaque is also from the *Wu-shuang P'u*. The female warrior is Lady Hsien, wife of Feng Pao, prefect of Kao-liang in the sixth century, who was known for her military skills.

fig. 213b. Poem about Lady Hsien from the *Wu-shuang P'u*.

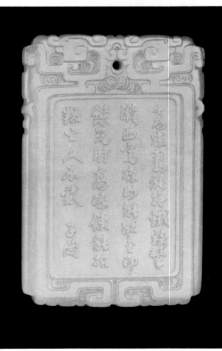

reverse

212

## 214. Tubular Bead

*White jade*
*Ch'ing, K'ang-hsi period*
*Height: 38mm; Diameter: 19mm*
*Philadelphia Museum of Art; Gift of*
*    Eugenia Fuller Atwood*

The bead is decorated with a relief carving of a man standing on a banana leaf holding up a wine cup in one hand and a fan in the other; beside him on the ground is a large wine pot in *t'ai-po tsun* shape with crackled glaze and another cup on a stand. The inscription is two lines from the *T'eng-wang Ko Hsü* (On the T'eng-wang Pavilion) by Wang Po (A.D. 648–675) with the signature of Tzu-kang.

Every element of the iconography of this piece is typical of the seventeenth century, in particular the banana leaf and the wine pot with the crackled glaze. Nearly all porcelain jars and vases depicted in late Ming and early Ch'ing paintings have crackled glazes, reflecting the great vogue in this period for the crackled effect in the decorative arts. People at this time used to bury porcelain jars in the ground to cause crazing of the glaze. The *t'ai-po tsun* shape of the wine jar is a common shape of the porcelain of the K'ang-hsi period.

The figure represented as holding up a wine cup is probably meant as T'ao Ch'ien. However, the accompanying inscription makes only a passing reference to T'ao Ch'ien in the first line and the second line makes references to both the Ts'ao family (ruling the Wei state at the time of the Three Kingdoms) and to Wang Hsi-chih, the most famous Chinese calligrapher of all times, who lived in the fourth century in the Eastern Chin period. Both lines quoted are meant to be adulatory remarks on the company assembled at the T'eng-wang Pavilion on the occasion of the writing of Wang Po's composition. However, this composition, which is in the *p'ien-wen* style (a composition in euphuistic and euphonius antithetical couplets), is also indicative of the period of the bead, for it was quite frequently used as an inscription on porcelains and other works of art in the seventeenth century and remained popular throughout the Ch'ing period.

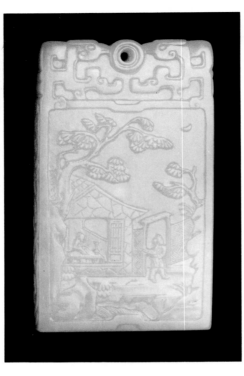

rubbing of reverse

## 215. Plaque Pendant

*White jade*
*Ch'ing, K'ang-hsi period*
*Length: 61mm; Width: 47mm;*
*    Thickness: 8mm*
*Victor Shaw*

A rectangular plaque pendant is designed in the form of a tablet with two *k'uei*-dragons facing each other, a circular perforation between them. The sides of the rectangle are carved with *ch'ih*-dragons. The pictorial side depicts a night scene, with trees blowing in the wind. Inside a house by a stream, a scholar sits at a table reading in the light of a candle, and a boy stands outside the gate observing the quarter moon. The inscription on the reverse side is a quotation from the famous *Ode to Autumn Sounds* by Ou-yang Hsiu, a poet-scholar-official of the Sung period. The signature is that of Tzu-kang.

The calligraphy of this piece is similar in style to that of no. 209 and should be of the same period. Ou-yang Hsiu's *Ode to Autumn Sounds* is, next to *Ode to the Red Cliff* by his near contemporary Su Shih, the most popular piece of literary composition used for decorative inscriptions in the Transitional to K'ang-hsi periods. The pictorial side provides an illustration to the text quoted.

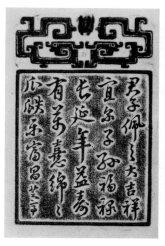

rubbing of reverse

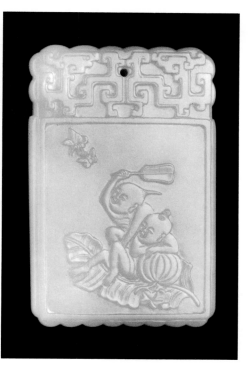

## 216. Plaque Pendant

*White jade*
*Ch'ing, K'ang-hsi period*
*Length: 64mm; Width: 43mm;*
*Thickness: 7mm*
*Chih-jou Chai Collection*

A rectangular plaque is decorated in low relief with two boys seated on a banana leaf; one chases two butterflies with a fan, the other holds a large gourd. The reverse is inscribed with a four-line poem and the signature of Chih-t'ing. The frame is surmounted by a double *k'uei* pattern.

This piece and no. 217 are signed Chih-t'ing, the only signature apart from that of Tzu-kang found on K'ang-hsi jade carvings. Other pieces signed Chih-t'ing are known, including one in the Philadelphia Museum of Art.

The gourd and butterflies constitute a rebus for "numerous descendants"—literally, spreading like melon vines—which is included in the auspicious inscription. The boys indicate that the offspring will be male.

rubbing of reverse

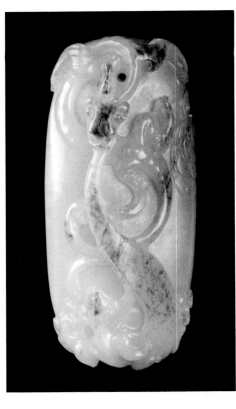

## 217. Pendant

*White jade with iron-rust markings*
*Ch'ing, K'ang-hsi period*
*Length: 63mm; Width: 29mm;*
*Thickness: 16mm*
*Chih-jou Chai Collection*

An elongated pendant is decorated in high relief with two dragons from the mouth of one of which issues a stream of water. The breakers on the edge of the water and swirling clouds provide a frame for the seven-character line, "The dragon submerges under the blue sea [waiting to] hear the spring thunder." The rust-brown skin is cleverly used to mark the backs of the animals and the jet of water. There is one perforation in the upper part. The signature reads, "playfully made by Chih-t'ing."

The carving of this piece is superb and has all the characteristics of the finest carving of the late seventeenth–early eighteenth centuries.

rubbing of reverse

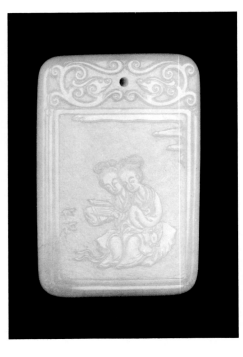

## 218. Plaque Pendant

*White jade*
*Ch'ing, Ch'ien-lung period*
*Length: 56mm; Width: 39mm;*
*Thickness: 8mm*
*Quincy Chuang, Esq.*

A rectangular plaque is decorated in low relief with two seated women reading a book on one side and an inscription on the reverse. The frame is plain and surmounted by two cursive dragons with a perforation between them. The signature is that of Tzu-kang.

The women depicted are the two Ch'iao sisters, famous beauties of the Three Kingdoms period. The inscription in clerical script is typical of most inscriptions of the Ch'ien-lung period, including inscriptions made on objects in the imperial collection. The cursive dragons with rounded snouts gradually replaced the square k'uei-type dragons on plaques in the eighteenth century.

216

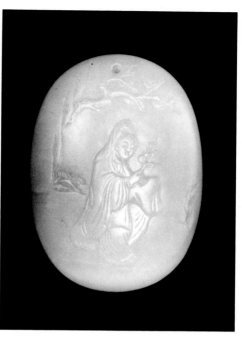

rubbings of both sides

## 219. Oval Pendant

*White jade*
*Ch'ing (second half 18th–early 19th*
*   centuries A.D.)*
*Length: 53mm; Width: 37mm;*
*   Thickness: 5mm*
*Victor Shaw*

On the reverse of the pendant is a poetic line that inspired the scene on the front of a man holding a branch of prunus walking among high cliffs near a prunus tree. There is one perforation at the top. The inscription is signed with a single character *Yung* and the seal reads, "Feng's seal."

The calligraphy, especially the large characters in clerical script, is in an elegant style suggestive of the second half of the Ch'ing period. The stippling on the rocky cliff and on the prunus branches is a well-known mannerism of the Su-chou school of hard stone carving from the eighteenth century onward.

The small-character running-script inscription reads: "after the *tz'u* poem of Liu T'un-t'ien," that is, Liu Yung, a Sung poet, but Liu Yung never wrote a line such as is inscribed in the larger characters in clerical script.

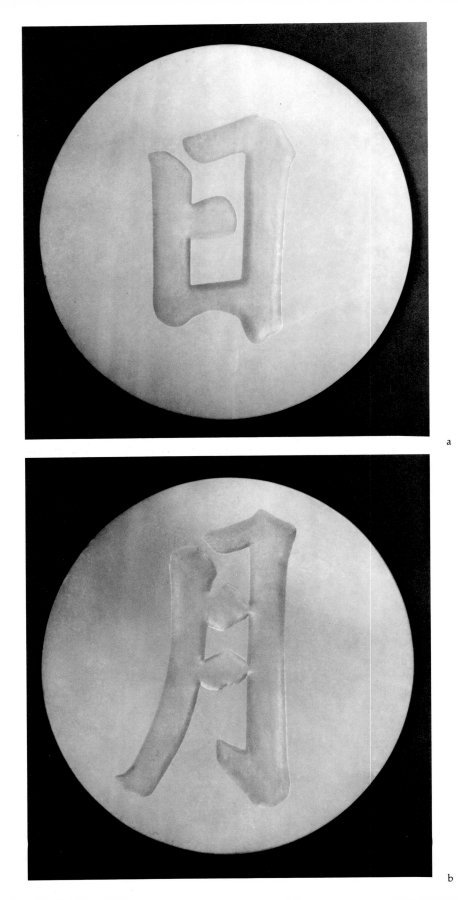

a

b

## 220. Pair of Decorative Discs

*Pale green jade*
*Ch'ing (late 17th–early 18th*
*centuries A.D.)*
*Diameter: 253mm; Thickness: 8mm*
*Joseph E. Hotung*

One of this pair of simple discs (a) is decorated in relief with the form of an elaborately coiffured and robed woman riding the waves on a gourd. The reverse side has the character for "sun" deeply carved in the center. The other disc (b) has the character for "moon" similarly carved on one side; on the other side is a scene carved in relief of two well-dressed women, one sitting on a stool with her elbow on the wooden stand for the book she is reading and the other on a bed with a matting top on which are a flower arrangement in a bronze *tsun*, books, and accessories for writing. On the upper right side is a four-line poem indicating that the two women are the Ch'iao sisters (see entry no. 218).

The elongated figure on the sun disc comes straight out of an early Ch'ing woodblock print, and the elaborate interior scene on the moon disc is in the style of illustrative paintings of the K'ang-hsi era.

Such disc-shaped desk screens, which probably began in the K'ang-hsi era, continued to be made throughout the Ch'ing period. The later versions often have four discs in the set.

rubbing of signature

## 221. Bird with a Peach

*White jade with iron-rust markings and*
*some calcification*
*Ch'ing, K'ang-hsi period*
*Height: 28mm; Length: 47mm;*
*Width: 31mm*
*Victor Shaw*

A small bird climbing on a peach curls itself to the shape, holding a peach-tree branch in its beak. Iron-rust markings are used effectively for the peach. A two-character mark on the underside reads: Tzu-kang.

The style of the signature of Tzu-kang in running script and the detailed carving suggest a date of K'ang-hsi similar to the plaque pendants with running-script inscriptions (nos. 210–214). The subject matter has a long ancestry going back to at least the Sung period (see also no. 82).

rubbing of inscription

## 222. Snuff Bottle

*Pale greenish white jade*
*Ch'ing, probably Ch'ien-lung period*
*Height: 31mm; Length: 65mm;*
*Width: 41mm*
*Anonymous loan*

This pear-shaped snuff bottle has a mottled green jadeite stopper. The sides are carved on one side with two poetic lines about prunus blossoms and the signature of Tzu-kang. The other side has an off-center relief carving of a prunus tree in blossom, rocks, and a small clump of bamboo leaves.

This is a case of a mark of Tzu-kang on a kind of vessel which Lu Tzu-kang himself would not have seen in his lifetime. The decoration is remarkably restrained, indicating an early date in the reign of Ch'ien-lung.

## 223. Pair of Bracelets

*White jade*
*Ch'ing, K'ang-hsi period or later*
*Diameter: 78mm; Thickness: 9mm*
*Seattle Art Museum; Eugene Fuller*
    *Memorial Collection*
*Published: Rawson and Ayers,* Chinese
    Jade, *no. 466.*

One bracelet is carved in three entwined loose strands, and the other is one continuous strand giving the effect of entwined loose strands. The former is marked with the characters *Ning-shou Kung* (Palace of Peace and Longevity) in a rectangular cartouche and the other with three characters each in a square reading *Shih(?)-ning Kung* (Palace of Generations [?] of Peace).

In the *Chin Shih,* History of Chin, in the section on geography, it is mentioned that north of the capital was a Ta-ming Kung, and that after the year A.D. 1179 the name was changed to Ning-shou Kung, and later again changed to Shou-an Kung. It would be nice to think that the mark on one of these bracelets is that of the Chin palace. However, in the *Ch'ing Shih Kao,* Draft Ch'ing History, in the section on queens and consorts, it is mentioned that from the reign of K'ang-hsi, the Dowager Empress lived in the palaces of Tz'u-ning, K'ang-shou, and Ning-shou. Thus one must give a date of K'ang-hsi or later to this bracelet and to its similarly worked and marked companion piece.

rubbing of signature

## 224. Bamboo-Shaped Ring

*Grayish white jade*
*Late Ming–Ch'ing*
*Diameter (outer): 52mm; Diameter*
*(inner): 35mm*
*Chih-jou Chai Collection*

A flat ring is decorated with a bamboo branch surrounded by leaves, the beginning and end overlapping. It is inscribed with the mark of Tzu-kang.

The ring may well be of late Ming date, but the mark may have been added later.

## 225. Thumb Ring

*White jade with brown markings*
*Ch'ing (late 17th –early 18th*
*centuries* A.D.)
*Height: 23mm; Diameter (outer): 28mm;*
*Diameter (inner): 19mm*
*Victor Shaw*

This thumb ring bears the mark of Lu Tzu-kang and a seven-character poetic line that describes a snowy mountain path. A heavily cloaked figure with a fly-whisk, seated on a donkey, is followed by a servant in a scene of prunus trees and rocks.

This much-worn piece has obviously seen considerable use since the time of its manufacture. The style of the calligraphy and pictorial decoration is that of the K'ang-hsi period.

The thumb ring of the Ch'ing period is derived from the archer's ring that must have been standard equipment for the nomadic Manchus in the early days.

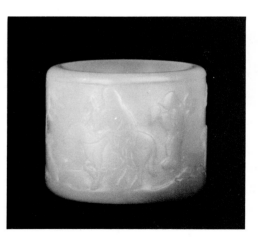

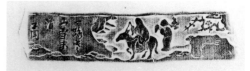

rubbing

## 226. Archer's Ring

*Grayish white jade*
*Ch'ing, K'ang-hsi period*
*Height: 10mm; Diameter (outer): 30mm;*
*Diameter (inner): 21mm*
*Victor Shaw*

The poet Li Po is depicted in a reclining position on a mat with one arm raising a goblet of wine. Beside him is a wine jar in crackled glaze with a ladle. On the other side of the ring are inscribed two lines referring to Li Po from a poem by Tu Fu on *The Eight Immortals in Wine* written in the running script. The piece is signed Chih-t'ing.

Tu Fu's light-hearted poem about the strong drinkers of Ch'ang-an in his time caught the imagination of illustrative artists of the late Ming period. There still exists a large number of finely painted handscrolls on this subject in the style of Ming figure paintings and signed indiscriminately with the names of Wen Cheng-ming, T'ang Yin, or Ch'iu Ying. Most of these scrolls are works by the professional painters of Su-chou in the seventeenth century and were mostly done in the K'ang-hsi period, although some of them may be of Ming date. *Famille verte* porcelain vases of the K'ang-hsi period were often decorated with scenes de-

picting the eight drinkers. The poet Li Po is sometimes singled out for individual representation as either a sculpture or a pictorial decoration. The shape of the wine jar and the crackled glaze are typical of the mid to late seventeenth century, as is the calligraphy.

## 227. Thumb Ring

*Grayish white jade*
*Ch'ing (19th century A.D.)*
*Height: 24mm; Diameter (outer): 28mm;*
*Diameter (inner): 24mm*
*Victor Shaw*

Grooved latticework borders a hunting scene of a horse and rider chasing a deer. Trees, rocks, and cirrus clouds are incised and cross-hatched. There is a four-character mark, "Chia-ch'ing Imperial Use."

Similar thumb rings housed in an elaborately constructed and decorated wooden box are in the collection of the Asian Art Museum of San Francisco and were exhibited in the Oriental Ceramic Society's jade exhibition in 1975 (Rawson and Ayers, *Chinese Jade*, no. 479). Although the mark may be apocryphal, the piece is credibly of nineteenth century date.

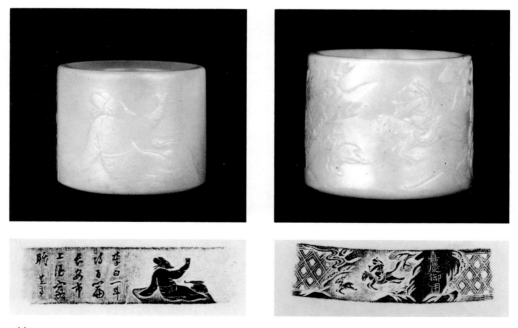

rubbing                    rubbing

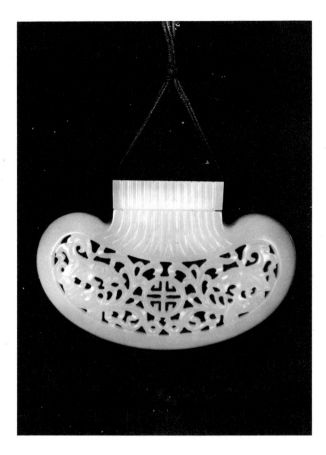

## 228. Pomander

*White jade*
*Ch'ing (18th century* A.D.*)*
*Height: 44mm; Length: 69mm;*
  *Width: 9mm*
*Dr. and Mrs. Cheng Te-k'un*

A purse-shaped pomander in three parts is decorated on each kidney-shaped lobe in openwork with two dissolved dragons and a longevity character in the center. The top is incised to form folds.

This is a fine example of Ch'ing carving of the eighteenth century. The dragons with foliated tails are latter-day versions of the makara. Two nearly identical pomanders with Ch'ien-lung marks were in the 1975 Oriental Ceramic Society jade exhibition (Rawson and Ayers, *Chinese Jade,* no. 465).

## 229. Pair of Earrings

*Greenish white jade*
*Ch'ing (18th–19th centuries* A.D.*)*
*Length: 39mm*
*Chih-jou Chai Collection*

These earrings are decorated in openwork with five-petaled flowers and butterflies. Earrings like this pair were made until quite recently.

# List of Chinese Names and Terms

A-ch'eng (Acheng)　阿城

An-hsi (Anxi)　安息

Ao-han (Aohan)　敖漢

Ao-li-mi (Aolimi)　奧里米

*ch'an (chan)*　蟾

*ch'an-ch'u (chanchu)*　蟾蜍

Chang Ch'ien (Zhang Qian)　張騫

Chang Ch'ou (Zhang Chou)　張丑

Chang Hsü (Zhang Xu)　張旭

Chang Hua (Zhang Hua)　張華

*Chang K'ung-mu Chih-k'an Mo-ho-lo (Zhang Kongmu Zhikan Moheluo)*　張孔目智勘魔合羅

Chang Shih-ch'eng (Zhang Shicheng)　張士誠

Chang Shih-nan (Zhang Shinan)　張世南

Chang T'ung-chih (Zhang Tongzhi)　張同之

Chang Ying-wen (Zhang Yingwen)　張應文

*Ch'ang-wu Chih (Changwu Zhi)*　長物志

Chao Erh-hsün (Zhao Erxun)　趙爾巽

Chao Tzu-lung (Zhao Zilong)　趙子龍

Ch'en Chi-ju (Chen Jiru)　陳繼儒

Ch'en Kuo-fu (Chen Guofu)　陳國符

Ch'en Lien-chen (Chen Lianzhen)　陳廉貞

Ch'en Meng-chia (Chen Mengjia)　陳夢家

Ch'en Po-ch'üan (Chen Boquan)　陳柏泉

Cheng-ho (Zhenghe)　政和

Cheng Min-chung (Zheng Minzhong)　鄭珉中

Cheng Te-k'un (Zheng Dekun)　鄭德坤

*Ch'eng-chai chen-wan (Chengzhai zhenwan)*　澄齋珍玩

Ch'eng Chün-fang (Cheng Junfang)　程君房

*Ch'eng-shih Mo-yüan (Chengshi Moyuan)*　程氏墨苑

Ch'eng-tu (Chengdu)　成都

*chi (ji)*　璣

Chi Yu-kung (Ji Yougong)　計有功

*ch'i (qi)*　氣

*Ch'i-hsi (Qixi)*　七夕

*Ch'i-hsiu Lei-kao (Qixiu Leigao)*　七修類稿

Chia Chou-chieh (Jia Zhoujie)　賈州杰

*Chia-i Sheng-yen (Jiayi Shengyan)*　甲乙剩言

Chiang Ch'un (Jiang Chun)　江春

Chiang-tso-chien (Jiangzuojian)　將作監

Ch'iao (Qiao)　喬

*Ch'ien-lung yü-shang (Qianlong yushang)*　乾隆御賞

*Ch'ien-shu Wang Chien Mu Fa-chüeh Pao-kao (Qianshu Wang Jian Mu Fajue Baogao)*　前蜀王建墓發掘報告

*Ch'ien-tzu-wen (Qianziwen)*　千字文

*chih (zhi)*　后

Chih-t'ing (Zhiting)　芝亭

*Chih-ya-t'ang Tsa-ch'ao (Zhiyatang Zachao)*　志雅堂雜鈔

*ch'ih (chi)*　螭

*chin ch'an (jin chan)*　金蟾

*chin ch'ien (jin qian)*　金錢

Chin Ku-liang (Jin Guliang)　金古良

Chin Shih (Jin Shi)　金史

*Chin Shih (Jin Shi)*　金史

*Ching Fu (Jing Fu)*　鏡賦

*Ching-pen T'ung-su Hsiao-shuo (Jingben Tongsu Xiaoshuo)*　京本通俗小說

*Ching-shih T'ung-yen (Jingshi Tongyan)*　警世通言

Ching-te Chen T'ao-tz'u Yen-chiu-so (Jingde Zhen Taoci Yanjiusuo)　景德鎮陶瓷研究所

*ch'ing (qing)*　磬

*ch'ing-pai (qingbai)*　青白

*Ch'ing Pi Tsang (Qing Bi Zang)*　清秘藏

*Ch'ing Shih Kao (Qing Shi Gao)*　清史稿

*Ch'ing-t'eng Shu-wu Wen-chi (Qingteng Shuwu Wenji)*　青籐書屋文集

*chiu (jiu)*　鳩

Ch'iu Ying (Qiu Ying)　仇英

*Ch'o Keng Lu (Chuo Geng Lu)*　輟耕錄

Chou Ch'en (Zhou Chen)　周臣

Chou Mi (Zhou Mi)　周密

Chou Tun-i (Zhou Dunyi)　周敦頤

Chu Hsi-tsu (Zhu Xizu)　朱希祖

Chu Pi-shan Lung-ch'a Chi (Zhu Bishan Longcha Ji)　朱碧山龍槎記

Chu Te-jun (Zhu Derun)　朱德潤

*chüeh (jue)*　块

Ch'un Yüan, Ch'i-shih-i (Chun Yuan, Qishiyi)　椿園　七十一

Chung-hsing (Zhongxing)　中興

Chung-hua Shu-chü (Zhonghua Shuju)　中華書局

Chung Kuang-yen (Zhong Guangyan)　鍾廣言

*Chung-kuo I-shu-chia Cheng-lüeh (Zhongguo Yishujia Zhenglue)*　中國藝術家徵略

*Chung-kuo ti Tz'u-ch'i (Zhongguo de Ciqi)*　中國的瓷器

*Chung-kuo Yü-ch'i Shih-tai Wen-hua Shih Kang (Zhongguo Yuqi Shidai Wenhua Shi Gang)*　中國玉器時代文化史綱

Feng (Feng)　馮

Feng Han-yih, Feng Han-i (Feng Hanyi)　馮漢驥

Feng-hsiang (Fengxiang)　鳳翔

Feng Meng-lung (Feng Menglong)　馮夢龍

Feng Pao (Feng Bao)　馮寶

*Feng Shen Yen I (Feng Shen Yan Yi)*　封神演義

*fu (fu)*　福

Fu Hsi (Fu Xi)　伏羲

*fu-pa (fuba)*　符拔

Hai-ch'an Tzu (Haichan Zi)　海蟾子

Han-shan (Hanshan)　寒山

*hao (hao)*　號

*ho (he)*　禾

*ho (he)*　和

*Ho-feng-t'ang Tu-shu Chi (Hefengtang Dushu Ji)*　和風堂讀書記

*ho-ho (he-he)*　和合

*ho-t'u (hetu)*　河圖

*hou-feng ti-tung i (houfeng didong yi)*　候風地動儀

*Hou-han Shu (Houhan Shu)*　後漢書

*Hsi-ching Tsa-chi (Xijing Zaji)*　西京雜記

Hsi-hsia (Xixia)　西夏

*Hsi-yü (Xiyu)*　西域

*Hsi-yü Yen-chiu (Xiyu Yanjiu)*　西域研究

*Hsi-yüan Ya-chi (Xiyuan Yaji)*　西園雅集

Hsia-ma (Xiama)　蝦蟆

Hsia Nai (Xia Nai)　夏鼐

Hsiang-kuo Ssu (Xiangguo Si)　相國寺

Hsiang Yü (Xiang Yu)　項羽

Hsiao-hsi-t'ien (Xiaoxitian)　小西天

Hsiao T'ung (Xiao Tong)　蕭統

*Hsiao-yüan Fu (Xiaoyuan Fu)*　小園賦

Hsieh Ying-po (Xie Yingbo)　謝英伯

Hsien (Xian)　洗

*hsien-pi (xianbi)*　羨璧

*Hsin Wu-tai Shih (Xin Wudai Shi)*　新五代史

*hsin-yu (xinyou)*　辛酉

Hsiu-nei-ssu (Xiuneisi)　修內司

Hsü Sung (Xu Song)　徐松

Hsü Wei (Xu Wei)　徐渭

Hsü Yü-fu (Xu Yufu)　許裕甫

*hsüan (xuan)*　玄

Hsüan-hua (Xuanhua)　宣化

Hsüan-miao (Xuanmiao)　玄妙

Hsüan-tsang, Hsüan-chuang (Xuanzang, Xuanzhuang)　玄奘

*hu (hu)*　壺

Hu Ying (Hu Ying)　胡應

*hua-pen (huaben)*　話本

*Hua Shih (Hua Shi)*　畫史

*huan (huan)*　貆

*huang (huang)*　璜

Huang T'ing-chien (Huang Tingjian)　黃庭堅

Huang-yu (Huangyou)　皇祐

*I Ching (Yi Jing)*　易經

*I-shu Ts'ung-pien (Yishu Congbian)*　藝術叢編

*I-wen Lei-chü (Yiwen Leiju)*　藝文類聚

*I-wu Chih (Yiwu Zhi)*　異物誌

Jao Tsung-i (Rao Zongyi)　饒宗頤

*ju-i (ruyi)*　如意

*ka-ha-la (gahala)*　嘎哈拉

*kang (gang)*　岡

K'ang-shou Kung (Kangshou Gong)　康壽宮

Kao Chü-hui (Gao Juhui)　高居誨

Kao Lien (Gao Lian)　高濂

*K'ao-ku (Kaogu)*　考古

*K'ao-ku-hsüeh ho K'o-chi-shih (Kaoguxue he Kejishi)*　考古學和科技史

*K'ao-ku Hsüeh-pao (Kaogu Xuebao)*　考古學報

*K'ao-ku T'u (Kaogu Tu)*　考古圖

K'ao-ku T'ung-hsün (Kaogu Tongxun)　考古通訊

K'ao-p'an Yü-shih (Kaopan Yushi)　考槃餘事

Ko Hung (Ge Hong)　葛洪

Ko Ku Yao Lun (Ge Gu Yao Lun)　格古要論

ku (gu)　瓠

Ku Chieh-kang (Gu Jiegang)　顧頡剛

Ku-kung Po-wu-yüan Yüan-k'an
　(Gugong Bowuyuan Yuankan)　故宮博物院院刊

Ku Kung-shuo (Gu Gongshuo)　顧公碩

Ku-pu-ku Lu (Gubugu Lu)　瓠不瓠錄

Ku-su Chih (Gusu Zhi)　姑蘇志

Ku Ying-t'ai (Gu Yingtai)　谷應泰

Ku-yü T'u (Guyu Tu)　古玉圖

Ku-yü T'u-k'ao (Guyu Tukao)　古玉圖考

Ku-yü T'u-p'u (Guyu Tupu)　古玉圖譜

kuai-tzu (guaizi)　枴子

kuan-yao (guanyao)　官窯

Kuang-ch'uan (Guangchuan)　廣川

Kuang-ming Jih-pao (Guangming Ribao)　光明日報

Kuang-wen Shu-chü (Guangwen Shuju)　廣文書局

kuei (gui)　圭

k'uei (kui)　夔

Kung-hsü (Gongxu)　公戌

Kuo-hsüeh Chi-pen Ts'ung-shu
　(Guoxue Jiben Congshu)　國學基本叢書

Kuo Yung (Guo Yong)　郭勇

La-ma-yeh-na yü Ch'en Hsün-chien
　Mei-ling Shih Ch'i Chi (Lamayena yu Chen Xunjian
　Meiling Shi Qi Ji)　「拉馬耶那」與「陳巡檢梅嶺失妻記」

Lang Ying (Lang Ying)　郎瑛

Li Ching (Li Jing)　李靖

Li Fang (Li Fang)　李放　李昉

Li Feng-kung (Li Fenggong)　李鳳公

Li Hsien (Li Xian)　李賢

Li Pien (Li Bian)　李昇

Li Shan (Li Shan)　李善

Li-tai Hsiao-shuo Pi-chi Hsüan (Lidai Xiaoshuo Biji
　Xuan)　歷代小說筆記選

Li Ti (Li Di)　李迪

Li T'ieh-kuai (Li Tieguai)　李鐵拐

lien (lian)　奩

Lin-an (Linan)　臨安

Lin P'ei-chih (Lin Peizhi)　林培志

ling-chih (lingzhi)　靈芝

Ling-kung (Linggong)　靈公

Ling-ling (Lingling)　零陵

Liu-ch'ao Ling-mu Tiao-ch'a Pao-kao (Liuchao Lingmu
　Diaocha Baogao)　六朝陵墓調查報告

Liu Hai (Liu Hai)　劉海

Liu Hai-ch'an (Liu Haichan)　劉海蟾

Liu Hsüan-ying (Liu Xuanying)　劉玄英

Liu Sheng (Liu Sheng)　劉勝

Liu Ts'un-yan, Liu Ts'un-jen (Liu Cunren)　柳存仁

Liu T'un-t'ien, Liu Yung
　(Liu Tuntian, Liu Yong)　柳屯田　柳永

Lo Fu-i (Luo Fuyi)　羅福頤

lo-hou-lo (luohouluo)　羅睺羅

lo-shu (luoshu)　洛書

lu (lu)　祿

Lu Tzu-kang (Lu Zigang)　陸子剛

Lü Ta-lin (Lü Dalin)　呂大臨

Lung-ch'üan (Longquan)　龍泉

Lung Ta-yüan (Long Dayuan)　龍大淵

Ma Yüan (Ma Yuan)　馬遠

Meng Han-ch'ing (Meng Hanqing)　孟漢卿

Meng Yüan-lao (Meng Yuanlao)　孟元老

Mi Fu, Mi Fei (Mi Fu, Mi Fei)　米芾

mi-se (mise)　秘色

Miao Ch'üan-sun (Miao Quansun)　繆荃孫

Ming-kuo (Mingguo)　明果

mo-hou-lo (mohouluo)　摩候羅

mo yü (mo yu)　墨玉

Nan-t'ang Erh-ling Fa-chüeh Pao-kao
　(Nantang Erling Fajue Baogao)　南唐二陵發掘報告

Nei-meng-ku Ch'u-t'u Wen-wu Hsüan-chi (Neimenggu
　Chutu Wenwu Xuanji)　內蒙古出土文物選集

Nei-meng-ku Tzu-chih-ch'ü Wen-wu-kung-tso-tui
　(Neimenggu Zizhiqu
　Wenwugongzuodui)　內蒙古自治區文物工作隊

Ni-ku Lu (Nigu Lu)　妮古錄

Nieh Ch'ung-i (Nie Chongyi)　聶崇義

Ning-shou Kung (Ningshou Gong)　寧壽宮

No-cha, Na-cha (Nuozha, Nazha)　哪吒

Ou-yang Hsiu (Ouyang Xiu)　歐陽修

Pai Yü-ch'an (Bai Yuchan)　白玉蟾

P'an Yung-yin (Pan Yongyin)　潘永因

Pao Chin Chai (Bao Jin Zhai)　寶晉齋

*Pao P'u Tzu (Bao Pu Zi)*　抱朴子

Pei-ching Hsi-chiao Hsiao-hsi-t'ien Ch'ing-tai
　Mu-tsang Fa-chüeh Chien-pao
　(Beijing Xijiao Xiaoxitian Qingdai Muzang
　Fajue Jianbao)　北京西郊小西天清代墓葬發掘簡報

*Pei-wei Shu (Beiwei Shu)*　北魏書

*pi-hsieh (bixie)*　辟邪

*pi-hui (bihui)*　避諱

Pi-sha-men T'ien-wang Fu-tzu yü Chung-kuo
　Hsiao-shuo ti Kuan-hsi (Bishamen Tianwang
　Fuzi yu Zhongguo Xiaoshuo
　de Guanxi)　毘沙門天王父子與中國小說的關係

Pien-ching (Bianjing)　汴京

*p'ien-wen (pianwen)*　駢文

*P'ing-hua P'u (Pinghua Pu)*　瓶花譜

*P'ing Shih (Ping Shi)*　瓶史

Po-hai (Bohai)　渤海

*Po-ku T'u (Bogu Tu)*　博古圖

*Po-wu Chih (Bowu Zhi)*　博物志

*Po-wu Yao-lan (Bowu Yaolan)*　博物要覽

*p'u-shou (pushou)*　鋪首

*San-ku T'u (Sangu Tu)*　三古圖

*San-li T'u (Sanli Tu)*　三禮圖

Shang-lin-hu (Shanglinhu)　上林湖

Shao-fu-chien (Shaofujian)　少府監

Shen Kua (Shen Gua)　沈括

*sheng (sheng)*　笙

Shih-chieh Shu-chü (Shijie Shuju)　世界書局

*Shih-i Chi (Shiyi Ji)*　拾遺記

*Shih-mien Tiao-k'o chih Po-hai Jen Feng-su yü
　Sa-shan-shih Hu-p'ing (Shimian Diaoke zhi Bohai
　Ren Fengsu yu Sashanshi
　Huping)*　石面雕刻之渤海人 風俗與薩珊式胡瓶

Shih-ning Kung (Shining Gong)　世寧宮

Shih-te (Shide)　拾得

*shih-tzu (shizi)*　獅子

*shou (shou)*　壽

Shou-an Kung (Shouan Gong)　壽安宮

Shou-lao (Shoulao)　壽老

Shou-pa (Shouba)　首拔

*shou-t'ien pai-lu (shoutian bailu)*　壽天百祿

Shu-chih (Shuzhi)　樹枝

*shuang huan (shuang huan)*　雙鑊

*shuang-kou (shuanggou)*　雙鈎

*Shuo Fu (Shuo Fu)*　說郛

Ssu-ma Chin-lung (Sima Jinlong)　司馬金龍

*Su-chou Cho-yü Kung-i (Suzhou Zhuoyu Gongyi)*
　蘇州琢玉工藝

*Su-chou-fu Chih (Suzhoufu Zhi)*　蘇州府志

Su T'ien-chün (Su Tianjun)　蘇天鈞

Sun K'ai-ti (Sun Kaidi)　孫楷弟

Sun Ts'e (Sun Ce)　孫策

*Sung Hui-yao Chi-kao (Song Huiyao Jigao)*　宋會要輯稿

*Sung Pai Lei-ch'ao (Song Bai Leichao)*　宋稗類鈔

*Sung Shih (Song Shi)*　宋史

Sung Ying-hsing (Song Yingxing)　宋應星

Ta-li (Dali)　達利

*Ta Ming Hsüan-te-nien Chih (Da Ming Xuandenian
　Zhi)*　大明宣德年製

*Ta Ming I-t'ung Chih (Da Ming Yitong Zhi)*　大明一統志

Ta-ming Kung (Daming Gong)　大明宮

*T'ai-ch'ang-chou Chih (Taichangzhou Zhi)*　太倉州志

*T'ai-chi (Taiji)*　太極

*T'ai-hu (Taihu)*　太湖

T'ai-i Chen-jen (Taiyi Zhenren)　太乙眞人

T'ai-lien Kuo-feng Ch'u-pan-she (Tailian Guofeng
　Chubanshe)　台聯國風出版社

*T'ai-p'ing Kuang-chi (Taiping Guangji)*　太平廣記

*t'ai-po tsun (taibo zun)*　太白尊

*T'ai-shang huang-ti chih pao
　(Taishang huangdi zhi bao)*　太上皇帝之寶

*T'an-chai Pi-heng (Tanzhai Biheng)*　坦齋筆衡

*T'ang-shih Chi-shih (Tangshi Jishi)*　唐詩記事

T'ang Yin (Tang Yin)　唐寅

*Tao-tsang Yüan-liu K'ao (Daozang Yuanliu Kao)*　道藏源流考

T'ao Ch'ien (Tao Qian)　陶潛

*t'ao-pa (taoba)*　桃拔

*t'ao-t'ieh (taotie)*　饕餮

T'ao Tsung-i (Tao Zongyi)　陶宗儀

Teng Chih-ch'eng (Deng Zhicheng)　鄧之誠

*Teng-she Pien (Dengshe Bian)*　登涉篇

Teng T'o (Deng Tuo)　鄧拓

T'eng Ku (Teng Gu)　滕固

*T'eng-wang Ko Hsü (Tengwang Ge Xu)*　滕王閣序

ti-t'ing (diting)　謠聽

T'ien (Tian)　天

T'ien Kung K'ai Wu (Tian Gong Kai Wu)　天工開物

t'ien-lu (tianlu)　天祿（天鹿）

T'ien-sheng (Tiansheng)　天聖

T'ien-tu (Tiandu)　天都

t'o-lung (tuolong)　鼉龍

T'o T'o (Tuo Tuo)　脫脫

Tou Wan (Dou Wan)　竇綰

Tsang Mao-hsün (Zang Maoxun)　臧懋循

Ts'ao (Cao)　曹

tsun (zun)　尊

Ts'ung-shu Chi-ch'eng Ch'u-pien (Congshu Jicheng Chubian)　叢書集成初編

Tu-jen Ching (Duren Jing)　度人經

Tu Yu (Du You)　杜佑

T'u Lung (Tu Long)　屠隆

Tuan Ch'eng-shih (Duan Chengshi)　段成式

Tun-huang (Dunhuang)　敦煌

Tung-ching Meng-hua Lu (Dongjing Menghua Lu)　東京夢華錄

Tung-fang Shuo (Dongfang Shuo)　東方朔

Tung-t'ien Chi (Dongtian Ji)　洞天集

T'ung-tien (Tongdian)　通典

Tzu-wang (Ziwang)　子岡

tz'u (ci)　詞

Tz'u-ning Kung (Cining Gong)　慈寧宮

wan-shou ch'ang-ch'un (wanshou changchun)　萬壽長春

Wan Shou-ch'i (Wan Shouqi)　萬壽祺

wang (wang)　罔

Wang Ao (Wang Ao)　王鏊

wang chang (wang zhang)　王枚

Wang Chen-to (Wang Zhenduo)　王振鐸

Wang Ch'eng (Wang Cheng)　王成

Wang Chia (Wang Jia)　王嘉

Wang Chien (Wang Jian)　王建

Wang Ch'ü-fei (Wang Qufei)　王去非

Wang Fu (Wang Fu)　王黼

Wang Hsi-chih (Wang Xizhi)　王羲之

Wang I (Wang Yi)　王逸

Wang Jen-ts'ung (Wang Rencong)　王人聰

Wang Po (Wang Bo)　王勃

Wang Shih-chen (Wang Shizhen)　王世貞

Wang Tu (Wang Du)　王度

Wang Ying-lin (Wang Yinglin)　王應麟

Wei Shou (Wei Shou)　魏收

Wen Chen-heng (Wen Zhenheng)　文震亨

Wen Cheng-ming (Wen Zhengming)　文徵明

Wen Hsüan (Wen Xuan)　文選

Wen-hsüeh (Wenxue)　文學

Wen-hua Ta-ko-ming Ch'i-chien Ch'u-t'u Wen-wu (Wenhua Dageming Qijian Chutu Wenwu)　文化大革命期間出土文物

Wen-ssu-yüan (Wensiyuan)　文思院

Wen Wu (Wenwu)　文物

Wen-wu Ts'an-k'ao Tzu-liao (Wenwu Cankao Ziliao)　文物參考資料

Wu-i-shan-li (Wuyishanli)　烏弋山離

Wu-li-p'ai (Wulipai)　五里牌

Wu-lin Chiu-shih (Wulin Jiushi)　武林舊事

wu-shuang (wushuang)　無雙

Wu-shuang P'u (Wushuang Pu)　無雙譜

Wu Ta-ch'eng (Wu Dacheng)　吳大澂

wu-t'ung (wutong)　梧桐

Wu-wei Han-chien (Wuwei Hanjian)　武威漢簡

yang (yang)　陽

Yang Hsian-kuei, Yang Hsiang-k'uei (Yang Xiangkui)　楊向奎

Yang Lien (Yang Lian)　楊鍊

Yang Po-ta (Yang Boda)　楊伯達

Yang Ssu-hsü (Yang Sixu)　楊思勗

Yeh Chih (Ye Zhi)　葉寘

Yen Chih-t'ui (Yan Zhitui)　顏之推

Yen-hsien Ch'ing-shang Chien (Yanxian Qingshang Jian)　燕閒清賞箋

Yen Hui (Yan Hui)　顏輝

Yen Li-pen (Yan Liben)　閻立本

Yen-shan Yeh-hua (Yanshan Yehua)　燕山夜話

Yen-shih Chia-hsün (Yanshi Jiaxun)　顏氏家訓

Yin-chang Kai-shu (Yinzhang Gaishu)　印章概述

ying-hsiung (yingxiong)　鷹熊（英雄）

Yu Mao (You Mao)　尤袤

Yu Yang Tsa Tsu (You Yang Za Zu)　酉陽雜組

Yu-yü (You-yu)　右玉

yü (yu)　玉

*Yü Hai (Yu Hai)* 玉海

*Yü Hsin (Yu Xin)* 庾信

*Yü Huan Chi Wen (Yu Huan Ji Wen)* 游宦紀聞

*yü-pi (yubi)* 玉璧

*yü-t'ang fu-kuei (yutang fugui)* 玉堂富貴

Yü-tien, Yü-t'ien (Yudian, Yutian) 于闐

*Yü Ya (Yu Ya)* 玉雅

*Yü-yang Shan-jen (Yuyang Shanren)* 漁洋山人

*Yü-yung-chien Tsao (Yuyongjian Zao)* 御用監造

*Yüan-ch'ü Hsüan (Yuanqu Xuan)* 元曲選

Yüan Hung-tao (Yuan Hongdao) 袁宏道

Yüan-ming Yüan (Yuanming Yuan) 圓明園

Yüan Yü-ch'ang (Yuan Yuchang) 袁遇昌

Yüeh-chih (Yuezhi) 月氏

*yün-ch'i (yunqi)* 雲氣

*Yün-yen Kuo-yen Lu (Yunyan Guoyan Lu)* 雲煙過眼錄

Yung (Yong) 勇

Yung-chi (Yongji) 永濟

Yung-feng (Yongfeng) 永豐

Yung-lo Kung (Yongle Gong) 永樂宮

# Selected Bibliography

CHENG TE-K'UN, *Jade Flowers and Floral Patterns in Chinese Decorative Art*, reprinted from the *Journal of the Institute of Chinese Studies* (Hong Kong) 2 (1969).

CHENG TE-K'UN, "T'ang and Ming Jades," *Transactions of the Oriental Ceramic Society* (London) 28 (1953–1954).

CHU TE-JUN, *Ku-yü T'u* [Ancient Jades Illustrated], compiled 1341, *San-ku T'u* ed., 1752.

D'ARGENCÉ, R.-Y. L., *Chinese Jades in the Avery Brundage Collection*, 2nd rev. ed., San Francisco, 1977 (referred to as *Brundage Jades*).

DOHRENWEND, D., *Chinese Jades in the Royal Ontario Museum*, Toronto, 1971.

FENG HAN-YIH, *Ch'ien-shu Wang Chien Mu Fa-chüeh Pao-kao* [The Tomb of Wang Chien of the Former Shu Dynasty], Peking, 1964.

Foreign Languages Press, *Historical Relics Unearthed in New China*, Peking, 1972.

GURE, D., "Selected Examples from the Jade Exhibition at Stockholm, 1963; A Comparative Study," *Bulletin of the Museum of Far Eastern Antiquities*, no. 36 (1964).

GURE, D., "Jades of the Sung Group," *Transactions of the Oriental Ceramic Society* (London) 32 (1959–1960).

GURE, D., "An Early Jade Animal Vessel and Some Parallels," *Transactions of the Oriental Ceramic Society* (London) 31 (1957–1959).

GURE, D., "Some Unusual Early Jades and Their Dating," *Transactions of the Oriental Ceramic Society* (London) 33 (1960–1961).

HANSFORD, S. H., *Chinese Carved Jades*, New York, 1968.

HANSFORD, S. H., *Chinese Jade Carving*, London, 1950.

HARTMAN, J. M., *Three Dynasties of Jade*, Indianapolis Museum of Art, 1971.

HAYASHI MINAO, "Haigyoku to Jū," [Jade Girdle Pendants and Cords for Suspending Ceremonial Objects], *Tōhō Gakuhō* 45 (1973), pp. 1–57.

KAO LIEN, *Yen-hsien Ch'ing-shang Chien*, collected in *I-shu Ts'ung-pien*, Shih-chieh Shu-chü ed., Taipei, 1962.

*K'ao-ku* (also *K'ao-ku T'ung-hsün*), Peking, 1955—

KKHP; *K'ao-ku Hsüeh-pao*, Peking, 1951—

KKTH; *K'ao-ku T'ung-hsün*, see *K'ao-ku*.

KU YING-T'AI, *Po-wu Yao-lan* [General Survey of Art Subjects], compiled 1639, reprinted Shanghai Commercial Press, 1960.

KUWAYAMA, G., *Chinese Jade from Southern California Collections*, Los Angeles, 1976.

LEE, S. E., "Chinese Carved Jades," *The Bulletin of The Cleveland Museum of Art* 41 (April 1954).

LOEHR, M., *Ancient Chinese Jades from the Grenville L. Winthrop Collection in the Fogg Art Museum*, Cambridge, Mass., 1975.

LÜ TA-LIN, *K'ao-ku T'u* [Pictures for the Study of Antiquities], compiled 1092, *San-ku T'u* ed., reprinted T'ien-tu, 1752.

LUNG TA-YÜAN, *Ku-yü T'u-p'u* [Illustrated Album of Ancient Jades], first issued in 1175, published again in 1779 by Chiang Ch'un.

NA CHIH-LIANG, *Chinese Jades, Archaic and Modern, from the Minneapolis Institute of Arts*, London, 1977.

NATIONAL PALACE MUSEUM, *Masterworks of Chinese Jade in the National Palace Museum*, Taipei, 1969.

NEI-MENG-KU TZU-CHIH-CH'Ü WEN-WU-KUNG-TSO-TUI, *Nei-meng-ku Ch'u-t'u Wen-wu Hsüan-chi* [Selection of Archaeological Finds from Inner Mongolia], Peking, 1963.

PALMER, J. P., *Jade*, London, 1967.

PINDAR-WILSON, R., AND W. WATSON, "An Inscribed Jade Cup from Samarkand," *The British Museum Quarterly* 23 (1960–1961), no. 1.

PIRAZZOLI-T'SERSTEVENS, M., "Un Jade Chinois des Collections de Louis XIV au Musée Guimet," *Arts Asiatiques* 25 (1972), pp. 199–204.

RAWSON, J., AND J. AYERS, *Chinese Jade throughout the Ages*, catalogue of an exhibition organized by the Arts Council of Great Britain and the Oriental Ceramic Society, London, 1975.

SALMONY, A., *Archaic Chinese Jades from the Edward and Louise B. Sonnenschein Collection*, Chicago, 1952.

SALMONY, A., *Chinese Jade through the Wei Dynasty*, New York, 1963.

*A Selection of Archaeological Finds of the People's Republic of China*, Wen Wu Press, Peking, 1976.

SKELTON, R., "The Relations between the Chinese and Indian Jade Carving Traditions," in *Westward Influence of the Chinese Arts*, Colloquies on Art and Archaeology in Asia, no. 3, London, 1973.

TOKYO NATIONAL MUSEUM, *The Exhibition of Ancient Art Treasures of the People's Republic of China— Archaeological Finds of the Han to T'ang Dynasties Unearthed at Sites along the Silk Road*, Tokyo and Osaka, 1979 (referred to as *Silk Road Exhibition*).

TSCC; *Ts'ung-shu Chi-ch'eng*.

T'U LUNG, *K'ao-p'an Yü-shih*, collected in *Ts'ung-shu Chi-ch'eng Ch'u-pien*, vol. 1559, Shanghai, 1937.

*Wen Wu* (also *Wen-wu Ts'an-k'ao Tzu-liao*), Peking, 1950—

WU TA-CH'ENG, *Ku-yü T'u-k'ao* [Illustrated Study of Ancient Jade in the Author's Collection], Shanghai, 1889.

WWTKTL; *Wen-wu Ts'an-k'ao Tzu-liao*, see *Wen Wu*.

# Other Works Cited in the Text

BUNKER, E. C., C. B. CHATWIN, AND A. R. FARKAS, "Animal Style" Art from East to West, New York, 1970.

BRITISH MUSEUM, Jewellery through 7,000 Years, London, 1976.

CHANG HUA, Po-wu Chih, collected in Ts'ung-shu Chi-ch'eng Ch'u-pien, vol. 1342, Shanghai, 1939.

CHANG SHIH-NAN, Yü Huan Chi Wen, collected in Ts'ung-shu Chi-ch'eng, vol. 2871, Shanghai, 1936.

CHANG YING-WEN, Ch'ing Pi Tsang [Collection of Artistic Rarities], collected in I-shu Ts'ung-pien, vol. 28, Taipei, 1962.

CHAO ERH-HSÜN, Ch'ing Shih Kao [Draft History of the Ch'ing Dynasty], reprinted Hong Kong, 1960?

CH'EN CHI-JU, Ni-ku Lu, collected in Ts'ung-shu Chi-ch'eng, vol. 1558, Shanghai, 1937.

CH'EN KUO-FU, Tao-tsang Yüan-liu K'ao [The History of the Tao-tsang], Chung-hua Shu-chü ed., Peking, 1963.

CH'EN LIEN-CHEN, "Su-chou Cho-yü Kung-i" [The Art of Jade Carving in Su-chou], Wen Wu (1959), no. 4, pp. 37–39.

CH'EN MENG-CHIA, Wu-wei Han-chien [Han Inscribed Strips from Wu-wei], Peking, 1964.

CH'ENG CHÜN-FANG, Ch'eng-shih Mo-yüan, first published 1595.

CHENG MIN-CHUNG, "Chu Pi-shan Lung-ch'a Chi" [The Dragon-Rafts by Chu Pi-shan], Ku-kung Po-wu-yüan Yüan-k'an (Peking), no. 2 (1960).

CHI YU-KUNG, T'ang-shih Chi-shih [Anecdotes Relating to T'ang Poetry], vol. 34, Chung-hua Shu-chü ed., Peking, 1965.

CHIN SHIH, Wu-shuang P'u [Album of Unique Characters], first published 1690, reprinted Hong Kong, 1979.

CHING-TE CHEN T'AO-TZ'U YEN-CHIU-SO, Chung-kuo ti Tz'u-ch'i [The Porcelain of China], Peking, 1963.

CHOU MI, Wu-lin Chiu-shih [Anecdotes of Wu-lin], compiled 1280–1290, Chung-hua Shu-chü ed., Shanghai, 1962.

CHU HSI-TSU ET AL., Liu-ch'ao Ling-mu Tiao-ch'a Pao-kao [The Tombs of the Six Dynasties], Monumenta Sinica, vol. 1, Nanking, 1935.

CH'U-T'U WEN-WU CHAN-LAN KUNG-TSO-TSU, Wen-hua Ta-ko-ming Ch'i-chien Ch'u-t'u Wen-wu [Cultural Relics Unearthed During the Cultural Revolution], Peking, 1972.

DAVID, P., Chinese Connoisseurship, London, 1971.

DAVIDOVA, A. V., "On the Question of the Hun Artistic Bronzes," Sovietskaia Archeologia 93 (1971).

ELIADE, M., Shamanism, translated by W. R. Trask, Princeton, 1964.

FENG MENG-LUNG, Ching-shih T'ung-yen, Chung-hua Shu-chü ed., Hong Kong, 1978.

FUJITA TOYOHACHI (trans. Yang Lien), "The Rivers Shu-chih and Ta-li in Yü-tien," Hsi-yü Yen-chiu [Studies on the Western Regions], Jen-jen Wen-k'u ed., Taipei, 1970.

GARNER, H., Chinese and Japanese Cloisonné Enamels, London, 1970.

GRYAZNOV, M. P., The Ancient Civilisation of Southern Siberia, translated by James Hogarth, Geneva, 1969.

GUMP, R., Jade, Stone of Heaven, New York, 1962.

GYLLENSVÄRD, B., Chinesische Kunst Sammlung König Gustav VI Adolf, Stockholm, 1977.

GYLLENSVÄRD, B., "Lo-tien and Laque Burgautée," Bulletin of the Museum of Far Eastern Antiquities 44 (1972).

GYLLENSVÄRD, B., T'ang Gold and Silver, reprinted from the Bulletin of the Museum of Far Eastern Antiquities 29, Stockholm, 1957.

GYLLENSVÄRD, B., AND J. POPE, Chinese Art: From the Collection of H. M. King Gustav VI Adolf of Sweden, New York, 1966.

HALL, E. T., M. S. BANKS, AND J. M. STERNS, "Uses of X-ray Fluorescent Analysis in Archaeology," *Archaeometry* 7 (1964).

HSIA NAI, "Shen Kua and Archaeology," collected in his *K'ao-ku-hsüeh ho K'o-chi-shih* [Essays on Archaeology and the History of Technology in China], Peking, 1979.

HSIAO T'UNG, *Wen Hsüan* [A Selection of Literary Essays], 1181 edition annotated by Li Shan, reprinted by Chung-hua Shu-chü, Peking, 1974.

HSIEH YING-PO, *Chung-kuo Yü-ch'i Shih-tai Wen-hua Shih Kang* [Concise History of Chinese Civilization in the Jade Age], Canton, 1930.

HSÜ SUNG, *Sung Hui-yao Chi-kao* [Collection of Important Events during the Sung Dynasty—A Preliminary Draft], vol. 75, Peking, 1957.

HSÜ WEI, *Ch'ing-t'eng Shu-wu Wen-chi* [Collected Essays of Hsü Wei], *chüan* 12, one of five poems on narcissus, *Kuo-hsüeh Chi-pen Ts'ung-shu* ed., Taipei, 1968.

HU YING, *Chia-i Sheng-yen*, collected in *Li-tai Hsiao-shuo Pi-chi Hsüan*, Hong Kong Commercial Press ed., Hong Kong, 1959.

JAO TSUNG-I, "A Study on the Painting Rubbings of the Stone Plinths of the Hsüan-miao Monastery in Wu-hsien, Kiangsu," *The Bulletin of the Institute of History and Philology* (Taipei) 49, part 2 (1974).

KO HUNG, *Hsi-ching Tsa-chi* [Miscellaneous Records of the Western Capital], *Jen-jen Wen-k'u* ed., reprinted Taipei, 1979.

KO HUNG, *Pao P'u Tzu*, Chung-hua Shu-chü ed., Shanghai, 1936.

KU CHIEH-KANG AND YANG HSIAN-KUEI, "The History of the 'Three Emperors' in Ancient China," *Yenching Journal of Chinese Studies*, Monograph Series no. 8, Peking, 1940.

KU KUNG-SHUO, "Mo-hou-lo," in *Wen-wu Ts'an-k'ao Tzu-liao* (1958), no. 7, p. 55.

LANG YING, *Ch'i-hsiu Lei-kao*, *chüan* 27, Chung-hua Shu-chü ed., Peking, 1959.

LAUFER, B., *Chinese Pottery of the Han Dynasty*, Leyden, 1909, reprinted Tokyo, 1962.

LAUFER, B., *Jade, A Study in Chinese Archaeology and Religion*, Chicago, 1912, reprinted New York, 1974.

LEE, S. E., AND WAI-KAM HO, *Chinese Art under the Mongols: The Yüan Dynasty*, Cleveland, 1968.

LI FANG, *Chung-kuo I-shu-chia Cheng-lüeh* [Compendium of Chinese Artists], first published 1914, reprinted Taipei, 1968.

LI FANG, *T'ai-p'ing Kuang-chi* [The T'ai-p'ing Collection of Fictional Novels], Chung-hua Shu-chü ed., Peking, 1961.

LI FENG-KUNG, *Yü Ya* [Allusions to Jade in Chinese Literature], Canton, 1935.

LI HSIEN, *Ta Ming I-t'ung Chih* [Unified Record of the Ming Dynasty], 1451 ed. reprinted T'ai-lien Kuo-feng Press, Taipei, 1977.

LIN P'EI-CHIH, "The Ramayana and the Story of How Ch'en the Inspector General Lost His Wife in the Mei-ling Mountains," *Wen-hsüeh* 11, no. 6 (June 1934), special issue on Chinese literature, reprinted Hong Kong, 1968.

LIU TS'UN-YAN, *The Authorship of the Feng Shen Yen I*, Wiesbaden, 1962.

LIU TS'UN-YAN, "Vaiśravana and Some Buddhist Influences on Chinese Novels," collected in his *Essays from the Hall of the Harmonious Wind*, vol. 2, Hong Kong, 1977.

LO FU-I AND WANG JEN-TS'UNG, *Yin-chang Kai-shu* [Introduction to Chinese Seals], Peking, 1963, reprinted Hong Kong, 1973.

LOVELL, HIN-CHEUNG, "Sung and Yüan Monochrome Lacquers in the Freer Gallery," *Ars Orientalis* 9 (1973), pp. 121–130.

MAHLER, J. G., *The Westerners among the Figurines of the T'ang Dynasty of China*, Rome, 1959.

MENG HAN-CH'ING, *Chang K'ung-mu Chih-k'an Mo-ho-lo* [Chang the Scribe Cleverly Investigates the Case of the *Mo-ho-lo*], collected in Tsang Mao-hsün's *Yüan-ch'ü Hsüan*, Shih-chieh Shu-chü ed., Shanghai, 1936.

MENG YÜAN-LAO, *Tung-ching Meng-hua Lu* [Memoirs of the Eastern Capital], annotated by Teng Chih-ch'eng, Hong Kong Commercial Press ed., 1961.

Mɪ Fᴜ, *Hua Shih* [The History of Painting], Taipei, 1973.

Mɪᴀᴏ Cʜ'ᴜᴀɴ-sᴜɴ (collected), *Ching-pen T'ung-su Hsiao-shuo*, Chung-hua Shu-chü ed., Peking, 1959.

Mɪᴢᴜɴᴏ, S., ᴀɴᴅ T. Nᴀɢᴀʜɪʀᴏ, *The Buddhist Cave Temples of Hsiang-t'ang-ssu*, Kyoto, 1937.

Mᴜsᴇᴜᴍ ғᴜʀ Osᴛᴀsɪᴀᴛɪsᴄʜᴇ Kᴜɴsᴛ, *Kunst Ostasiens*, Berlin, 1963.

Nᴀɴᴋɪɴɢ Mᴜsᴇᴜᴍ, *Nan-t'ang Erh-ling Fa-chüeh Pao-kao* [Report on the Excavations of Two Southern T'ang Mausoleums], Peking, 1957 (referred to as *Southern T'ang Mausoleums*).

Nᴇᴇᴅʜᴀᴍ, J., *Science and Civilisation in China*, vol. 3, Cambridge, 1954.

Nɪᴇʜ Cʜ'ᴜɴɢ-ɪ, *San-li T'u*, K'ang-hsi reprint, 1676.

Osᴀᴋᴀ Mᴜɴɪᴄɪᴘᴀʟ Mᴜsᴇᴜᴍ, *Arts of the Han Period*, Osaka, 1975.

Oᴜ-yᴀɴɢ Hsɪᴜ, *Hsin Wu-tai Shih*, Chung-hua Shu-chü ed., Shanghai, 1974.

Pᴀʟᴍɢʀᴇɴ, N., *Sung Sherds*, Stockholm, 1963.

P'ᴀɴ Yᴜɴɢ-yɪɴ (ed.), *Sung Pai Lei-ch'ao* [Collected and Classified Sung Anecdotes], reprinted from K'ang-hsi ed., Taipei, 1967.

Rɪᴅᴅᴇʟʟ, S., *Dated Chinese Antiquities, 600–1650*, London, 1979.

Rᴜᴅᴇɴᴋᴏ, S. J., "The Mythological Eagle, the Gryphon, the Winged Lion, and the Wolf in the Art of Northern Nomads," *Artibus Asiae* 21, no. 2 (1958).

Sᴄʜᴀғᴇʀ, E. H., *The Golden Peaches of Samarkand: A Study of T'ang Exotics*, Berkeley, 1963.

Sᴄʜʟᴏss, E., *Art of the Han*, New York, 1979.

Sᴛᴇɪɴ, A., *Innermost Asia*, Oxford, 1928.

Sᴜ T'ɪᴇɴ-ᴄʜᴜ̈ɴ, "Pei-ching Hsi-chiao Hsiao-hsi-t'ien Ch'ing-tai Mu-tsang Fa-chüeh Chien-pao" [Excavations of the Ch'ing Dynasty Tombs at Hsiao-hsi-t'ien, Peking], *Wen Wu* (1963), no. 1, pp. 50–59.

Sᴜʟʟɪᴠᴀɴ, M., *Chinese Ceramics, Bronzes and Jades in the Collection of Sir Alan and Lady Barlow*, London, 1963 (referred to as *Barlow Collection*).

Sᴜɴɢ Yɪɴɢ-ʜsɪɴɢ, *T'ien Kung K'ai Wu*, first published 1637, undated edition annotated by Chung Kuang-yen reprinted Hong Kong, 1978.

T'ᴀᴏ Tsᴜɴɢ-ɪ, *Ch'o Keng Lu* [Notes Written in the Intervals of Plowing], compiled 1366, reprinted Shanghai, 1922.

Tᴇɴɢ T'ᴏ, *Yen-shan Yeh-hua* [Evening Conversations at Yen-shan], Peking, 1963.

T'ᴏ T'ᴏ, *Chin Shih* [History of the Chin Dynasty], Chung-hua Shu-chü ed., Peking, 1975.

T'ᴏ T'ᴏ, *Sung Shih* [History of the Sung Dynasty], Chung-hua Shu-chü ed., Peking, 1977.

Tᴏᴋyᴏ Nᴀᴛɪᴏɴᴀʟ Mᴜsᴇᴜᴍ, *Chinese Paintings of the Yüan Dynasty on Buddhist and Taoist Figure Subjects*, Tokyo, 1975.

Tᴏʀɪɪ Ryᴜᴢᴏ, "Vases of the Sassanian Style and the Ways and Manners of the Po-hai People," *Yenching Journal of Chinese Studies* (Peking) 30 (1946), pp. 51–61.

Tʀᴇɢᴇᴀʀ, M., *Catalogue of Chinese Greenware in the Ashmolean Museum, Oxford*, Oxford, 1976.

Tʀᴏᴜsᴅᴀʟᴇ, W., *The Long Sword and Scabbard Slide in Asia*, Smithsonian Contributions to Anthropology no. 17, Washington, D. C., 1975.

Tᴜ Yᴜ, *T'ung-tien*, reprinted Taipei, 1964.

Vᴀʟᴇɴsᴛᴇɪɴ, S. G., *A Handbook of Chinese Ceramics*, New York, 1975.

Wᴀɴɢ Aᴏ, *Ku-su Chih* [Gazetteer of the Su-chou Area], Cheng-te ed., reprinted Taipei, 1965.

Wᴀɴɢ Cʜɪᴀ, *Shih-i Chi*, Taipei, 1969.

Wᴀɴɢ Fᴜ, *Po-ku T'u*, San-ku T'u ed., reprinted T'ien-tu, 1752.

Wᴀɴɢ Sʜɪʜ-ᴄʜᴇɴ, *Ku-pu-ku Lu*, collected in the *Ts'ung-shu Chi-ch'eng Chien-pien*, Commercial Press ed., Taipei, 1965–1966.

Wᴀɴɢ Yɪɴɢ-ʟɪɴ, *Yü Hai*, Taipei, 1964.

Wᴀssᴏɴ, R. G., *Soma: Divine Mushroom of Immortality*, The Hague, 1968.

WATERBURY, F., *Bird Deities in China, Artibus Asiae* Supplement 10, Ascona, 1952.

WATSON, W., *The Genius of China: An Exhibition of Archaeological Finds from the People's Republic of China*, London, 1973.

WEI SHOU, *Pei-wei Shu*, Chung-hua Shu-chü ed., Shanghai, 1974.

WEN CHEN-HENG, *Ch'ang-wu Chih*, collected in *Ts'ung-shu Chi-ch'eng*, vol. 469, reprinted Taipei, 1966.

WILLIS, G., *Jade of the East*, Tokyo, 1972.

WIRGIN, J., "Sung Ceramic Designs," *Bulletin of the Museum of Far Eastern Antiquities* 42 (1970).

YANG PO-TA, "On Sculptural Art in the Exhibition at the Palace Museum, Peking, in 1978," *Kuang-ming Jih-pao* (June 9, 1978), p. 4.

YEH CHIH, *T'an-chai Pi-heng*, [Notes from the Unperturbed Study], collected in T'ao Tsung-i, *Shuo Fu, chüan* 18, Shanghai, 1927.

YEN CHIH-T'UI, *Yen-shih Chia-hsün* [Family Admonitions of the Yen Clan], Taipei, 1958.

Photography credits: no. 11, Otto E. Nelson; no. 104, Fogg Art Museum, Harvard University, Cambridge, Mass.; fig. 1, Victoria & Albert Museum; fig. 2 from S. H. Hansford, *Chinese Carved Jades* (London: Faber and Faber, 1968), pl. 78, reproduced by courtesy of His Excellency The Marshal of the Realm, The Royal Palace, Stockholm; fig. 4, The Minneapolis Institute of Arts; *A Group of Inscribed Jades* figs. a and b, reproduced by courtesy of the Trustees of The British Museum.

Edited by Katharine O. Parker

Designed by Joseph Bourke Del Valle

Composition by Cardinal Type Service

Printed by Eastern Press, New Haven, Conn.

# Chinese Jades

Asia House Gallery, New York City
The Detroit Institute of Arts
Seattle Art Museum
Honolulu Academy of Arts